COMPENDIUM OF
WATERCOLOUR
TECHNIQUES

Over 200 tips, techniques and trade secrets

ROBIN BERRY

Search Press

A QUARTO BOOK

Published in 2011 by Search Press Ltd
Wellwood
North Farm Road
Tunbridge Wells
Kent TN2 3DR

ISBN: 978-1-84448-771-4

Conceived, designed and produced by
Quarto Publishing plc
The Old Brewery
6 Blundell Street
London N7 9BH

QUAR.WTTS

Senior Editor: Ruth Patrick
Art Editor: Jackie Palmer
Designer: Karin Skånberg
Copy Editor: Liz Jones
Author's photographer: Vicki Madsen
Photographer: Simon Pask, Phil Wilkins
Proofreader: Sally MacEachern
Indexer: Helen Snaith
Picture Researcher: Sarah Bell
Art Director: Caroline Guest
Creative Director: Moira Clinch
Publisher: Paul Carslake

Colour separation in China by Modern Age Pte Ltd
Printed in China by 1010 Printing International Ltd

10 9 8 7 6 5 4 3 2 1

Contents

Introduction

'Artists are not any more sure of themselves than anyone else; they simply create in spite of their insecurity.'

– Rollo May (1909–2004), American psychologist

There is an artist in everyone, and that artist needs only a simple guide to get started, expert advice to keep going and ongoing challenges to advance. This is that guide.

With over 200 practical tips and techniques to spark your creativity, this book is a workshop in your hands. In a world with seemingly endless variety in art supplies, it will be your teacher as you select what you need to start, what ideas may save you some money until you're sure of a direction and what is worth spending money on from the start. There is nothing more exciting than bringing home a bag of new art supplies. With this book you will have all you need to get to know how your materials behave, how you might use them for the first time or integrate them into your own style. Advanced painters will also likely find things they have never thought of before.

What remains then, is only how to get started: what to paint first? This book will help you build a personal aesthetic in the collection and keeping of your resource material. Follow the advice here and you will never be without something to paint – something that will grow from the artist within you.

Robin Berry

About this book

The information in this book is organised into four chapters:

Chapter 1: Getting Started
(pages 8–53)
Here you'll learn the basics: how to choose your sketching materials, paper, palettes, brushes and painting tools, supports, different types of watercolour paints, and how to set up your work space.

Tips and techniques
Over 200 tips and techniques are featured, each one revealing practical information to help you achieve the results you want.

Chapter 2: Painting
(pages 54–109)
Learn about the principles of design and composition, the various methods of transferring your subject to your support and how best to gather and make the most of reference material. This chapter also provides a wealth of subject ideas and useful tips to help aid you in your approach to watercolour painting.

Try it panels
Further develop and refine your technique by trying out new approaches.

Fix it panels
Correct any mistakes and improve your skills with these invaluable nuggets of wisdom.

Chapter 3: Choosing a Subject
(pages 110–145)
This chapter will help you hone your watercolour skills. You will learn to experiment with composition, colour and lighting, as well as deal with the challenges of capturing motion. Advice on choosing your subject for all aspects of painting are considered: from landscapes and cityscapes to still life.

Step-by-step sequences
Clear step-by-step information shows you how to successfully create professional results.

Chapter 4: Techniques
(pages 146–171)
A host of techniques is explored here. Find out how to achieve the special effects that will bring your paintings to life. Spraying, spattering, sponging and scumbling are just some of the many decorative techniques that can be used to add texture and expression to your paintings.

Artist at work
Subject-specific demos show you how to capture the right atmosphere.

Reference material
Shows the source the artist used as inspiration.

Palette and materials
An at-a-glance look at the colours and materials used.

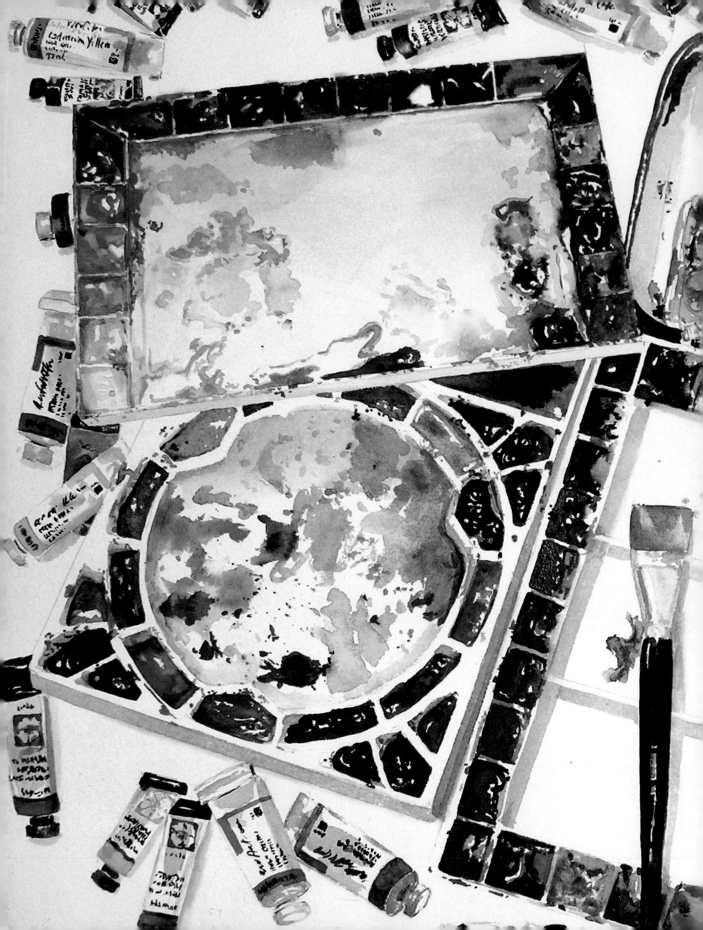

1

Getting Started

Among the most exciting moments in a painter's life is returning from the art supply store with a bag filled with new materials – a new brush or two, tubes of new pigments, a sketchbook and perhaps some pencils. In this chapter, you will not only find useful information about your supplies but also helpful hints to begin using them and – at the start of this chapter – advice on how to get in the right frame of mind to begin painting.

Art supplies
Virtually every artist falls in love with art supplies. In *Sisterhood of the Traveling Paints*, Robin Berry has expressed the excitement of a group of friends painting together by painting not the painters, but their palettes, tubes of paint and brushes.

To begin

If you want to paint, you can. All you need is the clear intention to try – take the phone off the hook and open your mind to what moves and inspires you. In this book, the work, wisdom and advice of watercolourists from around the world help you begin. You will find information on all the materials you need to pick up the brush and put your inspiration into watercolour.

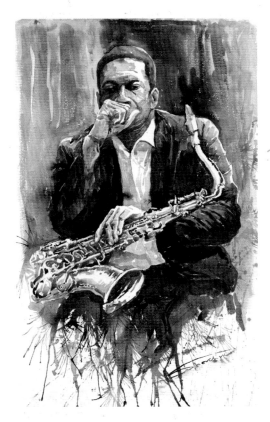

▲ **Think deep**
Yuriy Shevchuk's watercolour study *John Coltrane, Jazz Saxophonist* combines a masterful understanding of how to capture the contemplative character of the musician and great observational detail of the instrument.

Reduce distractions but don't forget the home comforts

If possible, try to reduce distractions during your painting sessions. Turn off the phone and don't answer the door. This is especially important if your studio is at home. Let your friends and family know this is your work time. Remember, you need to spend plenty of time sitting back, studying what you've done and thinking about the next move. Relaxing is all part of the process. Make it more enjoyable still by keeping a few comforts at hand. Be good to yourself.

- A kettle for coffee; cookies optional.
- A radio: spoken-word programmes provide a semi-interesting background burble, which keeps your left brain occupied and stops it from interfering with the non-verbal work in progress.
- Audiobooks: listening to a story helps pass the time.
- Music: both soothing and stimulating.
- A do-not-disturb sign.

- Art books, paint catalogues, work-related reading.
- Prepare well, get all the equipment you need together before you start. Watercolour is a medium that won't wait while you rush off to find an extra large brush or get a refill of clean water. Watercolour has a character of its own and it will do something unexpected while you are away (sometimes the unexpected happy accident is part of the creative process).

Freeing your mind

If an endless to-do list inhibits you from getting down to painting, try this exercise. It lets you briefly focus on your thoughts, hopefully to put them aside when you're done, and start painting. In your sketchbook, make a map of what's on your mind, of what you need to achieve today, this week, this year. In the centre, sketch a quick image that represents you. Surround it with words representing the major thoughts on your mind. Connect each to you. Growing in branches out of those major ideas are the details of what you need to do. This is a record, or a picture of your mind right now.

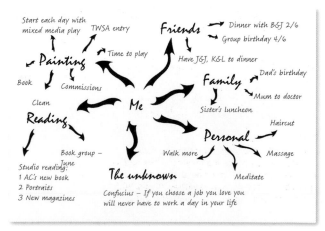

3

Inspiration from other artists

Often the urge to paint can come from looking at the work of other artists. One artist, William Lawrence, describes the process of being inspired by and learning from other artists.

In *The Palette* magazine (Sept.–Oct. 2010), Lawrence writes "On this trip [to New York] I saw many paintings by two of my favourite painters. Wassily Kandinsky and Arshile Gorky. Seeing their work again...I decided to get reacquainted with line and colour, with the enthusiasm and infatuation I felt in my younger days. We are all at some time seduced by the work of another artist. This can be a very positive influence on our work depending on how we incorporate the seduction. As an exercise, imitating another artist's work can be very informative."

What Lawrence is describing here is the way artists got inspiration and acquired knowledge through the centuries – and still do in classic art schools. As you practise the points in this book, a study of the artists whose styles you admire would be useful. We are fortunate to live in the digital era where such a search is easy and virtually most of the art in the world is available to us for both study and inspiration.

▲ **Exploring colour**
In William Lawrence's *Herrington Road*, exploration of colour is the dominant design element (see page 107).

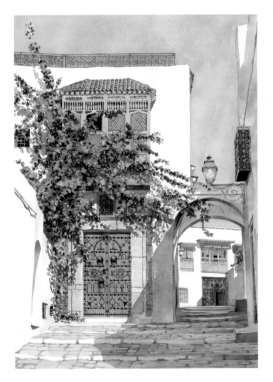

▲ **Inspired by light**
Moira Clinch's painting, *Tunisian Doorway*, expresses the thrill of light and colour coming together in the perfect subject. A simple description would never express what this bright and brilliant painting says without words. With such an inspiration, beginning to paint becomes easy.

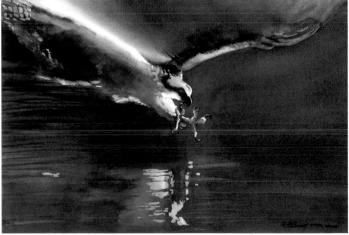

▲ **Inspired by nature**
In *Osprey Dive*, Robin Berry shows a moment of being at one with nature and in awe of a chance sighting of the mystery of another species.

4

What is it that makes you want to paint?

Painting is a way to show others what you find beautiful – be it light, birds, people or memories. Whatever it is, the quiet space you create around yourself will help you see it more clearly. So open your mind and your sketchbook, and begin.

Starting to sketch

To capture an idea – to get it down – so you can recall your first impression, you need only paper and a pencil. Paper and pencil were probably your first drawing tools in school and are still your most valuable now. Artist and sketchbook are so closely bound that virtually every artist keeps at least one, or sometimes many. Over the years, these will grow to form a rich history of your ideas – the evolution of your personal artistic vision.

▼ Sharpeners
A hand-operated sharpener with a container to catch the shavings, a simple manual sharpener and a simple electric sharpener.

5

Researching products

Did you know that art supply catalogues are an excellent source not only of what is available but also of information about how to use particular products? These catalogues can be ordered online, by phone or by return postcard. But do be careful not to get sidetracked or overwhelmed – there are thousands of products on the market. Take time to investigate just what you will need to get started.

6

Using sketchbooks

A sketch is a visual idea: a first impression, a quick record of something you've seen or a longer drawing of something that interests you. As an artist, you will use a sketchbook in all of these ways to capture moments of inspiration. Sketchbooks come in all shapes and sizes. You will find several different bindings: glued into a pad, spiral-bound in wire or plastic and book-bound. The paper can vary from inexpensive drawing paper to a high-quality, acid-free paper suitable for painting on, or for using pens. At first, choose a relatively inexpensive sketchbook that can take a bit of rough treatment. Don't be lured into buying an overly expensive book you won't dare to use in case you make a 'mistake'.

7

Finding the right sharpener

If you choose to use pencils, you will need a sharpener of some kind. For the studio an electric sharpener works best, but for the field a craft knife – with a retractable blade – will cut the wood away from the lead with ease.

8

Hard or soft pencil?

Pencils are the most common sketching tools. They are graded according to the degree of hardness or softness of the graphite 'leads' they contain. Hard pencils are labelled 'H': 2H, 4H and so on, and contain clay mixed with the graphite. Soft pencils are labelled 'B': 4B, 8B, etc. The higher the number, the harder or softer the lead. Very hard lead can be hard to see and will carve a groove into your paper unless you use a light touch. Very soft lead will smear very easily but is capable of very black blacks. The most useful pencils are of a medium hardness – H, HB (F) or B – dark enough to read but hard enough not to smear easily.

▶ Sketchbooks
Before you buy a sketchbook online, visit an art supply store and look at their sketchbooks. Feel the paper, and get an idea of how the size of the sketchbook relates to its use. Wirobound sketchbooks allow you to work flat and to easily tear out pages and start again.

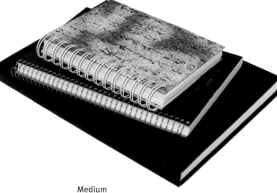

▼ Pencils
Pencils are relatively inexpensive. Try giving yourself a range of three steps on either side of F or HB. For example, choose an HB, H, 3H, 6H, B, 3B and 6B.

Very soft

Medium

Very hard

7B 6B 4B 2B B HB H F 2H 4H 6H

9

Colour on the move

Coloured pencils are ideal sketching tools if you're willing to carry a few different colours. It's useful to be able to record a scene in colour. Coloured pencils are generally composed of pigment mixed with clay or wax. If the pigment is bound with a water-soluble material rather than wax, it is known as a watercolour pencil. This looks like an ordinary coloured pencil but, when water is applied, turns into a wash of paint (though in most cases, your lines are still visible).

► Coloured pencils
Coloured and watercolour pencils can be purchased singly or in sets. If you buy a large set, you may find some pencils go unused. A small set is ideal – you can then add to it any extra pigments that you love to use.

6

10

Best pencil types

Wooden pencils are most readily available but require frequent sharpening. Choose a mechanical pencil if you want to avoid this. A lead holder takes a stouter lead. Although often used as drafting tools, these make terrific sketching tools, as the graphite rod can be quickly changed as your drawing need changes. Another wonderful sketching tool is the studio pencil. You'll have seen a stub of one behind every carpenter's ear. These are broad, flat pencils with thick, wide leads. This can be sharpened with a knife or blade into a variety of points, chiselled wedges or ovals.

11

Pastels and conté

Conté crayons or sticks are similar to pastels in appearance. Both are chalk-like. They are made of compressed pigment, graphite or charcoal mixed with wax or clay and formed into easy-to-handle sticks.

Conté sticks

12

Types of charcoal

Vine charcoal is the softest and most delicate form. Charcoal that is mixed with a gum binder and compressed makes sticks that can make darker marks and smudge less. Charcoal lead is thin, artificial drawing charcoal meant to be used in a holder, keeping the fingers relatively clean.

Charcoal

▼ Pencils and pens
There is a seemingly endless variety in pencils and pens. What's important is that they make the mark you want to make. All are useful in sketching.

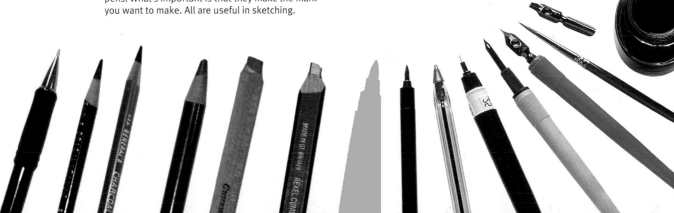

Types of watercolours

The first 'watercolour' pigments were derived from earth minerals such as ochre or soot, natural plant dyes, berries and insects. Until the Renaissance, the artists found, ground and mixed their own pigments. In the seventeenth century, this began to be a specialised activity, and in the 1830s, Winsor and Newton started to produce consistent, high-quality pigments, eventually inventing the collapsible tube that is still used today.

13

Which paint format?

There are various different ways to package watercolour paint. The type you choose will depend on your preferences and particular needs.

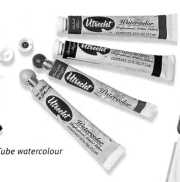

Tube watercolour

Chinese watercolour pans

▲ Tubes

Tube watercolour is a viscous mixture of finely milled pigment, ready to use once water is added. This kind of paint must be used with a palette.

▶ Pans and half pans

Pans and half pans are dried 'cakes' of pigment that can be reconstituted with water. They usually come set into a palette with other cakes of colour. Your first watercolour experience was probably with a small set of these in your early school years.

Pans and half pans

▶ Liquid watercolours

Liquid watercolour comes in small bottles and can be used straight from the bottle or poured into another container and diluted. These are usually dyes, not pigments.

Liquid watercolours

▲ Watercolour pencils

Watercolour pencils look like coloured pencils, but the pigment in them is water-soluble and doesn't have the waxy texture of coloured pencils. These are useful for dry sketching while travelling. Water can later be brushed into the sketch to create washes.

▲ Watercolour crayons

Watercolour crayons look and go onto paper like a crayon. They can be used dry or wet to make a creamy wash.

▶ Watercolour sticks

A watercolour stick is pure compressed pigment in stick form that dissolves into a creamy mixture when wet.

14

Watercolour tube sizes

Tube size varies considerably between brands, from tubes the size of your little finger (5 ml), to 15 ml, to those that fill the palm (37 ml). If you are in the early stages of painting, stick to the smaller sizes until you're sure which colours you'd like in your palette.

5 ml tube 15 ml tube 37 ml tube

16

Pure vs. mixed secondaries

Most watercolour palettes contain an orange, a violet and a green. Pure forms of these secondary colours are often more vibrant than they would be if mixed from primaries. When you determine the direction your palette will take, it will be clear whether these pigments will be helpful to you or not. For more advice about your palette, see page 24.

15

Ways of altering the paint

You may need to alter the nature of your paint, and several products, or mediums, can help you with this:

- Ox gall improves the flow of your washes. Add a few drops to your mixing water. However, don't overuse it or your washes will be dull.
- Gum Arabic is already a major ingredient in the paint; adding a little more either to a wash or your mixing water will increase the transparency of the paint. It will also help if you need to remove some colour. Beware, though,

as overuse will give an unpleasant gloss to the surface of your painting.

- Texture medium can either be added to paint or applied directly to paper to increase the textural appearance of an area of painting. Use old brushes and clean them immediately afterwards.
- Iridescent medium adds a glittering effect to an area of the painting. It works best for more decorative work and should not be allowed to contaminate your palette.

17

Student or professional?

Some brands of watercolour come in two grades – student or professional. The student-grade paint contains less pigment and more filler, so it is less expensive. It's important to note that when this grade of paint is used in a painting, it lacks the saturation and vibrancy of the purer paint in the professional line. The professional grade contains the full-strength formula of the pigment and, for that reason, is more costly. Some manufacturers do produce paint of excellent quality at a lower cost, though. It pays to compare brands and find what works for you.

Know your paint

Watercolour is the most accessible of all the painting mediums – every schoolchild has had experience with it. The excitement of watching rich colour flow onto paper is endlessly entertaining for anyone who loves this medium. But there are a few important things to know about the paint that will help to ensure success every time.

▼ Paint safety

Paint labels are required to have clearly marked health and safety warnings. Shown here is the warning label for Cadmium Orange. Always wear protective gloves when there is a chance of paint getting on your hands. Although not all paint is dangerous, some is, so it's best to be safe.

> WARNING: DO NOT SPRAY APPLY This product contains cadmium, a chemical known to the State of Califonia to cause cancer by means of inhalation
> Conforms to ASTM D 4236

FACT FILE

Common toxic ingredients

Aluminium
Amorphous silica
Carbon black
Chromium compounds
Cobalt, all forms
Cadmium, all forms
Copper
Crystalline silica
Iron oxide
Lead
Manganese
Nickel
Quinacridones
Phthalocyanines
(Phthalo or thalo)
Titanium dioxide
Zinc

18

Protect yourself

Every tube of watercolour sold is required to be labelled with information about the paint inside. Many paint ingredients are toxic. So, as a rule, if you are going to get paint on your hands, wear rubber gloves. Cadmium Orange, for example, contains the metal cadmium, which is known to cause cancer when inhaled, so it should not be applied using a spray technique. Any tube containing cadmium should mention this. This does not mean you shouldn't use and enjoy Cadmium Orange; it is one of the purest and loveliest oranges available. Just be aware of the precautions you should take as you apply it.

▼ Know your pigments

A thorough knowledge of your pigments will allow you to take advantage of all of watercolour's many benefits, such as rich, deep darks and clear, transparent colours, demonstrated here in *Sunflowers* by Lenox Wallace.

19

Colour index (C.I.) name

The C.I. name is the international standard code for each pigment. It tells you whether a colour has been made from a single pigment or mixed from more than one. It is generally considered better if a colour is made from a single pigment; the more pigments used, the duller the colour. However, modern manufacturing processes now allow for mixed-pigment colours that retain brightness (the range of bright proprietary greens available proves this).

The C.I. name also helps to clarify the situation when more than one manufacturer has used the same name for a colour, even though each manufacturer actually produces it from different pigments. Conversely, colours made from the same pigment may be given different names by separate manufacturers.

Pigment key

PY = pigment yellow	PBl = pigment black
PO = pigment orange	PW = pigment white
PR = pigment red	
PV = pigment violet	For example,
PB = pigment blue	PB28 = Cobalt Blue
PG = pigment green	PY42 is Yellow Ochre for
PBr = pigment brown	some manufacturers and
	Raw Sienna for others.

20

Use your computer as a classroom

Websites, such as www.handprint.com/HP/WCL/water.html/, provide expert, experienced advice on many topics including paint, paper, brushes and techniques. By entering key words, such as 'cadmium red', into a web browser, you will discover a wealth of information.

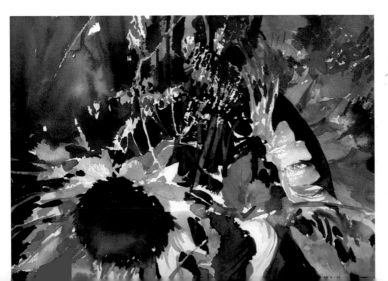

Understanding the label

Beyond listing the ingredients, paint labels can be very informative. For instance, some carry information about lightfastness ('I' is very lightfast and 'V' is not lightfast at all) along with the series number. The series number is related to the cost category, with 'Series 1' being the least expensive in the line and 'Series 4' the most. Next time you pick up a tube of paint in a store, see how much of the label you can understand and use this information to make an informed choice about buying it.

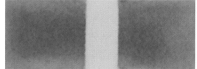

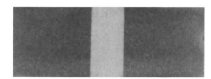

Cobalt Blue: non-staining

Phthalo Blue: staining

Staining vs. nonstaining paint

One important quality of paint is whether it sits on top of the paper or sinks deeply into the fibres, making it more difficult or even impossible to remove. Colours such as Alizarin Crimson and Phthalo Blue and Green stain the paper and defy all attempts to remove them. Others, such as Cobalt Blue or Ultramarine, sit on the surface and can be removed with gentle wetting and brushing.

In the illustration above, a blue strip was painted with Cobalt Blue, a nonstaining colour, and Phthalo Blue, a highly staining colour. Both were allowed to dry. As the illustration shows, the sample on the right deeply stained the paper and was not removable, whereas the Cobalt Blue sample allowed the colour to be removed, leaving white paper.

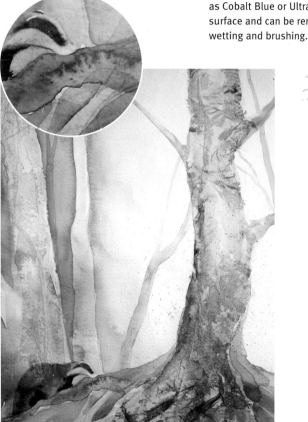

Testing for transparency

There is a wide range of possible transparency in watercolours from opaque, through semi-opaque, to translucent and transparent. It is important to know the opacity of your pigments, especially if they are intended for glazing (application of multiple thin layers). A simple test is shown below, in which three yellows were painted over a heavy pencil line. The pigment on the left, a neutral yellow, is completely transparent and would be ideal for glazing.

▲ **Transparent darks**
One of the biggest challenges in watercolour is to get the darkest darks possible and still keep them transparent so the light of the paper shines through. In *Forest Forager*, Shari Hills does this very well. If you look closely at the back of the badger, you will see that the background shows through and makes the animal seem a part of the whole rather than added on.

Aureolin transparent

Cadmium Yellow semi-transparent

Cadmium Yellow semi-opaque

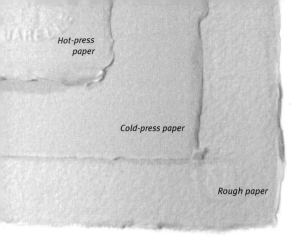

Hot-press paper

Cold-press paper

Rough paper

Watercolour paper

The first painting surface was a rock wall in a cave 35,000 years ago, followed by stone tablets, wood and eventually papyrus. Parchment and vellum were used as early as 1500 BC. Materials for making paper varied from vegetation such as reeds, to animal hides for vellum. Of the contemporary paper makers, Fabriano began in Italy in 1283, and Arches began in France in 1492. By that time, paper was made globally and many kinds of fibres were used.

Surface textures

When you are experimenting with paper brands, you will also have three different textures to choose from.

▲ Rough paper

Rough paper comes right off the bed (see opposite) and is allowed to dry as it is, giving it a unique, pebbled surface loved by many painters. The brush can either skim over the top of the texture leaving the valleys free of paint, or it can take a good scrubbing to push the paint deep into the valleys. Either way the light bounces off the paper and increases the surface excitement of the painting.

▲ Cold-pressed paper

Cold-pressed paper is run through cold rollers that press out a bit of the texture during the drying process. This paper is the one most commonly used. It offers surface excitement with a medium texture and at the same time will take washes beautifully, making it ideal for glazing.

▲ Hot-pressed paper

Hot-pressed (HP) paper is run through heated rollers that result in a very smooth surface. This smooth, absorbent paper is favoured for fine detail, and although some artists find its surface too absorbent, for others it is the perfect answer for subjects that do not benefit from heavy texture, such as portraits.

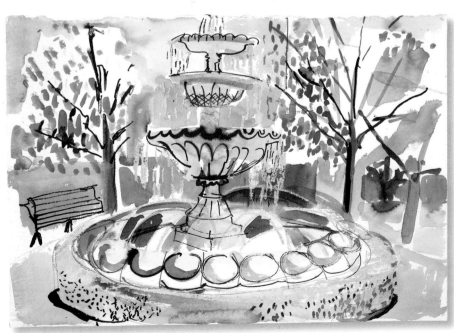

▲ Definition of details

Typical of Brian Innes's style, this fountain was painted with quickly laid-down washes to capture the basic scene, which is later defined in more detail with ink lines. Such a painting would require relatively smooth paper, such as HP.

25

Paper know-how

The best watercolour paper is made of 100 per cent long cotton fibres. It is made in a process that takes it from its raw form to pulp and then onto a bed where water drains away and sizing is added to make the 'blotter-like' pulp less permeable. The paper is then pressed and hung in gentle folds to dry. Finally, it is torn to the desired dimensions, inspected on a lightbox for flaws, and padded, blocked or packaged as required. There are many brands of high-quality watercolour paper. Experiment to find which you like best. Often, sample packs of several sheets are available from paper suppliers or art supply stores.

27

Paper pad or block?

Watercolour paper pads come in fairly standard sizes, from 10 x 12.5 cm (4 x 5 in.) to 50 x 74 cm (20 x 29 in.), and are padded or spiral-bound at one end only. Blocks, on the other hand, are padded all around with only a small area left free to slip in a knife and cut the finished painting free. The great thing about blocks is that should you prefer 190 gsm (90 lb.) or 300 gsm (140 lb.) paper, it never needs stretching. The disadvantage is that you need to finish that top sheet and cut it free before starting a painting beneath it. Pads are more versatile for drier watercolour techniques.

26

Paper weights

The most common paper weights are 190 gsm (90 lb.), 300 gsm (140 lb.) and 640 gsm (300 lb.), though others are available. All but the smallest size of 190 gsm (90 lb.) and all 300 gsm (140 lb.) papers need to be stretched to keep them from buckling when you paint. (See page 21 for more about paper stretching.) 640 gsm (300 lb.) paper is very sturdy and can be used without stretching.

28

Buying single sheets

As well as pads and blocks, watercolour paper also comes in sheets. These are generally available singly or in packs of 5, 10, 25, 50 or 100. The standard sheet size is 56 x 76 cm (22 x 30 in.). A larger size is called the 'single elephant' and is about 66 x 102 cm (26 x 40 in.). The 'double elephant' is 76 x 102 cm (30 x 40 in.). It is also possible to buy watercolour paper on long rolls of varying widths, opening up unlimited possibilities.

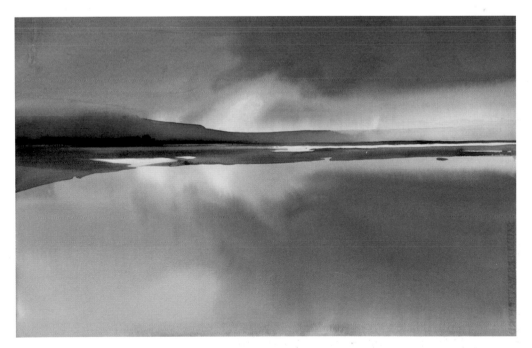

◀ **Flat paper – maximum control**

In her painting *Karamea Lagoon*, Adrienne Pavelka has worked on stretched 640 gsm (300 lb.) rough paper. Working in big, colourful washes, stretching works best, even with this heavyweight paper. Keeping the paper flat allows maximum control over the smooth, blended washes such as you see here.

Supporting the paper

Watercolour paper, even the toughest 640 gsm (300 lb.) variety, needs to be supported on a firm surface. It is floppy, especially when wet, and it's best to tape or clip your paper to a rigid board of some kind. Having your painting on a board allows you to move its position and tip and tilt it as needed.

29

To clip or to tape?

The watercolour paper can be clipped to your chosen support board. It is easy to release a clip, either to paint under it or to let the paper settle if it has moved. Some artists prefer to tape the paper on all edges, though, for two reasons. This holds the paper in place evenly, and gives a white border when the tape is removed.

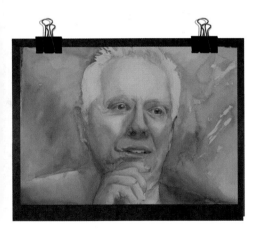

TRY IT
Find the buckling point

On small 20 x 25 cm (8 x 10 in.) to 28 x 38 cm (11 x 15 in.) unstretched pieces of 300 gsm (140 lb.) and 640 gsm (300 lb.) paper, see how wet you can get the paper with a brush and water before it buckles. You do not need to use paint. Dry the paper and it will be reusable.

30

Choosing a support board

There are a number of options available for support boards. Choose the one that suits your style of working best.

1 Plywood

Plywood makes a good support for watercolour paper, but it's relatively heavy. Another disadvantage is that unless it is sanded and varnished, it may have splinters. On the other hand, if you are stretching your paper, it works quite well as a support.

◄ **Clipped painting**
A piece of 300 gsm (140 lb.) watercolour paper can be clipped to a support board, such as Masonite, if the size of the paper is no more than 38 x 50 cm (15 x 20 in.) or so. If it is any larger, it will buckle. A 640 gsm (300 lb.) sheet of paper can be clipped at any size and will not buckle. Shown here on a 640 gsm (300 lb.) half sheet is *John Command*, by Robin Berry.

▲ ▶ **Taped painting**
The paper taped to the board on all four edges is 640 gsm (300 lb.) cold-press paper. It is a strong, boardlike sheet that is unlikely to buckle when wet.

2 Masonite

Masonite works well if you are taping or clipping your paper but not stretching it. It is lighter and more compact than plywood but heavier than Gatorboard or foam core. Both plywood and Masonite are available wherever lumber is sold.

3 Gatorboard

Gatorboard is a very durable, lightweight support for taping or clipping watercolour paper to, which is useful for painting on location. Its hard cardboard surface makes it an excellent choice for stretching your paper as well. It's more expensive than foam core and either plywood or Masonite, but a board will last for many years.

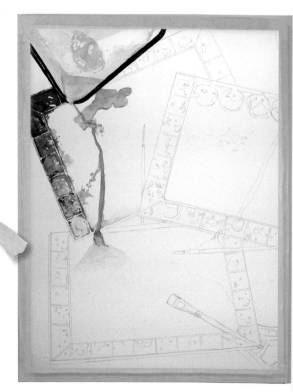

Stretching paper

If you like working on larger sheets of paper, or more lightweight varieties, stretching paper is a good skill to learn. With plywood or Gatorboard as a support, using 300 gsm (140 lb.) paper, you will then have a tough, resilient surface on which to paint. If you work very large, it is a good idea to glue and staple the paper to your support so it retains its shape. If you don't have the time to make your own sticky tape (as shown in Step 6), you can buy pre-glued brown tape.

1 Soak the sheet of paper in a clean tub of water for 10 minutes or so. The longer you soak it, the more size is released.

2 Pull it out of the water, holding two corners and tipping the sheet to drain off as much water as possible.

3 Carefully lay the sheet on your support board, taking care not to allow the paper to buckle or fold. Paper fibres have a memory and will return to their former state when wet.

4 When the paper is flat, use a staple gun and place a staple in an upper corner. Gently pull the opposite corner tight but do not overstretch. Staple that corner down. Do the same for the other two corners, again taking care not to pull too hard. Then add a staple in the middle. Be sure to put in the corner staples first and then the middle one.

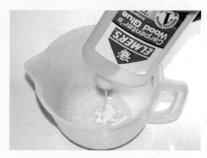

5 Make up a 1:1 mixture of wood glue and water.

6 Using brown paper packing tape, torn to fit each side of the paper, wet a strip with the glue mixture. Turn the glued packing tape over and place so it overlaps the paper by about 1.2 cm (½ in.). Press it in place. Repeat on the other sides.

7 Put staples every 5 cm (2 in.) on top of the brown paper tape and let it dry flat.

8 To leave a clean edge when the painting is done, use 5-cm (2-in.) white artists' tape, again overlapping the white paper by 1.2 cm (½ in.).

Brushes

Your primary tool as a watercolourist is the brush. While paintings can be made with a single kind of brush, and even a really cheap brush, you will not regret buying a selection of the best brushes you can afford. Brush performance does affect the painting. Different-shaped brushes accomplish different tasks.

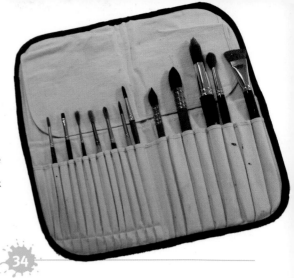

▶ **Brush case**
When you want a lot of brushes with you, a padded, folding case is a good option. The top can be folded back to form a stand for easy access.

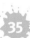

Choosing the right brushes

Each paint medium has its own brushes designed specifically to give the best performance using that kind of paint. Be sure to look for brushes made specifically for watercolour. The fibres will be red sable, Kolinsky sable, squirrel, goat, synthetic or a blend of natural and synthetic.

Where to start?

If you are buying brushes for the first time, try a synthetic blend. A no. 7 or no. 8, a no. 12 and a 2.5 cm (1 in.) flat will get you off to a good start. Avoid small brushes as it is too easy to get bogged down in making tiny brushstrokes.

▶ **Capped brushes**
If space is an issue, self-storing travel brushes (capped brushes) are the best brush choice.

34

Travelling with brushes

Travelling with watercolour brushes requires some thought due to the vulnerability of the brush hairs. Some brushes come with their own housing that can be attached to form a full-length brush or attached as a cover on the brush end. These can then be carried in a bag with no risk of damage. Your regular brushes are best carried in a protective case or even a paper towel tube sealed at each end with tissue.

35

Types of brushes

Brush types are generally distinguished by the shape of the brush end. The most common are 'round', 'flat', and 'wash' – which looks like an oversized flat. Additionally, brushes are numbered by size, with 'oo' being very small and '24' very large. Catalogues often show the brushes at actual size, which is helpful as there is not a universal size standard.

Brush types and sizes (see page 108 for the brushstrokes each can make)

Round		Flat		Mop		Wash	
1	Synthetic no. 24	6	Sable 2.5 cm (1 in.)	10	Squirrel no. 10	17	10 cm (4 in.) synthetic wash brush
2	Synthetic no. 14	7	Sable 2.5 cm (1 in.)	11	Squirrel no. 8	18	5 cm (2 in.) squirrel wash brush
3	Sable no. 14	8	Sable 2 cm (¾ in.)	12	Squirrel no. 6		
4	Synthetic blend no. 12	9	Synthetic 1 cm (½ in.)	13	Squirrel no. 4		
5	Synthetic no. 9			14	Squirrel no. oo		
				15	Rigger		
				16	Fan		

1 2 3 4 5 6 7 8 9 10 11 12 13 14

Brush substitutes

You can paint with anything, not just brushes. Some people find a sponge brush on a stick perfectly suitable for what they want to paint. These are very inexpensive. Natural sponges are often used for texture, as are sponge rollers. Experiment!

1 Sponge roller **5** Non-slip shelf
2 Eyedropper liner
3 Palette knife **6** Sea sponge
4 Toothbrush **7** Sponge brush

FACT FILE
Brush fact

The Winsor and Newton coveted Series 7 brush was named after the no. 7 brushes specially made by Winsor and Newton at the command of Queen Victoria in 1866.

TIPS

- Never leave brushes sitting in water or a pool of paint. Always rinse them clean after use.
- An old brush never dies. If it loses its point and gets scruffy, then keep it for special effects or trim it to form a different end for making dabs or applying masking or glue.

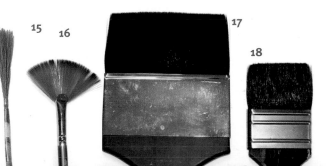

15 16 17 18

Which brush fibre is best?

Choose from various kinds of natural or synthetic, or blend fibres.

▶ Sable

The most coveted sable is taken from the winter coat of the Kolinsky weasel, found in Siberia. A close second is from the tail of a small sable found in a limited range across Siberia and Japan. The rarity, plus the high quality of this hair, is what makes sable brushes so expensive. Sable hairs, which are conical in profile, come together to form a fine brush point. Microscopic scales on the hairs allow them to each absorb a little water. A sable brush releases the paint to the paper gradually, in even amounts. It will make the paints much easier to control and is worth the investment.

▶ Squirrel and goat

Squirrel hair is also very common. It's not as springy as sable but its softness makes it ideal for wash and mop brushes, and it forms a point well. Goat hair is also made into brushes that are ideal for large washes as they drop a lot of water and paint, but will not point.

▶ Synthetic

Synthetic brushes are very popular, inexpensive and are often blended with natural hair. If they work for you, you will be able to buy several brushes for the cost of a single sable. It is worth trying these first. The only downside is that they have a tendency to release their paint load quickly, leaving a puddle of paint rather than a smooth line or wash. Practice will make it possible to avoid this.

Sable/flat

Squirrel and goat/round

Synthetic/flat

Palettes

The word 'palette' has two meanings in watercolour. The first meaning refers to the particular combination of pigments in a painting or in your personal collection of paint; the colours you prefer to work with. Then there is the paint holder, which is also called a palette. When you begin to look for a palette to hold your paint, you will find a wide array. Because many are quite inexpensive, most watercolourists have several, having experimented until finding the perfect one for them.

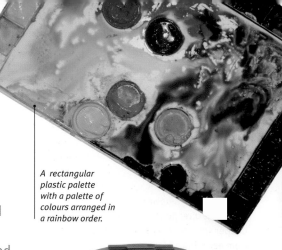

A rectangular plastic palette with a palette of colours arranged in a rainbow order.

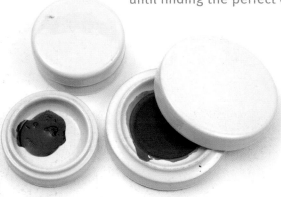

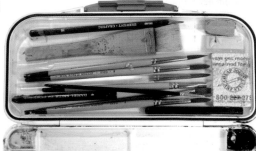

◀ **Porcelain palettes**
Individual porcelain palettes with lids are good for keeping colours separate and for saving colours for future use.

▼ **Palette selection**
Palettes vary greatly in terms of overall size, number of wells for holding colour, mixing space, durability of material – whether or not they are covered – and ease of use. You'll probably need to try out a selection before you find the one that works best for you.

▲ **Folding palette with brush holder**
This type of folding palette is ideal for the artist who would like to have just one and plans to paint away from the studio. It holds 18 pigments and has a brush-holding space with a clear plastic cover. This can be removed for mixing paint.

 38

Plastic or porcelain palettes?

Most of the covered plastic palettes are very lightweight and handle easily. Your paint will stay workable for some time under the relatively airtight cover. Some manufacturers make porcelain versions. These are more permanent studio fixtures, because they're heavy, but they have the advantage of not moving around on your table or staining. Most come with covers. Porcelain palettes cost two or three times more than the plastic equivalents.

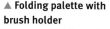

 39

Studio or travel palettes?

Although most plastic palettes are light enough not to be a burden to travel with, there are some designed especially as travelling palettes. These are smaller than the studio versions, for easier use outdoors. The size varies greatly. If you think you'll be doing a lot of painting outdoors, it might be worth investigating these options.

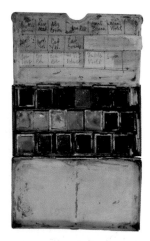

40

Number and design of paint wells

Most palettes have between 8 and 30 wells (sometimes even more) for holding the paint. How many you need will depend on what pigments you want in your palette. The more important thing is the shape of the well; this can vary from a shallow well with no fourth side at all – in other words you can pull paint directly out into the mixing area – to deeper wells with a partial 'dam' to prevent paint from escaping.

No ridge
This palette has no ridge to prevent the paint from flowing into the mixing area. This is a convenient well for those who paint fast and freely and like mixing paint.

Light ridge
This well is deep at the back but has only a light ridge as it meets the mixing area. Paint is easily pulled from the well into the mixing area but will not run out easily.

Contained well
This well has equal sides all around. Paint will stay contained in the well until the brush pulls colour out.

For those who prefer to set up a different palette for each painting, freely blend many colours or who like to pour, butchers' trays are perfect. They are heavier than plastic, but won't stain or break.

TRY IT
Palette substitutes

If you prefer not to make a commitment to a palette until you find your painting style, there are a few other options for holding paint. You might even decide to use one permanently.

White china plate or bowl
Glazed white china or porcelain makes an ideal palette surface as it is non-staining and allows you to see the real colour of your mixtures.

Clear glass bowl or plate
These work well as a palette substitute because you can easily see through the sides to the colour within. Also, if you make a quantity of mixture in a covered glass, for example, you can see what is within, and it is easy to store.

▼ Disposable plastic plate
Using a disposable plate is a great way to play around with your colour preferences without committing to a given palette until you're ready. These can be found in a design that interlocks so that one plate forms the cover for another.

41

Advantages of butchers' trays

Some artists prefer more of a free-form palette on which to arrange their paints. The traditional butcher's tray is an excellent choice in this case. Made of white enamelled metal, it is sturdy, easy to clean and not difficult to travel with. Like palettes, these also come in plastic and porcelain, in a range of sizes.

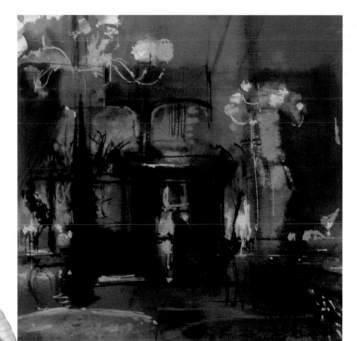

◀ **A striking palette**
Out of a full range of colours possible in a palette, in *Le Maitre D'*, Francis Bowyer chose a very limited 'palette' for his painting – warm oranges and sienna and cool blues. Limiting choices can make a very powerful statement.

Visual aids

Artists are, by nature, visual. They pride themselves on their ability to remember an exact shade of red, to quickly see and recall a gesture or to reconstruct a scene. But the truth is, they all need visual aids from time to time, and it's no embarrassment to have a number at hand in your studio. Most are available from your art supply store or online, although you can also make your own.

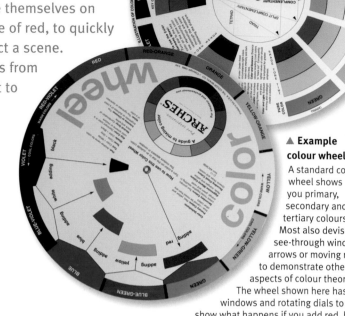

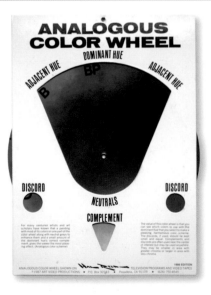

▲ Example colour wheel
A standard colour wheel shows you primary, secondary and tertiary colours. Most also devise a see-through window, arrows or moving rings to demonstrate other aspects of colour theory. The wheel shown here has windows and rotating dials to show what happens if you add red, blue, yellow, white and black to a colour. The back shows what the tint (add white), tone (add gray) and shade (add black) of each colour looks like.

The colour wheel

There are dozens of versions of the standard colour wheel on the market. Most are systems for mixing the colour you want by showing you, through rotating dials, which pigments will mix a particular colour. If money is tight, it's not necessary to buy one – you can make your own (see page 48).

The analogous colour wheel

The analogous colour wheel is less intuitive than the standard colour wheel and can be more useful in many ways. It emphasises clusters of colours that are in close proximity on a standard wheel. It also shows open slots for complementary and discordant colours. Using analogous colours can give your painting a more harmonious overall look.

▲ Colour wheel with windows
This colour wheel shows the close and continuous nature of colour. In addition to the wide window at the top showing a colour and its neighbours, there is an opposite cutout for the exact complement, as well as two for discordant colours, often used in small areas near the centre of interest.

▲ Additional information
The back of this colour wheel has a mixing guide as well as information on other aspects of colour theory.

44

Perspective finders

Do you have trouble seeing perspective correctly? If so, you can buy perspective finders. These are made of plastic with a magnetic frame and two movable metal bars. It is also very easy to make your own. Simply take two strips of board and punch a hole in one end of each of the pieces. Secure them with a fastener that allows them to move (see below). Simply hold this device up to the building or object you are drawing, find the correct angle, and transfer it to paper.

◀ **Examples of perspective finders**

The top perspective finder has two sliding magnetic bars. It can be held against a photo or an actual scene and the bars adjusted to match the perspective being viewed. Below is a simpler, pre-ruled plastic sheet that can be held against a photo or view to determine the correct angle.

TRY IT
Make an adjustable viewfinder

Cut up a small board so that the dimensions are about 15 x 25 cm (6 x 10 in.). There is nothing magic about this size; it could be bigger or smaller. Then cut across a diagonal and use these pieces to make two 'L'-shaped halves. These can then be slid against each other to enlarge or contract the edges of the scene you're looking at.

45

Viewfinders

A viewfinder is perhaps the most useful of the visual aids. A viewfinder enables you to frame what you are looking at and isolate it from its surroundings, making it easier to evaluate composition. Sliding adjustable viewfinders are available commercially. Or, even easier, make an 'L' shape with each of your thumbs and index fingers and use them in the same way.

46

Value finders

Buy or make a value finder. Most are simple cardboard rectangles with a scale of greys printed around the edge and a slip of red cellophane in the cutout centre. This will enable you to assess the lights and darks in your work. For more about value, see page 82.

By holding a value finder up to your scene or your painting, colour will be turned to shades of greys and black.

Your painting space

Some people need to get completely away from their daily routine to make art. Some need to be in the middle of it all or share a space with others. For others, a separate room of any kind will suffice. If one doesn't exist, then a corner will do. If not a corner, a table. If not a table, an easel. It's possible to spend a great deal of money on a large, fully-outfitted studio, but a great many wonderful paintings have also been made on the kitchen table.

47

Get the basics right

Wherever you paint, there are some things that are essential to get right, and the images below show you the main ingredients.

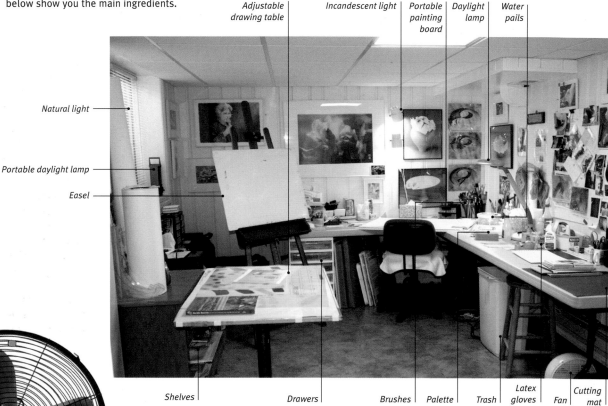

Labels: Adjustable drawing table · Incandescent light · Portable painting board · Daylight lamp · Water pails · Natural light · Portable daylight lamp · Easel · Shelves · Drawers · Brushes · Palette · Trash · Latex gloves · Fan · Cutting mat

◄ A comfortable environment

Watercolour works well within the temperature range that most of us find comfortable and needs no special consideration. But, it is important that you are comfortable. If it is too cold, you will tighten up or rush through your painting. Too hot, and you'll lack the energy to continue. Fans that do not blow directly on your painting work well for controlling the temperature. Space heaters are also useful if you follow safety precautions.

▲ Light sources

Most of us end up working with a mixture of natural and artificial light. The 'daylight' bulbs you can buy also work well. What's important is that you feel you can see your colours well and that you don't cast a shadow on your work.

AT A GLANCE
Useful Studio Tools

- Hair dryer (for drying paintings)
- Staple gun (for stretching paper)
- Screwdriver (for assembling frames)
- Pliers
- Metal ruler or T-square
- Water source
- Comfortable chair – you can't stand all the time
- Phone
- Music
- Coffee or tea
- Books
- Easel if you use one
- Storage for paints and tools
- Paper cutter
- Light source
- Plastic floor covering if necessary

48

Storing your work

Paper and finished work is best stored flat and protected. A drawer of adequate size is ideal. A cabinet for painting supplies is also useful, especially if there is a chance that small children or animals could access them – remember that paints are toxic.

Shelving

Sturdy shelves are a must for your reference material and all the things an artist accumulates.

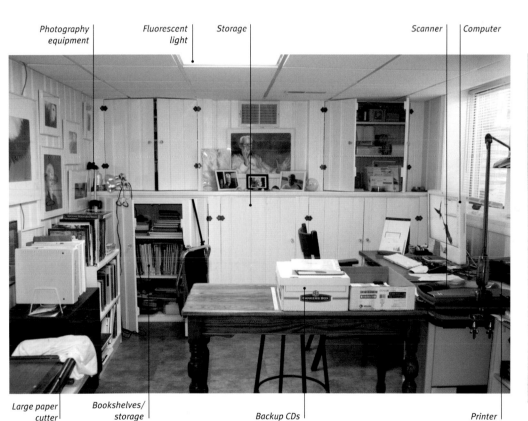

Photography equipment · Fluorescent light · Storage · Scanner · Computer

Large paper cutter · Bookshelves/storage · Backup CDs · Printer

TIP

Storage is a big deal. It doesn't need to be fancy, but make sure that it is:
- Clean
- Dry
- Flexible
- Sturdy

Ideal storage for finished paintings would be flat in a drawer (such as a plan chest) in a flat file, if unsupported. Vertical storage is better for shrink-wrapped, supported or framed paintings.

49

Protect your carpets

If you work on a floor that is waterproof, there is little need to cover it. Watercolour, when it dries, will wipe clean from an impermeable surface. But if you are on carpet or an unsealed surface, a covering of plastic is a good idea. A wide roll that will lie flat is the best choice.

50

Maximizing storage

How much storage you need depends on how much stuff you have, and that probably depends on how long you've been painting. Aim for as much storage as you can, though; keeping your studio neat will contribute to a 'cleaner' feeling to your paintings and you will be able to find things more readily when you need them.

Arranging your equipment

Look around at the space you've selected to be your studio, be it a table or a room. The most important thing is that you feel comfortable in it, that you feel the natural movements of your arms fit into the space you've allowed, and that there is room to place paper, palette, water bucket, towels and brushes. Any space beyond that is a bonus!

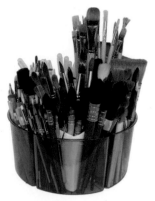

▲ **3 Brushes**
Brushes can be kept within easy reach in a handy caddy on a turntable such as this one.

Positioning your table

Make a plan to use the space you have most efficiently. Top priority is the placement of your painting table. Place this where the light is good. Facing a north window may work, or have the light from this window coming in from the left if you're right-handed and vice versa. Balance the light from the side with lighting from above and from the other side. You may need to experiment to make sure the wet paper has no glare.

◀ **2 Tissues**
You can never have too many tissues. A box on either side is highly recommended.

▶ **1 Towels**
If you are pouring paint, it is useful to cover your painting board with towels to absorb any spills.

Make a portable surface

If you need a movable painting surface, one that can be cleared away when the space where you paint is needed for other things, try this arrangement. On a piece of 1.2–2.5-cm (½–1-in.) white Gatorboard, big enough to hold the largest dimensions of paper on which you intend to paint, place a piece of similarly sized Plexiglas, with the edges taped for safety. With 5-cm (2-in.) tape, tape the Plexiglas to the Gatorboard. The idea is to have a surface for your paper that is easy to clean and can also act as a temporary palette for a few dabs of paint if you need them. The whole board can be removed and stored elsewhere when the space is needed.

AT A GLANCE
Studio extras

Here are some items not shown in the photo that are extremely useful in any studio:
- Tape – masking or white artists' tape
- Masking fluid
- Natural sponges
- Scrubbers
- Old toothbrush – custom-cut with sharp blade
- Water pails – 2 litre (½ gallon) or larger
- Trash can
- Salt – table and kosher
- Magnifying glass
- Reducing glass
- Plastic scrapers
- Foam rollers
- Textured material of any kind
- Stamps – preferably made by you
- Stencils – preferably made by you
- Cut-out shapes to lift colour from specific areas

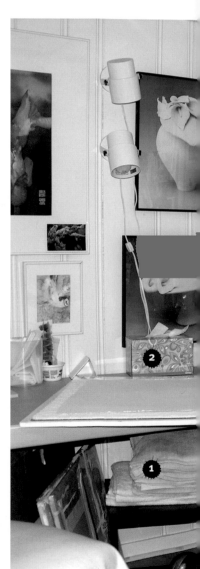

▲ 4 Portable surface

Having a portable surface, even on a permanent table, extends the space available to you.

▶ 6 French curves

These help with drawing smooth curves.

▲ 5 Daylight bulb

Where electric bulbs are necessary, daylight bulbs are best. Most artists have a mixed light setup.

▼ 7 Water containers

If you don't have a sink in your studio, a good time-saving device is to keep filling your water container with a rose-less watering can and tipping the dirty water into a bucket.

▲ 8 Palette

Your palette should be an easy and natural distance away.

▶ 9 Sponge

A large sponge is useful for drying off brushes on as you work.

◀ 10 Spray bottle

Pump-action spray bottle for misting or spritzing with water.

▼ 11 Latex gloves

You never know when you'll need to protect your skin, so keep a box of latex gloves at hand.

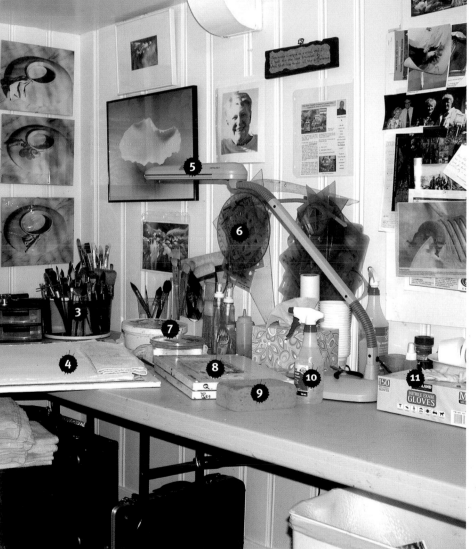

Reference material

Develop your personal aesthetic by assembling things you love, colours that thrill you, photos that excite your imagination and images or ideas you'd like to share or that make your heart beat a little faster. Though hardly discussed, assembling your own view of the world will open creative doors you never dreamed existed and, rather than simply copying a photo you've shot, you will find yourself able to develop your own unique spin on it. Follow the suggestions here and you will never be without something to paint and references that will help you.

How to organise your material

Choose either a large sketchbook with sturdy paper (number the pages) or a three-ring binder with clear plastic sleeves and assemble what you've collected onto a page. Date it, and begin an index of what you have collected. Each time you add something to the sketchbook, add it to the index. In a decade you will have collected masses of material and will be very pleased you kept track of it in this way. Well done – you have begun a record of your 'personal aesthetic'.

What to collect?

Collect everything! If it's too big, or in someone else's magazine, photograph it. Use your mobile phone, e-mail it to yourself, print it out and add it to the collection. The point is that you somehow record what you've seen.
- Photos – your own or from magazines
- Colour swatches from anywhere
- Pieces of collected leaves, fabrics, seed pods, any other found objects...

Storing your photos

Because we live in a digital age, much of what you photograph will be digital. It is possible you will take ten times as many photographs as you might have with a 35 mm camera and prints. These are easily stored on your computer and backed up on CDs and DVDs. Chances are you will print out only the ones you like the best. This is where the three-ring binder and clear sleeves, also known as sheet protectors, provide the perfect solution. The binders are inexpensive and most of them even have a system for labelling the contents. Consider having a separate binder for each subject that interests you.

▲ **Keeping your collection**
Assemble a collection of colours, textures and images that please or excite you. Keep them in a sketchbook of some kind.

▶ **Using material**
Shown here are two old family photos, a large colour sketch and a photograph of the final painting. If this material is ever used again in the future, the artist would be able to plan the next painting knowing what to avoid, change or keep.

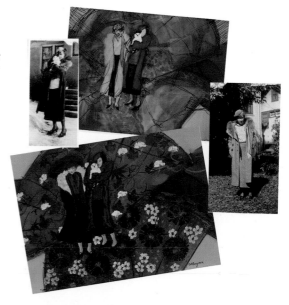

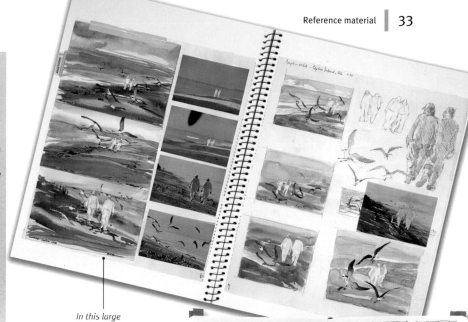

TRY IT
Review your sketchbooks

Don't let your creative treasures gather dust. Go through your sketchbook material on a regular basis. Have you had a new idea? Where does it fit in? Go to that page in the sketchbook and add a photo, sketch or swatch. Add it to the index, too. By regularly browsing through your sketchbooks, you will come up with several things you want to paint. If you limit your sketchbooks only to sketching, you may miss some of the other thoughts you had. Fill those pages with anything you can!

In this large sketchbook: thumbnail sketches on watercolour paper, reference photos, quick colour sketches, practice drawings of the figures and a photo of the final painting.

 56

Large or small sketchbooks?

The advantage of a large sketchbook, perhaps even as large as 36 x 43 cm (14 x 17 in.), is that a single page holds a lot and you can draw or paint your ideas right on the page along with your photos. The disadvantage of a sketchbook this large is that when full, it is very heavy – 12 kg (25 lb.) or more. It also requires a fair amount of space to store and to use. If you have an abundance of space and weight is not an issue, this is a wonderful format to use and you will come to treasure these books. If you go for small sketchbooks, you'll use more of them, but they are lighter weight and more easily transportable.

Both reference photos and quick value sketches are shown in this small sketchbook. There's not much room, but it is much easier to handle than the large sketchbook.

TRY IT
Remembering reference

When you have finished a painting using your reference material, you could photograph it and keep a copy of it with that page of material. Good references will be useful over and over again and, by keeping a record, you will be able to see the progress in your skills and painting style. Even if you haven't used any particular page of reference for a painting, start one with your next painting.

Sketches in black-and-white and colour, notes and a photo of the finished piece.

Inspiration from photographs

Traditionally, in art schools, artists were told not to paint from photos, that going out in the sun and wind and rain was preferable and somehow more real. That may be true. But we live in times where everything moves faster and we have made many technological advances. The modern camera has become one of the visual artist's most valuable tools. The camera is less a crutch than a notebook of thoughts, actions and reactions – a way to remember.

◀ Get the best out of it
Be sure to read your camera's instruction manual.

Making the most of your digital camera

Today cameras are so easy to use – just point and shoot – that anyone can take pretty good pictures. But to get the most use from your camera, learn how to use its menus for optimal flexibility. Some cameras even have the facility for limited editing. Bear in mind that you usually only remember what you use often. So take your camera to the grocery store and photograph the new delivery of apples or the people unloading the truck... Just use it frequently.

Disciplined downloading

Downloading your new photos to your computer, and backing them up onto a removable device such as a DVD, is a task as essential to your art as keeping an orderly studio. It is part of the work and is respectful of the efforts you've made. In addition to this, having the photos on the computer allows you to use the computer as an editing and conceptualising tool. Don't forget to make prints or contact sheets of your photos, and printouts of any compositions you come up with while editing.

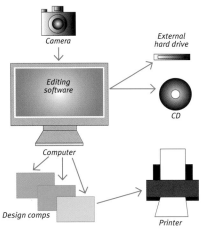

Camera

External hard drive

Editing software

CD

Computer

Design comps

Printer

◀ Working routine
A useful routine to follow is this: When you've completed a photo session, immediately download the photos onto your computer and back up this batch onto a CD, DVD or external hard drive. It only takes a few minutes and, until you empty your camera card, you have three copies of the shoot. As soon as possible, do any editing you consider necessary and print out the results. Now you have your working material. Store printouts in your sketchbooks or three-ring binders.

Editing your photos

Most computers come with simple photo-editing software. You do not need an expensive program. If do you happen to have one, though, learning to use it properly will greatly enhance your ability to play with different compositions. But even a simple one that allows you to remove colour, view your photo in grayscale, and crop it will be extremely useful. Each photograph can become

a library of painting options. Before computers, most editing was done by making several sketches of the photograph and rearranging elements in each sketch. Another option was to make a print of your photograph and crop it by cutting up the copy and rearranging the elements. Many people still prefer these tried-and-true options. But with a computer as a tool, photo-editing

programs make it easy to alter almost every aspect of your photograph. It is even possible to alter the overall colour theme of the photograph. Be careful, though; if your passion is to paint, don't let editing photographs become more important than painting.

FIX IT
Take enough photos

Every artist who has taken a photo has also discovered that the resulting image, though it records the scene or the subject, rarely reflects what captured the imagination to begin with. Fix this before you run into the problem, before you get ready to paint and wish you'd taken more pictures. The more complex the scene, the more photos you should take. Turn your camera from horizontal to vertical, or even hold it on the diagonal. Walk around the subject, and go behind it. Zoom in on details. Zoom out for the long views. Turn around. Then when you begin your painting, as the artist in charge, you will have information with which to build your design. And as the artist in charge, your original idea can take over.

60

Focusing on one idea

In front of Notre Dame cathedral, a crowd gathered around a man feeding the birds. He was so completely focused on this task, it gave rise to the feeling that what he was doing, and where he was doing it expressed a single idea: 'compassion'. A very quick sketch was made and a series of photos shot so as not to lose the moment. Parts of the photos were incorporated into the final painting, *Bird Man of Notre Dame* by Robin Berry.

TRY IT
The same view, ten ways

Take a field trip with your camera, either through your home or in the city or countryside near you. For each view that catches your eye, find at least ten ways to photograph it.

Detail was eliminated in the final painting in favour of the main idea. The focus was the spiritual connection between the man and the birds.

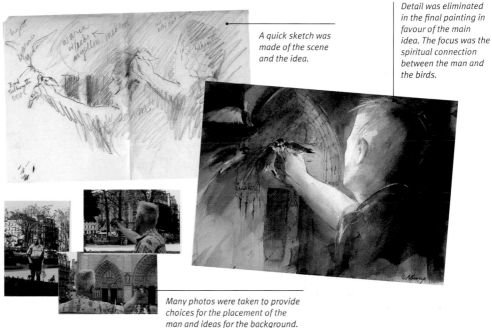

A quick sketch was made of the scene and the idea.

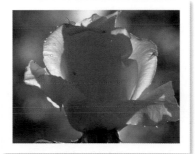

Many photos were taken to provide choices for the placement of the man and ideas for the background.

61

Explore the possibilities

When you are looking at a photo you'd like to paint, do not begin until you have run through every possible idea you can think of. To make the leap from the bland photo to the backlit rose, the photo was turned into black and white, and 12 small printouts, 4 to a page, were made. Then, with black and coloured watercolour pens, many variations were explored. This is a fun exercise and will help you begin your painting with more confidence.

▼ Initial inspiration
The backlit aspect of this rose captured the artist's imagination.

▼ Evolution
The final painting (*Backlit Rose* by Robin Berry) is dramatically different, but retains the backlighting.

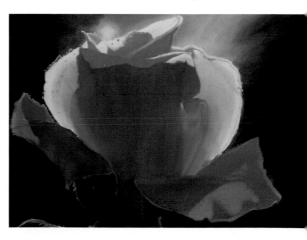

FIX IT
Rescuing a bad photo

What constitutes a bad photo is subjective. Broadly, it means one that doesn't satisfy you as the artist. One person may prefer the motion that occurs in a blurred picture, while another may prefer a sharper image. Perhaps you've taken a photo that is too cluttered, and it needs to be simplified. Or maybe it is too muted. Whatever the flaw, it is still possible for you to rescue the idea from the photo.

Try these suggestions:
- In your photo-editing software, convert the photo to grayscale and increase the contrast. Print this out and, with markers, block out the clutter.
- If you don't have a computer, photocopy and enlarge the picture. Make several copies so you can cut and paste as well as use markers, coloured pencils or crayons to improve the image.

62

Altering reference photographs

On a sunny day, a sailboat was stranded by the tide on Cape Cod. The glitter of the water accompanied by soft waves and gull calls provided the perfect setting for sketching and painting on the beach. As the tide came in, the boat moved further out into the water and it soon became impossible to photograph it as it has been, although five small paintings were done. Before leaving, it was photographed out in the water, as were other boats. Back in the studio, with no single photo expressing the glitter of the day, the photos were combined and recombined until a pleasing scene was found. A photo of the final painting was also included on the sketchbook page.

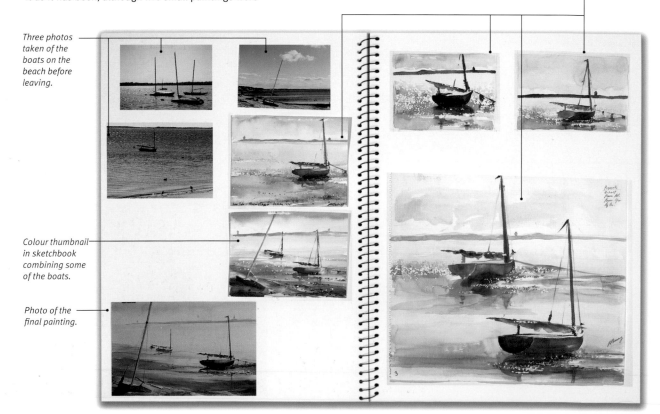

Sketches of the stranded sailboat.

Three photos taken of the boats on the beach before leaving.

Colour thumbnail in sketchbook combining some of the boats.

Photo of the final painting.

Painting from a photo

Making a painting from a photograph is rarely as simple as taking the picture and starting to paint. The following tips may help to bring your vision to reality.

1 Take the photograph.

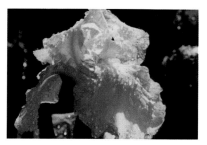

2 Crop it.

◀ **Make a simple crop**
Virtually all photo-editing programs allow you to crop your photograph. Be sure to save the cropped picture as a different file so you always have your original.

3 Make a sketch.

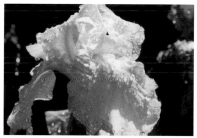

4 Turn the photograph to black and white.

◀ **Try out value**
Another important editing feature of most programs allows you to remove the colour from your photograph so you can better see the pattern of light and dark. Again, be sure you save the original as well as the edited version.

5 Make a value sketch in monochrome watercolour in your sketchbook.

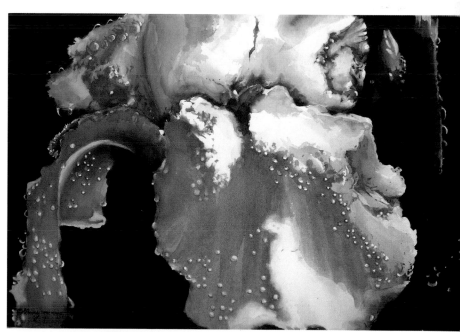

6 Make your full painting – by now you will know your subject well. This painting is *Glory* by Robin Berry.

Palette

Perylene Green | *Bismuth Vanadate Yellow*

Deep Scarlet | *Manganese Blue*

Materials

Tracing paper

HB pencil

Watercolour paper Richeson 300 gsm (140 lb.) 100 percent rag paper taped to board

Brushes: 2.5 cm (1 in.) and 1 cm (½ in.) flat, no. 4 and no. 8 round

Masking fluid

Techniques used

Masking (see pages 96–99)

Glazing (see page 158)

Limited palette (see page 40)

▶ **1** The figures are first drawn on tracing paper at a scale much larger than the original photograph to make them the only focus of the painting, which is about the women and their decorative robes. The flow of their quiet walk and the movement of the shifting fabric contrast with the stiff, linear bamboo. When complete, the drawing is transferred to the watercolour paper by rubbing the back of the tracing paper with pencil (see page 80). The tracing paper is then positioned on the watercolour paper, the lines redrawn on the front side, and the drawing transferred to the watercolour paper. Finally, the drawing is touched up.

ARTIST AT WORK
Paint fabric folds and textures

To paint realistic fabric in watercolour, careful observation of the light and shadow on folds is a good first step. Building up glazes around the highlights will make the fabric shimmer. Shadows are important to show the form beneath the fabric. To make the robes of the women the focus of the painting, Suzanne Hetzel rearranged elements or eliminated them entirely.

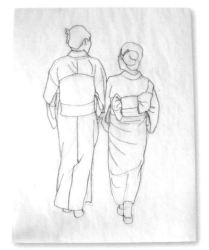

▶ **2** Only four colours are used in this painting. Limiting the colour in this way forces the artist to rely on mixing to achieve the hues and values needed. The first wash is an underpainting, intended to unify the painting. The colour covers the background and part of the figures to tie the painting together and create a light source. Perylene Green is added to begin the bamboo area, standing in for blue to create a warmer tone in the painting.

◀ ▲ Choosing a subject
Of the two subjects, the artist chose the wooded background scene but eliminated the umbrella, feeling it was a distraction. She then chose to have the women enter the scene from the left.

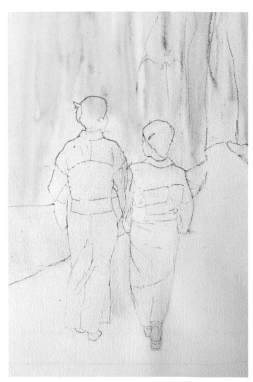

▶ **3** Washes of light layers of line are painted into the background with a narrow flat brush. The first layers of shadows are put into the robes underneath the highlights, as well as the colour for other parts of the garments. With all shapes defined, a second layer of shadowing is laid into the robes. It is necessary to put the shading values in first, before the pattern, while the background is lighter than the foreground. Once the shadows are in, the pattern is inserted. Note that the bends of fabric have smooth, flowing colour but the folds of fabric have edges. A weak wash of Bismuth Yellow and Deep Scarlet is mixed for the faces of the two women.

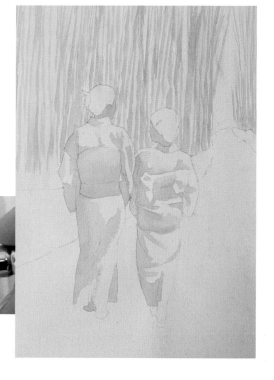

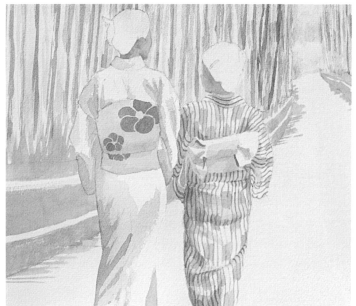

◀ **4** With the shadow established, the next step is to put in the patterns. In the red robe on the right, the pattern is applied directly, one layer at a time, using at least three layers. For the dark robe, masking fluid is applied where the white pattern is to appear. While the masking dries, Deep Scarlet, Bismuth Vanadate Yellow and Perylene Green are added to the ground to increase the value.

64

Painting realistic-looking fabric

To paint realistic-looking fabric, work from light to dark, adding layers of glazes for shadows. Draped fabric consists of bends that have soft-edged glazes and folds that have hard-edged glazes. Put your shading and shadows in first, and then add your pattern. Make sure the pattern follows the bends and folds.

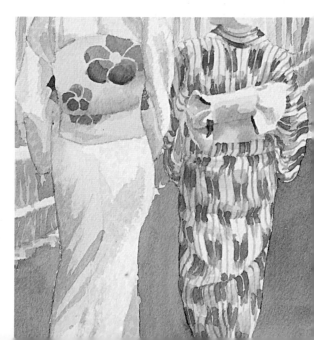

▶ 5 When the masking fluid is dry, the first layers of black are applied – a combination of green and a small amount of red. This black is a medium-value wash, with each subsequent layer becoming stronger and more intense, applied to the robe and the hair. Layers of brown are added to the grass fence, and new layers of green are added to the bamboo as the painting evolves.

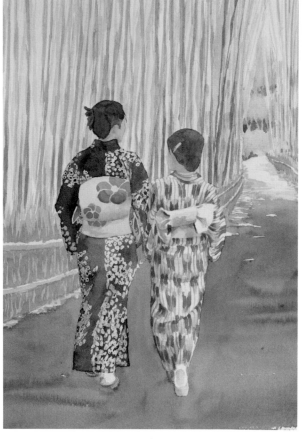

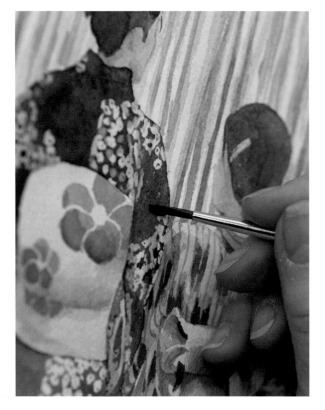

◀ 6 The final glazes of colour are selectively applied to the black robe and hair, leaving lighter values for highlights. Layers of red are added to the robes to show dimension. A cool layer of Manganese Blue is added to the sides of the robes and the bamboo to push some areas of the painting into the background. Finally, the deepest values are painted into the robes; the artist also adds shadow on the ground to anchor the figures.

65

Put the pattern in early

By placing a pattern into the fabric early in the process, subsequent glazes will blend with it and into the background, but the paper must be completely dry each time. Any undesirable softened lines can be tightened up later.

66

Use a limited palette

By using a limited palette, the artist is compelled to mix all colour from three or four basic pigments. This gives an underlying unity to the painting. Try these two other limited palettes: one you might try for landscapes; the other for a flower portrait.

Landcscapes limited palette 1

Winsor Red

Aureolin Yellow

Antwerp Blue

Brown Madder

Flower portrait limited palette

Quinacridone Red

Quinacridone Magenta

Hansa Yellow Medium

Phthalo Blue

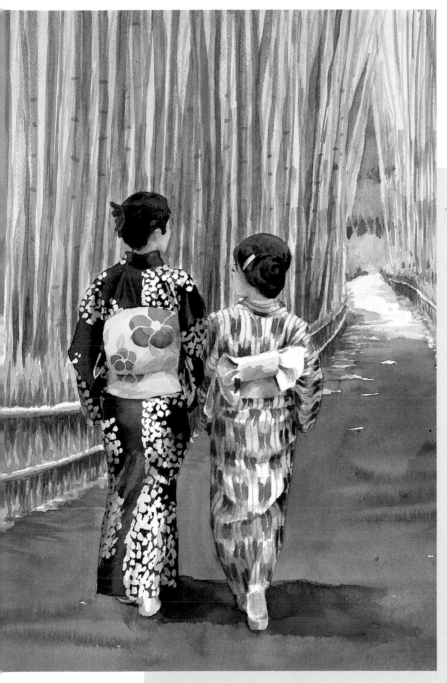

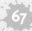

Japanese Girls
40 x 30 cm (16 x 12 in.), 300 gsm
(140 lb.) 100 percent rag paper
taped to board.

Suzanne Hetzel

67

Flexibility of digital prints

The artist had toyed with the idea of keeping the parasol in the composition. As a variation she painted the parasol as a stand alone image, then using digital imaging software she scanned and placed it into a scan of the painting. This method can be useful if you want to produce giclée prints as you could create a unique image for each print by altering the composition each time. Giclée prints are digital prints and you can find many companies online who will provide scans and print one or multiples within a few days. The images can be printed onto watercolour texture paper and you can vary the size from the original.

◄ **Digital aspects**
A silhouette image of the parasol was painted, then scanned and placed into the painting. It was a little larger than needed, but being digital it was easy to reduce the size and change the angle to make a balanced composition.

Selecting pigments

There are as many ways to organise a palette as there are artists who paint. The urge to paint comes with ideas, some unconscious, about colour – what's beautiful and what goes together. There is no right answer, only the guarantee that as you progress in your painting, your palette of colours will change and grow. You do not have to fill in all the wells in the palette. Leave a few empty for your next pigment discovery.

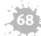

Choose primary colours

A visit to an art supply store or glance at their catalogue is enough to overwhelm even the most experienced painter. You need to plan before you build your palette. 'Primary' means principal, foremost, first in line. This applies to colour theory as well. No matter what direction your palette ultimately takes, start with the primary colours: red, yellow and blue. These are colours that cannot be mixed, but from them you can make every other colour, except pure black.

▼ **Beyond primaries**
The colour wheel below shows when primary colours are mixed with each other, the result is a secondary colour. There are three: orange, green and violet, and, of course, warm and cool versions of each. Tertiary colours result when a primary is mixed with a secondary, resulting in lovely complex colours such as blue-green or red-orange.

Cadmium Scarlet

French Ultramarine Blue + Double Alizarin

Cadmium Orange

French Ultramarine Blue + Alizarin Crimson

Winsor Yellow Deep

French Ultramarine Blue + Cobalt Blue + Winsor Red

Cadmium Red

Winsor Red

Alizarin Crimson

Orange from neutrals Winsor Red + Aureolin Yellow

Violet from neutrals Winsor Red + Cobalt Blue

French Ultramarine Blue + Cobalt Blue + Winsor Red

Lemon Yellow

French Ultramarine Blue

Cobalt Blue + Cadmium Orange

Aureolin Yellow

Phthalo Blue + mixed green

Cobalt Blue

Winsor Yellow Deep + Cobalt Blue

Cadmium Yellow

Cerulean Blue

Green from neutrals Cobalt Blue + Aureolin Yellow

Mixed green + more blue

Phthalo Green Gold

Aureolin Yellow + Cobalt Blue + Winsor Deep

KEY

—— Primary colours neutral

—— Primary colours warm

—— Primary colours cool

—— Secondary colours

- - - Tertiary colours

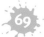

69

Selecting your palette

To be safe, be sure you have at least one neutral red, yellow and blue. Try Winsor Red, Aureolin Yellow and Cobalt Blue. You can warm up or cool down a primary colour by using a little of one of the other primaries. Then, make further choices based on your preferred subject matter. If you are interested in painting animals, consider natural coat colours and include them. You may also want to include black and a rich brown and gold for eyes. On the other hand, if you're interested in marine paintings, you would need an array of blues, greens and purples along with a warm and cool version of each primary colour. Basing your approach on a range of considerations will give you more versatility.

▶ Primary palette

There is nothing more basic to colour nor exciting to the eye than the primary colours. They are used to mix other colours, announce focal points, stimulate imagination and to engage the eyes of children in particular.

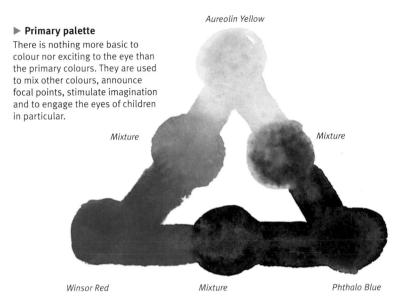

▼ Animal palette

If you would like to paint animals, the freshest paintings will be achieved with the actual colours found in fur and eyes. This warm combination can be cooled by using Cobalt Blue in a mixture, or add any other colour you wish (see page 44 for an example of an unusual animal palette).

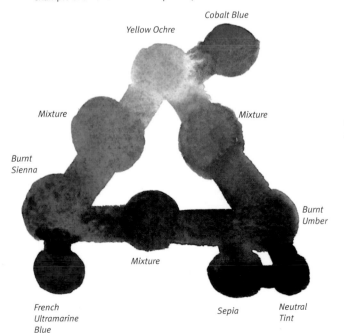

▼ Marine palette

The colours in a marine palette will vary depending on what ocean you are painting, from deep blue or green to turquoise. As long as you have a variety of blues, supported by some sandy reds and a green and gold or two for mixing, you will have a flexible marine palette.

70

A compatible pigment palette

A palette based on the original nature or chemical content of the pigments is one possible approach. You may prefer earth colours such as ochers and umbers if you're a landscape painter, or a palette of all the bright quinacridone colours if you're a flower painter (see right). If you want deeply intense colours, a palette of all staining colours might be in order.

▶ **Garden palette**

Artists who like to paint gardens and flowers tend to prefer pure pigments and so will add several different reds, yellows and blues along with unmixed secondary colours of purple, orange and green (although mixed greens are more natural).

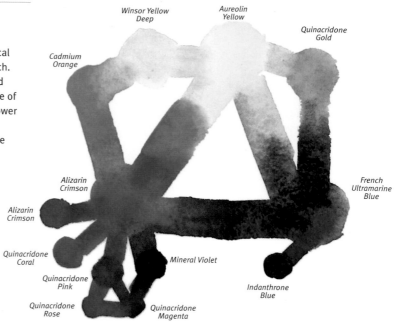

Winsor Yellow Deep
Aureolin Yellow
Cadmium Orange
Quinacridone Gold
Alizarin Crimson
French Ultramarine Blue
Alizarin Crimson
Quinacridone Coral
Mineral Violet
Quinacridone Pink
Indanthrone Blue
Quinacridone Rose
Quinacridone Magenta

71

Use your personal aesthetic

A palette based on personal aesthetic might look like a quirky combination of colours such as purples, greens and ochre, or all warm colours, or all cool colours. There is nothing wrong with such a choice, although you may need to add to it if you change subject matter, so leaving plenty of empty wells is a good idea. If you are unsure of what this might look like for you, try different combinations. It's a sure way of developing your own 'look'.

▶ **A unique palette**

Sparkler for Earthwood by Sarah Rogers is an example of an unusual palette of colours chosen by the artist for her own unique vision of the subject. It not only uses the predictable colours of browns and golds, but adds bright red and orange to spot the graceful curves of the horse's body in combination with lavender with which the shadow areas are painted. Lavender is an ethereal or spiritual colour and with it Rogers lets us in on her feelings about Sparkler.

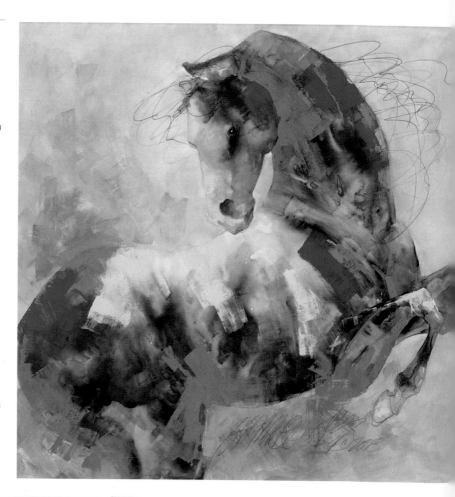

72

A subject-driven palette

If you prefer a palette based on the subject to be painted – a series of paintings, perhaps – then your choices will be based on the local colours of the scene, or on those special colours you prefer to use instead. The only caution here is not to put too much paint in the well. For example, if you're doing a series on the landscapes of the southwestern United States, then your colours will be earth tones, muted reds and violets, and a brilliant blue for the sky. If your next series is on the ocean shores of the northeastern United States, only your blue will do and you'll need to choose a whole different set of colours. Choosing a balanced primary palette (see page 43) would work for both.

▶ **Muted palette**
In his paintings of the great cathedral interiors, Paul Dmoch is inspired by the quality of light and its effects on the surrounding architectural detail. In this painting, *Autel-secondaire, Scalzi, Venise, Italie*, he has chosen a warm, muted palette with a value range from white to very dark with a few areas of red or blue or gold added to draw the viewer's eye.

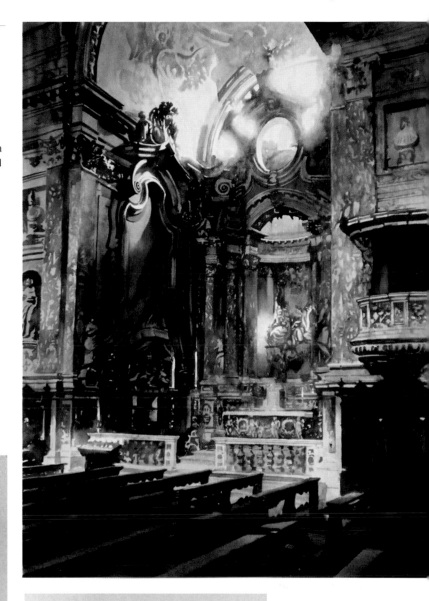

FIX IT
The right primaries

A good rule of thumb is to have two versions of each primary colour. Many paintings can be corrected by use of a warmer or cooler version of the pigment. In landscapes that feel flat, glaze the background with Cobalt Blue and it will be pushed into the distance. Is your focal point lost? A touch of a warm red, such as Cadmium Red, will make it pop right out. A palette with both warm and cool primaries is a balanced palette no matter what other pigment choices you make. For example, you could start with Alizarin Crimson, a red that leans towards blue, a cool colour; and Cadmium Red, a red that leans towards orange, a warm colour. Next choose Aureolin Yellow, which is neutral for a yellow, and a cooler yellow such as Lemon. Finally Ultramarine Blue, a blue that leans towards red, which is warm; and Cobalt Blue, which is nearly neutral, would complete a primary colour palette. For more about building your palette, see page 46.

TRY IT
Expanding your palette

You are not 'locked in' to your initial choices. There are many other possibilities should you find your palette insufficient.

• Get a second palette and set it up in a new way.
• Remove colours you no longer want and store them in small, airtight containers until you need them again.
• Make a temporary palette on a plastic plate until you are sure of the new colours.

Putting paint onto the palette

Many experienced painters carry all their tubes with them and squeeze only a little into each well, preferring to keep the paint fresh in the palette. Others fill the wells. What you prefer may be determined by where you want to paint. If you are travelling you may not want to carry the extra weight of tubes. Remember to check with your airline for any restrictions if you're flying. As a guide, squeeze out a dollop of paint the size of the end-joint of your thumb, or more if you're painting large – mixing a wash can require a fair amount of paint. Any leftovers in the palette are easily reconstituted.

Ways of grouping your paints

A palette is a very personal tool. In it you assemble colours that will move you to express yourself. It is unlikely you will include colours you don't like, nor should you. That said, there are sensible ways to organise the colours you have.

Palette for primaries:
1 *Cadmium Yellow Lemon*
2 *Aureolin Yellow*
3 *Cadmium Yellow Medium*
4 *Winsor Yellow Deep*
5 *Cadmium Orange*
6 *Cadmium Scarlet*
7 *Cadmium Red Medium*
8 *Winsor Red*
9 *Alizarin Crimson*
10 *Quinacridone Pink*
11 *Quinacridone Coral*
12 *Brown Madder*
13 *Burnt Sienna*
14 *Cobalt Blue*
15 *French Ultramarine Blue*
16 *Cerulean Blue*
17 *Antwerp Blue*
18 *Phthalo Blue*
19 *Viridian Green*
20 *Phthalo Green*

▲ **Arranging a primary palette**
Arranging your paint in the order of the colour wheel is the most common-sense way, especially if you have chosen a round palette. There is an advantage to this. If paint spills from one well to the well next to it, the 'contamination' will be minor and easily used.

Notes on mixtures:
- All cadmiums are compatible.
- Alizarin Crimson and French Ultramarine Blue work well together.
- Aureolin Yellow and a small amount of Phthalo Blue work well together.

Darks to try:
- Brown Madder + Antwerp Blue
- Burnt Sienna + French Ultramarine Blue
- Alizarin Crimson + Phthalo Green

TIP
Think of the position of your palette in relation to your painting setup. Where, for example, would you like your favourite colour choices?

Warm colours

Cool colours

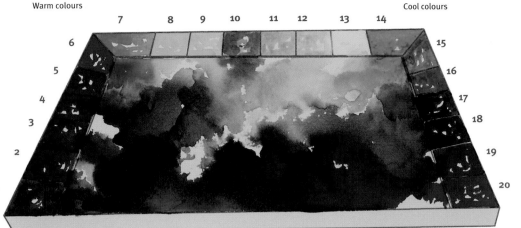

Palette by colour temperature:
1 French Ultramarine Blue
2 Quinacridone Violet
3 Quinacridone Magenta
4 Burnt Sienna
5 Brown Madder
6 Cadmium Red
7 Cadmium Orange
8 Hansa Yellow Deep
9 Cadmium Yellow
10 Quinacridone Gold
11 Naples Yellow
12 Aureolin Yellow
13 Bismuth Yellow
14 Permanent Green Light
15 Viridian Green
16 Cobalt Blue
17 Antwerp Blue
18 Permanent Violet
19 Alizarin Crimson
20 Quinacridone Rose

▲ Arranging a palette by colour temperature

This palette is arranged by warm and cool colours – a split primary colour arrangement. Warm primaries one side, cool on the other.

The powerhouse in this palette is Ultramarine Blue – it mixes with Alizarin Crimson and quinacridones to make exciting purples, and with various yellows to make exciting greens.

Palette for flower painting:
1 Cadmium Lemon
2 Aureolin Yellow
3 Phthalo Yellow Green
4 Winsor Emerald
5 Cobalt Turquoise Light
6 Cobalt Blue
7 French Ultramarine Blue
8 Phthalo Blue
9 Phthalo Turquoise
10 Phthalo Green
11 Quinacridone Gold
12 Quinacridone
 Burnt Orange
13 Quinacridone Sienna
14 Quinacridone
 Burnt Scarlet
15 Quinacridone Red
16 Quinacridone Coral
17 Quinacridone Pink
18 Quinacridone Rose
19 Quinacridone Magenta
20 Quinacridone Violet

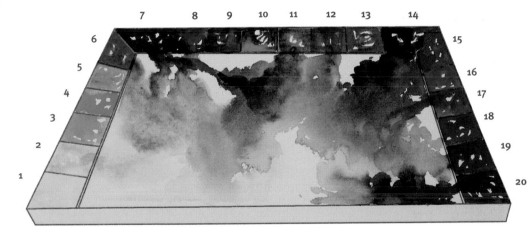

▲ Arranging a specialized flower palette

Flower pigments need to be very transparent. This palette, using the quinacridone colours (11–20), offers a great range of reds and magentas (15–20), as well as earth colours (11–14). These differ from the natural earth colours by being made of dye rather than earth minerals. Note: the quinacridone earth colours are more compatible with each other than the earth minerals would be with them.

TRY IT

Picturing your palette

Once you have arranged your paint, or even before, take a piece of watercolour paper the size of the top of your palette and make a swatch of each colour and its placement in the palette. Make notes about the pigments on it, place it in a clear plastic sleeve and tape it to the outside of your palette cover (or pin to your wall) with double-sided tape.

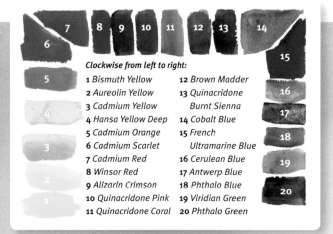

Clockwise from left to right:
1 Bismuth Yellow
2 Aureolin Yellow
3 Cadmium Yellow
4 Hansa Yellow Deep
5 Cadmium Orange
6 Cadmium Scarlet
7 Cadmium Red
8 Winsor Red
9 Alizarin Crimson
10 Quinacridone Pink
11 Quinacridone Coral
12 Brown Madder
13 Quinacridone
 Burnt Sienna
14 Cobalt Blue
15 French
 Ultramarine Blue
16 Cerulean Blue
17 Antwerp Blue
18 Phthalo Blue
19 Viridian Green
20 Phthalo Green

Mixing colour

Commercial colour wheels are made to help you see what colours mix best to form other colours, but shouldn't replace experimentation. You need to know how your paint works. It's safe to say that almost every colour you could mix, you could also buy. But you'd need hundreds of tubes to do what a few could do if you're willing to experiment with mixing your own colours from a basic palette. In a short time, you will find this intuitive.

Phthalo Blue

*Hansa Yellow
Light Lemon*

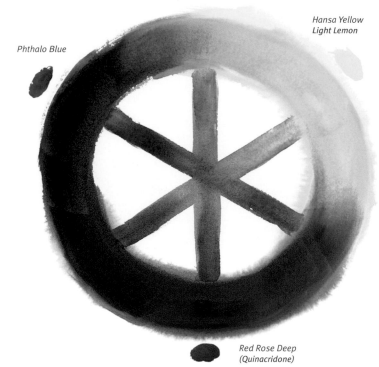

*Red Rose Deep
(Quinacridone)*

74 Use an intuitive colour wheel

You can make an 'intuitive colour wheel' from your own palette (see above). On a sheet of watercolour paper, draw an equilateral triangle. At each point, place a small dab of red, yellow or blue. Wet and spread each colour a little, forming a puddle. Rinse the brush well between colours. Next, again with a clean brush, draw the colours towards each other, making orange with the yellow and red, green with the yellow and blue and purple with the red and blue. When you have a rainbow circle, draw colours opposite each other towards each other, again with a clean brush. In the centre you will find a wealth of greys and neutral colours.

75 Paint colour swatches

It's always a good idea to paint swatches of the colours you have chosen for a painting ahead of time, even if you are working from a commercial colour wheel. Label them so you will remember how to make them. If you find a happy accident – say a lush, rich grey from accidentally touching violet with yellow ochre, make a note of it so you can recreate it later.

76 Success with complementary colours

A look at any colour wheel will immediately illustrate what a complementary colour is. It is the colour opposite another on the wheel. For red this is green, for orange it is blue and for yellow it is violet. Place two complements next to each other and the brighter of the two will pop out. Mix any two complements and the result is grey. Equal mixtures produce a neutral grey. Unequal mixtures will lean the resulting grey in a warmer or cooler direction.

Notice that when a deep red and a solid green come together the colour is almost black.

Because purple is a stronger colour than yellow, their combination leans towards a greyed purple or brown.

The colour resulting from the combination of these two is a greyed green or olive.

TIP
Tips for darks

- Mix your own.
- Add depth with darks, being careful to save whites (see page 96).
- Test darks first on a scrap of paper to be sure they are not muddy.
- Let darks mix on the paper for a more interesting effect.
- Avoid the 'colouring book look', that comes with filling in the lines. Go outside the lines.
- Vary paint intensity within a shape.

77

Warm and cool colours

In general, some colours are warmer in feel than others. The red, orange and yellow side of the colour wheel is warm. The green, blue, and violet side is cool. It is, however, possible within the reds, for example, to have warmer and cooler versions. Cadmium Red is warmer because it contains more yellow; Alizarin Crimson is cooler because it has more blue in it. Don't over think this. Experimentation is the best indicator of how the colours work together.

Cool	Warm
Cadmium Lemon	*Cadmium Yellow Medium*
Alizarin Crimson	*Cadmium Red*
Cerulean Blue	*Ultramarine Blue*

78

Avoid muddy darks

Clear, transparent, non-muddy darks are essential to a good painting. On a sheet of watercolour paper, using only transparent pigments, try various combinations of the following: Alizarin Crimson, Burnt Sienna, Brown Madder, Phthalo Green and Blue and French Ultramarine Blue. These are all examples of the darkest values of their particular hue or colour. No matter how hard you try, yellow will never make a dark as it is a very light value.

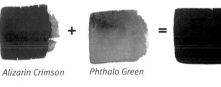

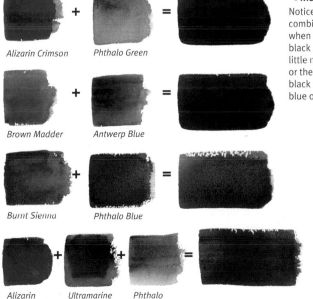

Alizarin Crimson + *Phthalo Green* =

Brown Madder + *Antwerp Blue* =

Burnt Sienna + *Phthalo Blue* =

Alizarin Crimson + *Ultramarine Blue* + *Phthalo Green* =

◄ **Making darks**
Notice that all four combinations shown here, when combined, make black or near-black. A little more of one colour or the other will shift the black to dark, rich red, blue or green.

79

Mixing muted colours

A colour can always be muted by its complement. It can also be somewhat muted by an analogous colour to the complement.

Cobalt Blue added to Aureolin Yellow makes green. By adding the complement of green, Winsor Red, olive or a greyed green results.

A stronger yellow, Cadmium Yellow, will form a darker green. By adding the complement, Alizarin Crimson, a dark olive, almost brown, results.

80

Mixing on the paper

Many artists, wanting complete control over the colour that goes onto the paper, will mix the colour first in the palette then paint it onto the paper. If you prefer a more vibrant and painterly mixture, paint one colour on the paper and, while it is still wet, drop in the second or even third colour.

Palette

Quinacridone Gold

Phthalo Blue (green shade)

New Gamboge

Quinacridone Burnt Orange

French Ultramarine Blue

Burnt Sienna

Aureolin Yellow

Materials

Arches 300 gsm (140 lb.) cold-pressed paper, stretched

Pencil

Masking fluid

Super Nib

Round brushes: no. 4, no. 6, no. 8, no. 10

Angled 1 cm (½ in.) flat brush

Round 1 cm (½ in.) stiff-bristle brush

White watercolour pencil

ARTIST AT WORK

Capturing drama by working dark to light

By working from dark to light, a dramatic atmosphere is captured, lighting the subject in Lisa Hill's painting. Late afternoon sun gives a golden glow and there is little white to leave. By using completely transparent colours, the light of the paper gives a translucency to the deep colours in this floral still life.

Techniques used

Masking (see pages 96–99)

Blending (see page 49)

Glazing (see page 158)

Stippling (see page 152)

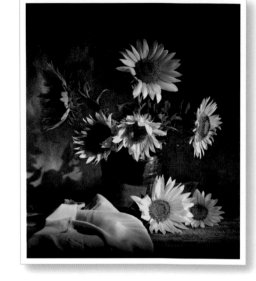

Masking fluid is dotted in the centre of the flower.

▶ **1** A realistic painting requires an accurate drawing to indicate creases, folds and shadows. Masking fluid is applied with a fine Super Nib along the edges of the petals, the reflection on the pot, and numerous dots for the stamens in the flower centres.

 81

Masking fluid applicator

Using a fine-tip masking fluid applicator gives complete control when saving whites for fine lines, dots and reflections (see page 98).

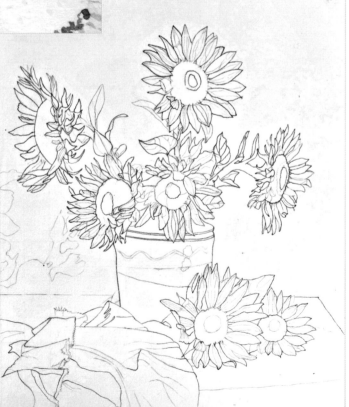

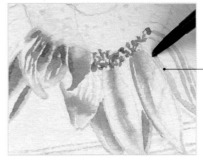

Feathered edges in the creases of the petals.

◄ **2** The darkest values in the creases and folds of the petals are established with a mix of Quinacridone Gold and a touch of Phthalo Blue. The artist uses a no. 4 round brush to apply the colour and feathers some edges with a damp no. 6 round brush. A balance between lost and found edges is developed by softening some with a damp brush.

A damp brush was used to blend the edge of the shadow on the cloth.

▶ **3** Using Phthalo Blue and New Gamboge, a monochromatic map of both the leaves and the cloth is created. Repetition of this colour gives unity to the painting. With a no. 8 brush, graded washes are applied in all areas where deep shadows give way to highlights and the object curves in and out of the light. Notice the care taken to leave the white of the leaf veins untouched. A damp brush is used to make a soft edge where colour merges into white.

82

Softening edges

When laying in the shadows in the first few steps, it is important to avoid too many hard, harsh edges throughout the painting. Soften hard edges with a damp 1 cm (½ in.) flat brush and blot with tissue.

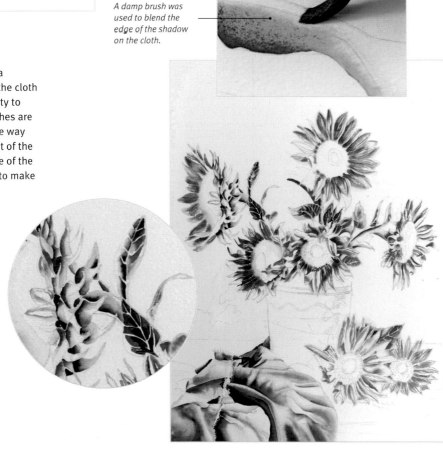

▶ 4 Quinacridone Burnt Orange and Phthalo Blue are mixed for a deep, rich brown. A ½ in. (1 cm) angled brush is used with short, horizontal strokes to establish the wood-grain pattern. The artist softens some of the hard edges. A loose, granulated background is developed by dropping in Ultramarine Blue, Burnt Sienna and Quinacridone Gold wet-into-wet in several layers. The work is allowed to dry between layers.

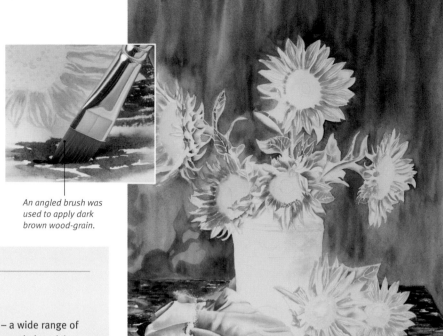

An angled brush was used to apply dark brown wood-grain.

83

Mixing browns

There is no need to buy tube browns – a wide range of browns, from sienna to umber, can be made by mixing Phthalo Blue with Quinacridone Burnt Orange.

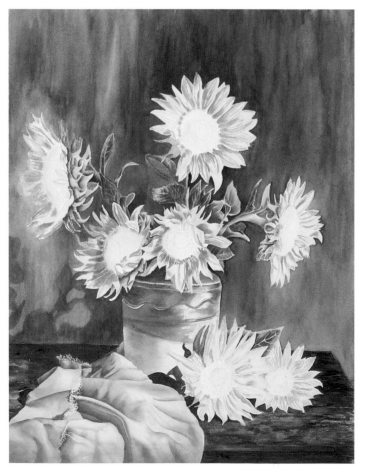

◀ 5 Phthalo Blue and Aureolin are mixed, and this bright green wash is applied to the cloth, directly over the monochromatic value underpainting. Once dry, the shadows are strengthened and local colour added with additional glazes. Aureolin Yellow is glazed over the flower petals, leaves and sepals. Once dry, the shadows in the petals are strengthened with Quinacridone Burnt Orange. The artist uses the brown mix from Step 4 for the first glazes on the pot.

Yellowish-green colour was applied to the cloth.

84

Choose transparent colours

Use only transparent watercolour when glazing light values over dark values. The dark values will show through beautifully.

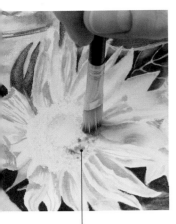

Quinacridone Gold was stippled with a stiff brush in the flower centres.

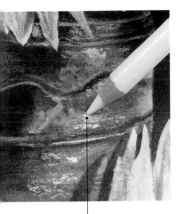

The highlights on the pot were strengthened with a white watercolour pencil.

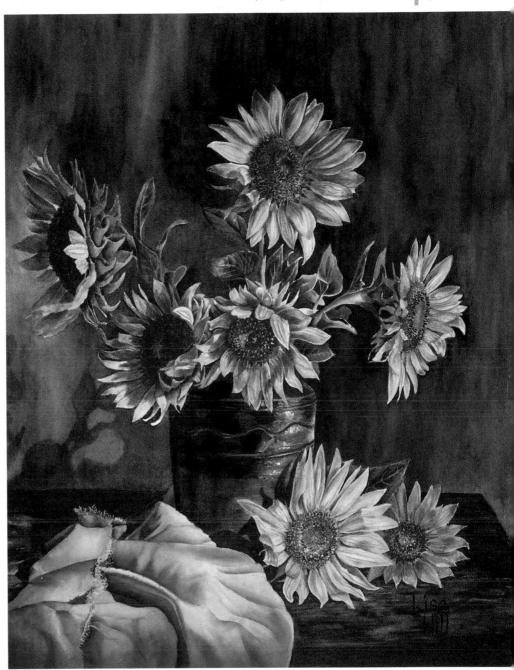

Choose staining paints

When developing mid to dark values first, transparent staining paints give the best results. They are less likely to 'lift' and make 'mud' when the light values are applied over the top.

▲ 6 The artist begins the flower centres by stippling Quinacridone Gold with a ½ in. (1 cm) round stiff-bristle brush. Once dry, a range of browns, oranges and greens are mixed from Phthalo Blue, Quinacridone Burnt Orange and Quinacridone Gold. Strong mixtures are stippled into the centre of the flowers. Weaker mixtures are used to paint more detail into the petals. Then the masking fluid is removed from the centres and the reserved paper is glazed over with Aureolin. The masking fluid is removed from the reflection on the pot and additional dark brown glazes applied. The bright highlights on the pot are re-established with a white watercolour pencil.

Seven Suns
455 x 262 cm (179 x 103 in.),
on cold-pressed Arches 300 gsm
(140 lb.) paper, stretched.

Lisa Hill

Painting

To a watercolour painter, the moment fresh
paint is dropped or brushed onto the surface
of pristine paper is like no other. This is where
your materials meet your artistic vision; where
what is about to happen has never happened
before. This chapter shows you how you
can bring your materials and your creativity
together in wonderful new ways.

Paint becomes passion
In *Necessities*, Denny Bond has captured in paint the
magic of a single moment when the light hit the subjects
and his creative mind was there to experience it. In this
painting, paint turns to passion in the hands of the artist.

The basics

One of the most essential skills to learn is controlling the balance of water to pigment. Unfortunately there is no magic formula, and repeated practice and experimentation with your brushes and your chosen pigments is necessary to develop a feel for it. Erring towards the weak side will always allow you to darken the passage with a subsequent wash, while removing colour from a too-dark passage is harder. With time you will learn to mix the paint just right for the desired effect.

▲ **Stronger into weaker**
Dropping colour into an already executed wash works beautifully if you make sure the colour being dropped is stronger than the colour on the paper. As you can see it spreads into the wet paper but does not create a bloom.

Exploring paint consistencies

Many artists liken their mixtures of paints to other liquids. Described below are the most useful consistencies for watercolour painting.

Weak-tea mixture
A *weak-tea* mixture contains a lot of water. This might also be called a watery mixture. It would produce the lightest of washes, and when dry would appear as a light tone on the paper.

Tea-strength mixture
A *tea-strength* mixture contains more water than paint but has detectable colour to it. It will still dry lighter, because watercolour does that, but when dry, you will have a definite sense that a colour has been put down on the paper.

Milk-strength mixture
A *milk-strength* mixture contains far more pigment. There is substance and some density to the mixture. Your eye will soon become accustomed to the saturation of your mixture but until that happens, keep a piece of watercolour paper next to your palette to test a mixture's intensity before you add it to your painting.

Tea-strength and weak-tea mixtures

White paper – no paint

Milk-strength mixture

Stronger-than-cream mixture of this colour

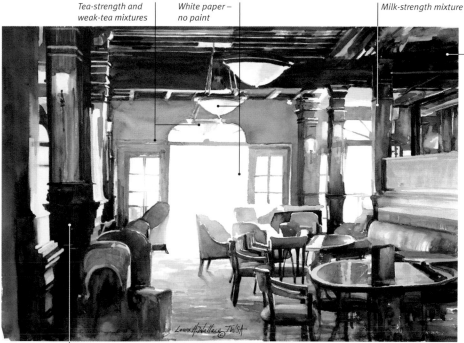

Cream-strength mixture

◀ **Varying the paint strength**

In Lenox Wallace's *Awaiting the Rush*, the atmosphere of intense, bright light with very deep shade has been skilfully created by varying the relative strengths of just two pigments. Near the door, where the light is brightest, the paint strength is weak. In the surrounding shadow, you find deep, pure colour. This simple plan has resulted in a very strong painting.

Cream-strength mixture

A *cream-strength* mixture is one that contains very little water. You might use this for your final, very dark darks, but would rarely use it at the start of the painting.

Stronger-than-cream mixture

Any stronger than a cream-strength mixture would be nearly pure pigment, suitable for particular effects such as drybrush, stamping or spattering.

TRY IT
Darker application

Apply watercolour a little darker than you need it, since it dries lighter.

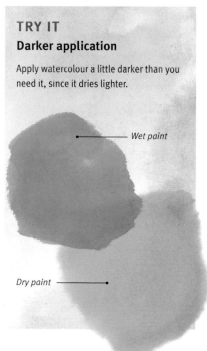

Wet paint

Dry paint

When paint and paper meet

Washes are often the first step in applying the paint to the paper. How they are applied establishes the feel of the overall painting and often brings a unity to it by giving it an underlying homogenous colour.

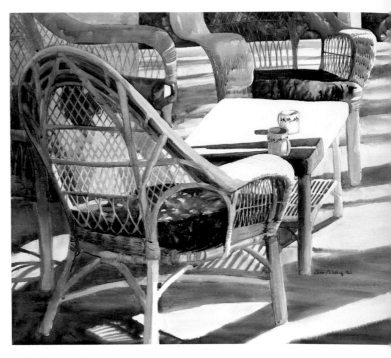

 87

Types of wash

Although a wash is an overall application of colour, it can be applied in different ways for particular effects.

▲ **Multiple washes**

In *Afternoon Coffee*, Lenox Wallace makes use of many small, controlled washes to show the complex shade of the afternoon sun on what is, essentially, an all-white scene. Because she does not mask her painting's whites, this careful approach along with a well-thought-out design brings the scene alive.

Graduated wash

A graduated wash begins dark and smoothly fades to light or vice versa.

▲ **Flat wash**

A flat wash is the most difficult to achieve as it is literally defined. Follow the 'bead' of paint as it moves down the paper with each stroke. Keep your board tilted a little. Do not vary the intensity of the paint. Work from a premixed puddle.

▲ **Variegated wash**

A variegated wash varies in density and colour across the paper and is easier to apply than a graduated wash.

FIX IT
Wash your brush

To avoid wet and dirty paint wells, don't dip your brush into your water bucket and then straight into the paint. Instead, wash off your brush, then dab the excess water out of it. If you need a bit of water to pick up paint or mix it, dip the brush into clean water and pick up just enough to accomplish your task.

Control vs. freedom

The wetness or dryness of the paper and the saturation of the paint together determine how much control you have over what the paint does when it hits the paper. Here are a few possible approaches to paint application.

▲ **Wet-into-wet**

The paper is wet without having any puddles; the sheen has begun to leave the surface of the paper. Any mixture of paint, from weak to strong, will spread softly into the wetness without forming a bloom. However, the wetness dilutes the paint further. While this method offers the least control, it is also the most painterly.

▲ **Dry-into-wet**

A thick mixture of paint is added to a wet area of the paper. To make this work, practice is required, but the results can be stunning. It is an exciting way to add deep colour to pristine white or create vibrant contrast between two colours.

▲ **Wet-into-dry**

The background is left paper white or a wash allowed to completely dry. Linear details can be painted over the background, the edges will remain hard and crisp unless the paint touches a wet or damp area of the painting. This is a controlled technique for fine detail and calligraphic type marks.

▲ **Dry-into-dry**

This method is called 'drybrush' (see page 109). If the paint mixture is thick cream, the brush will skip along the dry texture of the paper. This is often used to show sheen on water or grassy areas.

TRY IT
Spreading paint

Tape a clean piece of paper at least 20 x 25 cm (8 x 10 in.) to a stiff board, and wet the paper to halfway down with a wet sponge or a wash brush. Next mix a cream-strength puddle of paint and apply it to the top of the wet area. Observe the results. Before the wet of the paper dries, dip your brush in the pigment with just enough water in it to allow it to spread, but thicker than the first mixture, and apply it to the clean wet area. Notice how little the paint spreads. Repeat the experiments on the dry area and record your findings.

The first touch

When approaching the paper with a brushful of wet paint, you should feel the impulse to paint not in your fingers, or even your hand, but in your shoulder. Whether the paper is wet or dry, move your arm and brush in many different directions. Go outside the lines and think about this underpainting as a colour that will glow up through subsequent washes, giving a unified result. This does not have to be a single colour. Change the pigment each time you reload your brush. For the time being, forget about your reference photo and the whole idea of local colour. The idea is to entertain and stimulate the viewer's imagination. Choose clean, bright, clear colours.

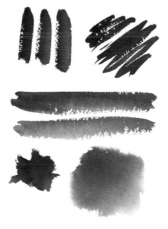

▲ **Don't do this...**

When you put your first paint on the paper, especially if painting wet-into-wet, avoid simple strokes and geometric shapes. These will start the painting on a restricted note and could show through at the end.

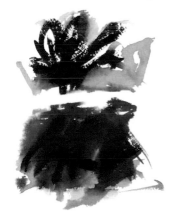

▲ **...do this**

On wet paper, use broad strokes to put down your first colour. Avoid staying inside the lines of your drawing. This will give a unity to what you paint next. By beginning this way and combining small shapes into larger shapes, your painting will have a looser feel.

Designing your painting

Much of what goes into making a successful painting occurs before paint ever touches paper. Learning to think like an artist, to see a scene differently and to explore possible ways to express an idea are the beginnings of a good design. A good design includes a collection of tools or devices that both assure a more interesting painting and act as a guide while you are making the painting.

Using reference material

This is where your reference material (see page 32) comes in handy. You may have already collected photos or pictures because of your attraction to a subject or an idea. The best advice is to collect more! Assemble ideas into scenes and scenes into ideas. For example, if your idea is 'light' – its brilliance, the joy it brings – find your best examples and put them together to form a scene. If the scene you love is of an ocean shore, put thought into what it is you love about the shore – the motion of the waves, or the birds flying by, or the people, and incorporate these ideas into the scene.

What is your idea?

Virtually everyone who wants to paint has an idea of why or what they want to paint. Perhaps you notice light or get chills when looking at certain colours. Perhaps it is the subject that moves you – faces, dancers, cats, trees, oceans or birds. Whatever moves you to paint is where you begin.

A painting is an experience

All paintings have a story, simple or complex. What follows is a story of a moment in time, captured only in the mind's eye of the artist, a five-second experience and multi-faceted journey to recreate that experience. 'Driving on a narrow curve on Captiva Island, Florida, I saw an egret, standing in the sunlight in front of a hedge of bougainvillea. It was a beautiful moment that went unphotographed. Many attempts were made to recreate it using sketches and photographs of the area including a photo of a similar experience a bit later. The composite here is made up of three sketchbook pages that include actual paintings in the book as well as taped-in references from a vast collection of Captiva Island photos.'

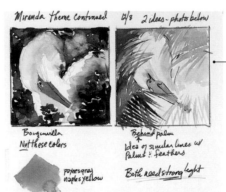

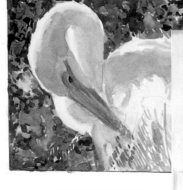

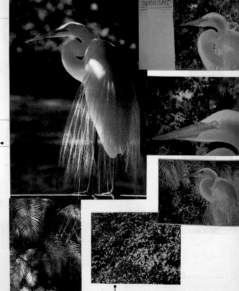

The first sketches after the experience. Just get it down. Think of alternatives. Make several sketches and jot down any ideas.

This is a photo of the watercolour sketchbook painting for the record.

A search of egret photos was made using reference photos taken over several years. Sketches were made using each along with the flowered background. Other foliage was also explored.

Other reference photos were taken to support the needs of the painting.

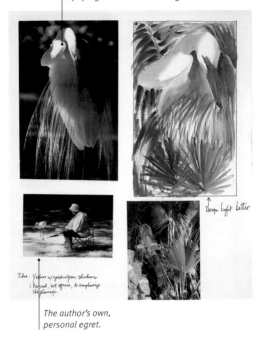

This photo was rejected as it was not as uplifting as the one on the right.

Design light better

Idea: Yellows w/ spring green shadows : Vignette, lost spaces, to emphasize the plumage

The author's own, personal egret.

After many sketches had been made, a similar sight – an egret walking in front of a bright, flowered hedge.

Once it was decided to use primarily flowers with a few palm leaves added, and the pose and lighting on the egret was firmly in mind, a painting was made in a sketchbook of 300 gsm (140 lb.) cold-press watercolour paper. You'll notice the drawing challenge hadn't been worked out as the painting goes over onto the side page.

▼ Creating drama

By backlighting the egret and allowing the protruding plumage to catch the light, Robin Berry creates exoticism and drama in her final painting, *Aria*.

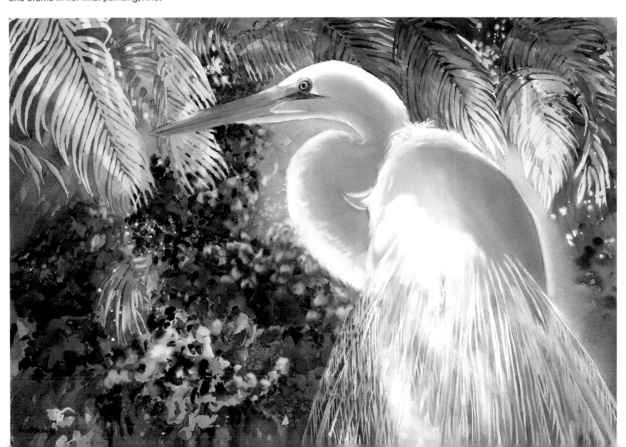

Design and composition

Once you've decided on the subject and the shape of your painting, you need to decide what the overall thrust of the painting will be. There are many different possibilities when it comes to design. Here are some ideas, but you may have others. This is another great use for your sketchbook. Copy these patterns and add your own; they will be there for reference later.

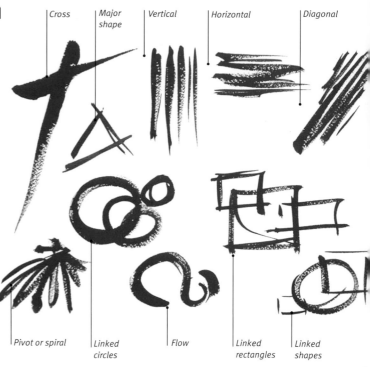

Cross | Major shape | Vertical | Horizontal | Diagonal

Pivot or spiral | Linked circles | Flow | Linked rectangles | Linked shapes

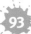

93

Think about the underlying structure

A well-placed cross forms one of the strongest underlying structures available. The centre of interest would fall at the intersection. But there are other patterns you can try: vertical lines, horizontal lines, diagonal lines, interlocking circles, interlocking rectangles, off-balance, perfectly balanced, spiralling or pivot shapes, natural landscapes... On top of this underlying design idea, you would place your subject.

94

Explore the seven elements

The following seven elements of design are as old as the hills, and the reason they still survive is that they are so basic to the design of a painting that there is little way to talk about design without them.

▶ **Line**

As children, lines are the very first thing we draw and they still underpin most artwork. In *Ties to Childhood*, Suzanne Hetzel has created a masterly painting of lines, reminiscent of those powerful first expressions – the fleeting, ever-moving and fresh energy of youthful colour. When thoughtfully combined with the other elements, the eye is drawn on an endless and fascinating journey evocative of a childhood memory.

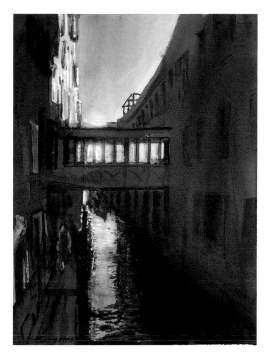

◀ Shape

A shape is a self-contained space, and may be regular or irregular. Once it is defined, the background also has a shape, known as 'negative space'. Negative painting usually involves painting deeper values into the negative space to give the illusion of depth, as can be seen in *Sunrise Canal* by Robin Berry.

◀ Texture

Janis Zroback's painting, *The Trees... the Prayer*, makes wonderful use of texture. Texture is the surface feel of the painting or parts of the painting and can be conveyed by the paper itself, a pattern you paint onto the paper, the thickness of the paint application or by techniques such as salting, spritzing or blotting.

▼ Value

In Paul Jackson's painting, *Forecast*, value is the structure that holds together a complex scene and makes sense of it. Value is about lightness or darkness. By changing a colour image to grayscale or using a value finder, the values of individual colours can be seen. Value is the strongest design tool because the human eye responds to light and is immediately drawn to it in paintings.

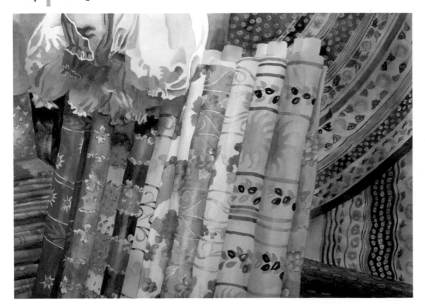

◄ Direction

In *All Things French*, Suzanne Hetzel illustrates how all of the elements in the painting work together to establish the direction of the design – diagonal. Direction is the primary thrust of a line, shape or composition, and carries meaning. Horizontal implies stability, groundedness and calm. Vertical implies growth, stature or upward thrust. Diagonal lines and shapes are tools of motion, energy and growth.

► Colour

A good example of the power of colour is found in *Goldfinches* by Robin Berry. Pure, strong hues (colours) play the dominant role in highlighting the subject, the birds, by surrounding them with their complementary colour, violet. All other colours are subdued.

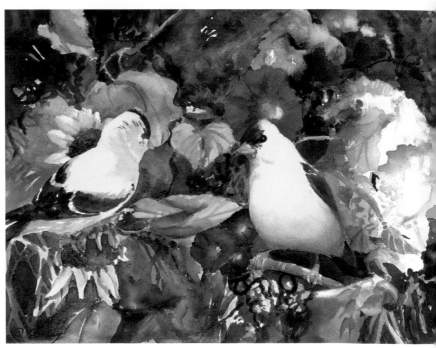

◄ Size

Yuriy Shevchuk's painting, *Italian GP 1961 Ferrari*, uses the relative sizes of the cars and people to evoke a memory of another time. Size is about context and scale. It is usually evident in the relationship between elements.

The principles of design

Having a powerful assembly of tools is not a guarantee of success. But knowing how to follow the 'blueprint', or the principles of design, is. By using the elements of design on pages 62–64 in the manner suggested here, you will find your way to the most exciting compositions.

Underlying composition: Linked rectangles (see page 62).

Movement of values: The red circles and lines locate major dark values in the painting below. The blue line shows the flow of the eyes through the composition ending in the lighter areas below, giving the eyes a place to rest.

▼ Exploiting complexity

In a complex painting such as *Go with the Flow* by Robin Berry, it is possible, even necessary, to make judicious use of every element (see pages 62–64) and principle (see pages 66–67) available to create an image that at once holds to the initial idea and is a unified whole. Most of the elements and principles of design are annotated, but see if you can find more examples.

Value *Darks hold the composition on the paper and keep it from floating off at the top.*

Colour *Every colour is used, with an emphasis on the primary colours.*

Repetition *Shapes are repeated with variation or gradation to avoid boredom.*

Direction *Upward swing of the direction of the palettes with running paint pulling down to balance.*

Contrast *Circles vs. rectangles; lines of brushes and circles of cups.*

Line *Rectangles form a wide, curving swathe across the horizontal plane.*

Harmony *Harmony here is in the idea of the excitement of palettes and flowing paints.*

Texture *Patchwork quilt texture formed by wells; repetition with variation.*

Balance *Self-balancing line formed by the 'S'-shaped swatch of rectangles and palette at the bottom.*

96

Compositional principles

The following six principles can be thought of as ways in which the elements of design (see pages 62–64) can be used in a composition. These principles are time-tested suggestions, but only you can discover how they work for you, through practice.

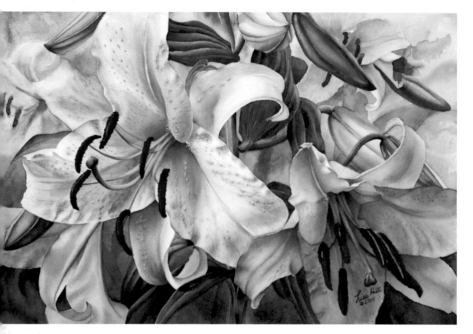

◀ Balance

In Lisa Hill's painting, *Casa Blanca*, balance is the principle that captivates the eye. Balance refers to the relative weight of an element, conveyed by its size, colour, value or placement in the picture. A small element can balance a large one if it is darker or brighter or even placed higher in the picture plane.

▼ Repetition/Variation

Nancy Emmons Smith has mastered the nature of trees. In *October Sixteenth* she has made a strong vertical composition that, although it repeats shapes is always interesting because of the gradation or variation in the tree trunks as well as the light coming through the leaves. Repetition and variation go together. While it is useful to repeat shapes and lines, a painting would quickly become boring if these were not varied in size, shape, value, placement and texture.

◀ Contrast

Catherine Brennand gives us a perfect example of the power of contrast. Contrast connects elements that are different or opposite, for example, black and white. Contrast is an important device for leading the eye to the focal area.

▲ Harmony

Here Catherine Brennand repeats identical shapes in a way that makes each a little different, yet has an overall harmonious effect. Harmony implies the well-thought-out choice of elements, such as the use of analogous colours or shapes being echoed. It is a feeling the viewer gets when he or she looks at the whole.

▶ Dominance

In the Light, by Robin Berry is an example of dominance. The repeated circles and curves of the coconuts interlock to form a larger circle of light. Dominance is achieved when one of the elements becomes the major storyteller or director of the scene. It may not achieve this alone, but it clearly stands out.

◀ Unity

Here all the elements work to hold the scene together. Paul Dmoch, in his painting *Choeur – fragment, Franziskanerkirche, Vienne*, brilliantly combines a nearly monochromatic painting with the excitement of red highlights to pull together the separate parts of the church and create a feeling of unity.

97

Computer 'comping'

Perhaps you've come up with an idea that seems like a good one but you can't quite get a handle on how it might look. Or maybe you have several ideas and can't decide which is best. Use your computer to your advantage here. In your photo-editing program, open the photos you intend to use. Cut out the simplest element and copy and paste it onto the photo that is to form your background. You should be able to move this element around to decide on its best position. Be sure to save your work so you can find it again if you decide to use it in the future and print out a copy for your sketchbook.

Photo editing

1 Take an action photo.
2 Take a dramatic photo.
3 Cut out the action from no. 1 in a photo-editing program or with scissors.
4 Place it in the dramatic photo, perhaps in the distance.
5 Now try it in the foreground.
6 Pick the composition you like best and make a thumbnail painting to begin the design process.

1

2

3

4

5

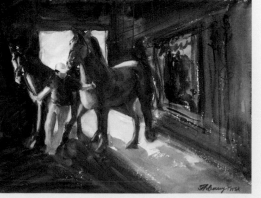

6

98

Palette exploration

When you are sure where you are going with your idea, on a scrap (or two or three) of watercolour paper, begin to test different colour palettes. It's probably not a good idea to plan to use every colour. Rather, pick four to six pigments that best express your idea. Wet the scrap of paper on the left side, leaving the right side dry. With a creamy mixture of colour from your palette, make a left-to-right stroke. Pick another colour and do the same, letting it blend at the edges with the first colour. Repeat this process until you have an idea of how your chosen colours work together and look when mixed. Do several of these tests. Surprise yourself by trying an unexpected colour. You may want to consider using a spot of special colour not found any other place in the painting.

99

Making thumbnails

Make three small drawings, or thumbnails, of your painting: a 7.5 x 12.5-cm (3 x 5-in.) one, a 12.5 x 17.5-cm (5 x 7-in.) one and an 20 x 25-cm (8 x 10-in.) one. Of course these sizes don't need to be exact; the idea is to work from small to large as you figure out the details. The smallest is to capture the main idea of your chosen colour palette. No details at all, just blocks of colour, whites and darks. The middle size will give you more room to put in specific lines and shapes that will have the strongest impact. It will also let you locate, if you haven't already, your focal point or centre of interest. Think of the largest sketch as a trial run. You are really getting to know your subject now. Refine the centre of interest and the tools you will use to make sure your viewer's eyes land there.

100

The Golden Mean

There is a useful ratio you can use as a guideline for the placement of your focal point, or centre of interest. It's called the Golden Mean and, as this diagram (right) demonstrates, it can show the four most advantageous places to put the focus of your painting. Although there are exceptions to this, it's best not to centre the focal point on your paper even if you like it in the photo. It acts like a black hole and the viewer's attention will land and stay there.

▶ **Moving the focus**
How you use this illustration depends on the subject you'd like to paint. Decide what the focus is. Make sketches and try placing that focus in each of the red/orange spots on the diagram. Using the tools of design, try different ways of leading the eye to the focus.

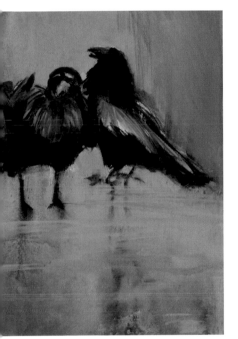

◀ **Engaging**
In *Dawn Patrol*, Robin Berry places the crow that is engaging the viewer in the upper left magic spot. It is an immediate message: 'I'm watching.'

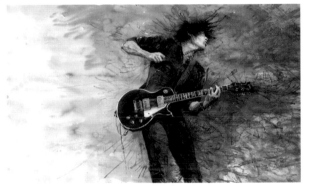

▲ **Approach**
In Yuriy Shevchuk's painting, *Jazz Rock Guitarist*, the viewer has to approach the subject by moving across the paper to it. There, a powerful, nearly audible, image is found.

TRY IT
Locating the focal point

On a piece of clear acetate the size of your reference picture, draw the Golden Mean design. Move this around on your reference material until you find the centre of interest aligning under one of the four 'hot' circles – the ideal placement. Here you will place your strongest value contrasts, your hardest edges and your brightest colours.

▶ **Curves and colour**
In Robin Berry's *On To Happy Hour*, the upper left was chosen for the dominant face and supported by surrounding it with red. A composition filled with curved lines keeps the viewer in the company of the two women.

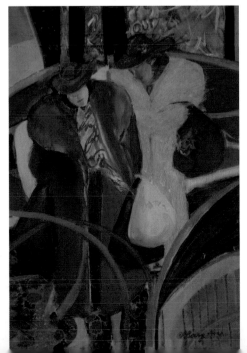

101

Improving on an image

With your image at hand, spend time studying it. What first attracted you to the image? For example, in this image (right) it might have been the backlighting and the bright red against a strong light. Think about three different formats – vertical, horizontal and square. Take into account the general thrust of the main object of your photo and whether you want to go with that thrust or counter it. (Countering the photo shown at right would result in a horizontal format.) There is white space to fill when you don't copy a photo exactly, and this is the creative challenge. There isn't a right answer here. You are the artist and it is your decision, every time. There is little accomplished by copying a photo without making changes for the better.

▼ **Use your imagination**
The photo of the backlit vase is shown with three possible formats (below). In addition to the central view of the vase, you could push it into the background and add people at the table or bring it up very close and show the individual flowers. You are limited only by your imagination when you begin to think about a painting, so free yourself from your preconceptions and do little sketches until you find the arrangement that speaks to you.

The horizontal format idea: an abundant vase with wide-ranging blooms and berries, with colour and also backlit. The design is rectangles, which provide places for the eye to rest as it moves through the painting.

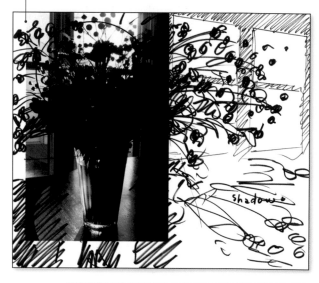

The vertical format idea: a conversation going on outside the window. The scene is backlit, as is the original photo. The basic design is the cruciform. The idea is to draw the viewer's eye outside as well as in. The palette would be whites, darks and red with a couple of spots of green.

The square format idea: a party, but in the background. The lighting is backlit although the foreground food will have light hitting it from the windows. The design is the golden mean. The palette would be darks, white and some brights in the food.

Capture your idea before it changes

While waiting in a hair salon, a couple of quick sketches were made in a small sketchbook. As the drawings progressed, the scene kept changing. These photos were shot with a mobile phone camera to capture a moment that was about to change. Later, in a photo-editing program, each was cut and pasted into a single new document. The feeling of someone on the outside dominated and dictated not only the final arrangement of the three figures, but the colours chosen, especially for the figure on the left. It is not enough to copy a photo. An idea, thought or emotion added to your painting will communicate rich layers for the viewer.

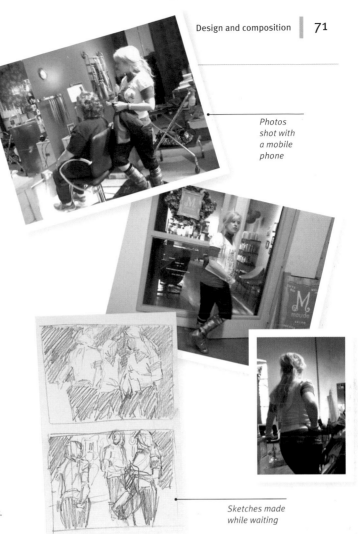

Photos shot with a mobile phone

A printout of selected computer compositions. Filters were applied to reduce the detail in the photo comp.

Sketches made while waiting

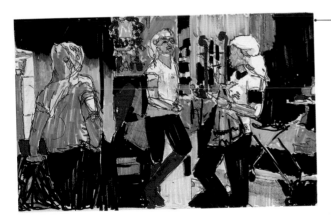

A sketch was made that was first intended as a value sketch. Once the lights and darks were established, colour was added with watercolour brush pens.

The final painting (Hot Gossip by Robin Berry) reflects the original feeling that someone was being left out or being talked about. The mood was dark and intimate. This was accomplished with dark values.

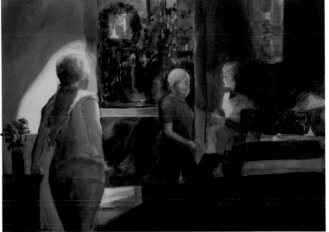

How much drawing?

How much drawing is necessary for a painting? Certainly enough to get your ideas down on paper; also enough to let you arrange and rearrange elements until you have a good design. Even abstract painters draw. It's a skill worth practising. It may take several drawings to formulate your idea or put together a scene. Every time you sketch a drawing, you gain knowledge of the subject.

The power of doodling

Most people have time while on the phone, while watching TV or just daydreaming to doodle with a pencil or pen on paper. This is no idle activity. It has the potential to be a very useful idea generator and a way to capture ideas and feelings about things you see every day.

Below are some doodles – or contour drawings – of cats done during a phone conversation. These led to an intentional search for photographic opportunities, sketches and ultimately, a painting (see page 136).

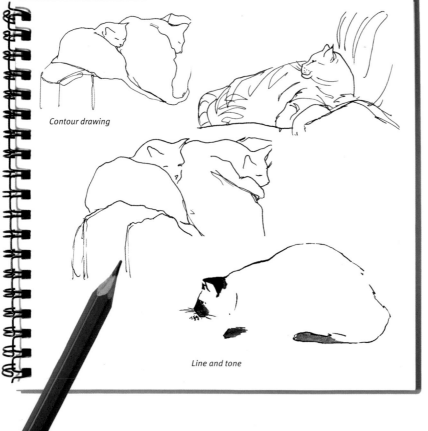

Contour drawing

Line and tone

▲ **Practice shows**
A painting as spontaneous and fresh as *Daisy Chain*, by Stephanie Butler, is possible only from someone with drawing experience. 'Drawn' in watercolour with a rigger brush for the fine, dark outlines while holding a single daisy, this is a great example of just how closely related painting and drawing can be.

TRY IT
Arranging elements

In your sketchbook, make a few drawings of something in your surroundings that you would like to paint – your cat, dog or favourite corner of the room. How should you draw it? First, draw it on a piece of paper or in a sketchbook. Do not draw on the watercolour paper until you are sure of the arrangement of the elements. Some artists cut up the large shapes and arrange and rearrange until a pleasing scene is designed.

The meditative value of drawing

If you would like to draw, it's important to know that with enough information in front of you, such as a photo or a scene, and a willingness to explore contour, detail and proportion, you will be able to reproduce what you see. You need an idea, some reference material and patience. Absorbing yourself in your subject and methodically recording what you see creates a meditative or relaxed state of mind, connecting you, through your eyes and hand, to the object you view.

What is drawing?

Drawing is of the present. It involves active, visual engagement, looking at what's in front of you and seeing it in a way that identifies form, notices gesture and detail, recognises colour, shadow and position. This more complete way of seeing enables you to learn to draw. Drawing is seeing through the hand.

TIPS
Learning about drawing

In 1941 Kimon Nicolaïdes, a master teacher of drawing, wrote an elegant book entitled *The Natural Way to Draw, A Working Plan for Art Study*. Nicolaides's thoughts about art and drawing are as relevant today as they were over 70 years ago – especially for beginners. 'You must draw to learn to draw. Painstakingly', he said. 'The sooner you make your first five thousand mistakes, the sooner you will be able to correct them.'

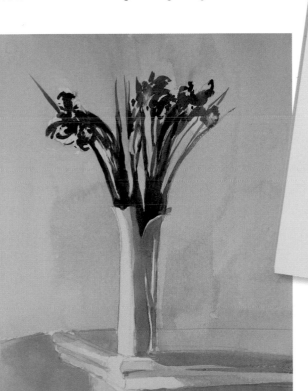

▲ **Development drawings**
A photo was taken of a fresh bouquet in a white vase in a white room. Contour drawings were done of this arrangement as the flowers opened (above), both because of the quiet, meditative scene and because the white on white presented a challenge. Eventually an idea for a painting presented itself and a watercolour sketch was made for future reference (left).

FIX IT
Improving drawing style

When drawing in your sketchbook, there are a few specific drawing skills worth practising:

- Varying the line weight
- Avoiding 'sketchy' marks
- Keeping your pencil in contact with the paper when contour drawing
- Slowing down for accuracy
- Practicing seeing 'fast' to capture a gesture
- Squinting at the subject if you're having trouble with lines
- Using the side of your lead to fill in the grey and dark values
- Adding value to give dimension to your drawing

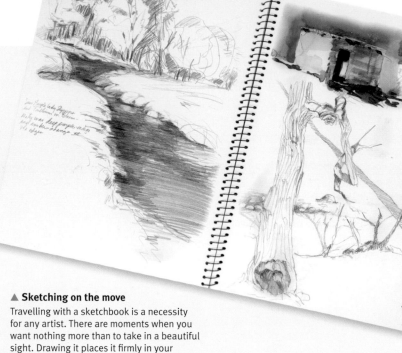

▲ **Sketching on the move**
Travelling with a sketchbook is a necessity for any artist. There are moments when you want nothing more than to take in a beautiful sight. Drawing it places it firmly in your memory in a way that just looking at it can't.

◀ **Capturing motion**
Capturing motion can be done as a rapidly executed line drawing, or by turning your pencil and making broad swatches of tone with the side of the lead to reflect the gesture. Either way, gesture details can be filled in after the moment has passed.

Seeing differently is meditative

When you're fully engaged in seeing and drawing, you may find yourself in a light meditative state where you lose all sense of self-consciousness and even of the passage of time. It's a joyful, relaxed state in which your eyes and hand move in unison and your mind overrides judgment, quieting the critic in your mind. Concern yourself only with the experience of seeing differently. For many artists, drawing is a prerequisite to painting, not for the drawing itself but for the engagement of the creative mind and the anxiety-free meditative zone it allows you to enter.

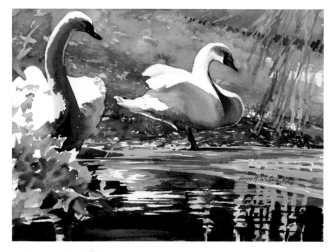

▲ **Painting from a sketch**
In *Matched Pair*, Lenox Wallace captures a moment of peaceful reflection. These swans could have been drawn from a photo. But imagine engaging in nothing but sketching their forms in the light, their poses, their involvement only in each other and the space that is theirs.

Capturing the idea

When it's clear in your mind just what is inspiring you, draw it – on a scrap of paper, on a placemat, in your sketchbook. Just get the idea down so you don't forget that initial inspiration. Don't worry about how it looks. Often these first ideas retain more charm and spontaneity than all of the iterations that follow.

◀ **1 Initial sketch**
The crow paintings below began when two ideas came together: 1) A line in *Sand County Almanac* by Aldo Leopold: '...just to tell the world how vigilant crows are...'; and 2) a couple dozen crows hanging around a bird feeder. This was a five-minute sketch to capture the idea.

▲ **2 Thumbnail**
Several quarter-sheet paintings were done. To create a dramatic background, each sheet was sprayed with water, rubbed with various reds and allowed to dry.

◀ **3 Final paintings**
Robin Berry's paintings, *Crow Vigilance I & II*, resulted. A good image is never finished, so keep a record of the process for future inspiration.

108

Drawing as part of a painting

Most artists prefer to have a visual guide to follow on the watercolour paper when they begin a painting, and exactly how this is executed will affect the style of your painting. If you want your lines to show, giving the painting a graphic feel, draw with a heavier, sketchier style, or choose another medium such as watercolour crayon. If you do not want your lines to show at all, keep the drawing light or erase the lines before covering them with paint. Other choices include drawing with a fine brush and paint, or not drawing at all.

109

Guidelines for guidelines

On watercolour paper, regardless of your choice of style for the final painting, keep your lines dark enough to show through one or two washes, especially if you are not using transparent paints exclusively. Once covered with paint, lines are hard to erase. To cover lines still visible in light areas, paint up to and include the line in an area of darker value.

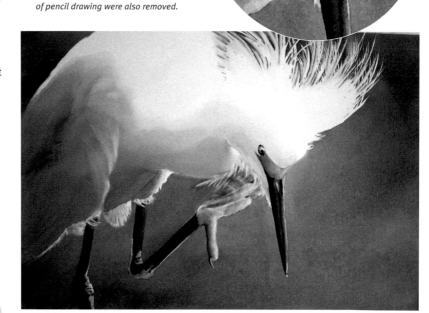

The feathery crest and chin were accomplished by drawing with masking fluid using a very fine brush and a light touch. When the masking was removed, all traces of pencil drawing were also removed.

This detail shows that the graphic lines were not limited to the outline of the bird but made their way into the form itself.

▲ **No pencil marks**
Robin Berry relied on the white of the paper to create sunlit plumage. Pencil marks would interfere with this illusion.

◄ **Line to show motion**
Here line was the primary motion tool used to show the rapid movements of canopy feeding. The freely executed gesture drawing was essential to the feel of this painting by Robin Berry.

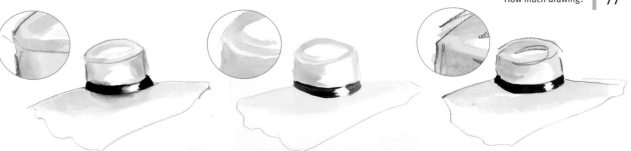

HB pencil (normal lines): This is the most common approach to drawing on watercolour paper. Once painted, there is a slight indication of the line under the paint.

H pencil (fine, light lines): If you do not want your lines to show at all, this would be the choice to make.

Studio pencil (heavy lines): Use this kind of line if you want to introduce a graphic feel to the painting by making your drawing part of the painting.

Watercolour pencil (dissolvable lines): Any drawing done with watercolour pencil will become part of the wash when wet, although the line will still be visible. This is more graphic.

Watercolour crayon (dissolvable character lines): Like watercolour pencil, these lines will dissolve when painted and become a part of the wash, although they may dissolve better than pencil.

Watercolour pigment stick (dissolvable, blending lines): While drawing with pigment sticks will produce a drawing that will dissolve, the lines are unlikely to blend. This is pure pigment and will retain a strong presence in the painting.

110
Underdrawing styles

Shown above are six different drawing styles using six different tools, to try as underdrawings. Most people, professional artists included, don't take the time to experiment at this stage of their paintings. By trying it yourself, you may be surprised at the interesting effects you can achieve.

111
Watercolour pencils, crayons and pigment sticks

Watercolour pencils, crayons and pigment sticks can be used at any point during the painting process, not just to draw your design. They have two things in common: first, that they are portable and easy to use; second, that they dissolve in water. However, it can be seen from the hat sketches above and the boat drawings below that commonality stops there. The watercolour pencil is best for fine drawing, detail and thin lines. If you prefer a stronger graphic look, choose the watercolour crayon with little blending; for a smoother look, blend it well. Watercolour pigment sticks have the strongest graphic effect and are better used for bold strokes as opposed to detail.

Pencil dry/brushed

Crayon dry/brushed

Pigment stick dry/brushed

Transferring your drawing

Between the design of your painting and the painting itself is a step that often causes anxiety – getting the drawing onto the watercolour paper. How this is accomplished depends primarily on your drawing skills, but even the beginner need not be daunted by the process. There are several choices, and good reasons for choosing each of them. Most watercolour artists would prefer to have a guide on the paper since it is not desirable to have to remove wrongly placed colour – though it can be done.

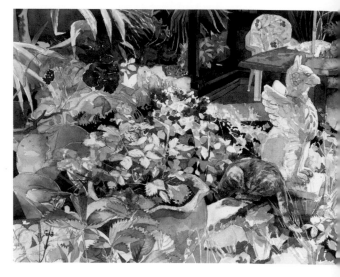

112 Try free drawing

For the confident artist, free drawing is perhaps the most direct way to begin. Pick up a pencil, draw directly onto the watercolour paper and begin. For the plein-air landscape artist, this is also the most practical method, since minimal equipment is required and the reproduced shapes are organic and not absolutely critical. Any painting requiring only a few easy lines to serve as a guide for building up washes in layers is ideally suited to this approach. Spend time looking at the subject before you begin. Plan the lines you will make in your head and when you are confident of what they are and where they go on your paper, draw.

▶ **Expressive drawing**
Let your drawing range freely around the scene you want to paint, taking in a variety of shapes and connecting them with interesting negative space, as Keith Kennedy does in *Tigger and Griffon*.

▶ **Sketching live**
While there are times when a carefully executed drawing is called for, often a more exciting approach is sketching live, and freely, from something in front of you. This may also inspire you to paint it with the same freedom.

113 The danger of erasure

The main risk with free drawing on watercolour paper is that if you make a mistake, you will need to erase it. Erasure on watercolour paper disturbs the naturally formed surface of the paper and ruffles the fibres, marring it even if you can't see the damage. When a wash is applied to this area, chances are the erasure will show. Use a soft pencil and don't press so hard that you leave an indentation. If you have to erase, use an extra-soft white eraser very gently. When you are satisfied with the results, take the back of your fingernail and burnish the paper where you erased to help the fibres lie flat.

▲ **Erasing effects**
Here a dark pencil line was drawn and partly erased. A white eraser at the top, a kneaded eraser in the middle and a pink pencil eraser at the bottom all revealed 'scars' on the surface when a wash was applied.

114 Portable scale finder

A scale finder is a simple tool that may prove to be very useful in transferring drawings (see opposite page). These simple framing devices help you isolate what you want to paint and then translate what you see onto the painting surface. Improvise a scale finder using dark threads glued between the two parts of an old colour slide mount. Create a variety of grids. Keep them handy on a key ring.

Make a large-format scale finder

Although you can buy large-format scale finders, they are so simple to make there is no need to buy them. On a small, clear piece of Plexiglas with the edges taped for safety, draw a grid of squares with a permanent marker. The scale of the grid will depend on the size of the plexi. A smaller size is more useful, not larger than 12.5 x 17.5 cm (5 x 7 in.). This tool is most useful when using the grid system to transfer your drawing (see the instructions below).

To start, align the edges of the scale finder to the area of the subject you want to paint.

TRY IT
Transferring a design

Take a photo, a photocopy of a photo or a drawing, and draw a 2.5-cm (1-in.) grid over it, either on the paper itself or on a piece of clear acetate. Next, create the same grid, very very lightly, on your watercolour paper. If you are increasing the size of the drawing, enlarge it on a separate piece of paper first and then repeat the process to watercolour paper at a 1:1 size ratio.

Using the grid system

The grid system is the most widely taught method of transferring any drawing to a piece of paper and enlarging it at the same time. Knowledge of this technique enables you to transfer the smallest reference or sketch to a large piece of paper, and it's very simple.

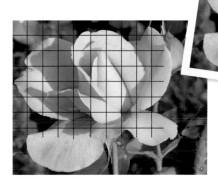

The original photo to be transferred (above). A decision was made to crop the right and bottom edges. A grid was then placed over the part of the photo that was to be included in the drawing (right).

1 Divide the reference into a grid. If you do not want to draw directly onto a photo, make a photocopy of it, possibly enlarged. Divide it into 2.5-cm (1-in.) squares, unless it is very small, then make smaller squares. Do not think of the content of each square as a picture, but only as a group of shapes. You could also use your scale finder (see above), which already has the grid drawn onto it.

2 If your drawing is on parchment or tracing paper, you can draw your grid directly onto it, lay it over the watercolour paper and reach under it to draw, or use transfer paper.

3 Carefully draw the details of each square in your reference material onto the watercolour paper. Now you have an enlarged version of your drawing or picture. See page 80 for other ways to transfer a drawing.

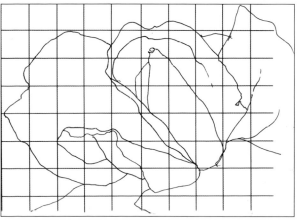

Moving over the reference photo square by square, the lines were drawn on the watercolour paper.

117

Using a slide projector

If your reference material is on a slide and you're happy with it the way it is, or can see in your mind the combination of more than one slide, simply tape your paper to a wall, project the slide onto it (ensuring that the projector lens is aligned to the wall to prevent distortion), and draw.

118

Using a lightbox

If you have one, a lightbox is a slick way to transfer a 'same size' drawing. Simply turn on the light, and place the drawing on the lightbox and the watercolour paper on top. You will be able to see through the paper well enough to transfer the drawing, provided your original drawing is sufficiently dark.

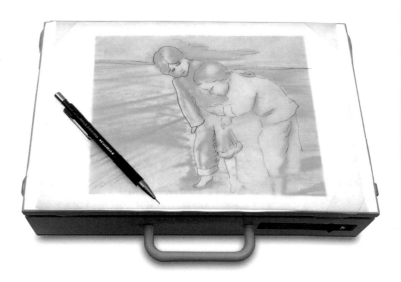

119

Transfer paper method

Transfer paper comes on a roll in several colours, as well as graphite. Graphite looks like pencil drawings when it is applied. To use it, lay a sheet of transfer paper between your original drawing and the watercolour paper. Then trace the drawing, leaving a line from the transfer paper on the watercolour paper. Be careful not to lean hard on the drawing, or the transfer paper may leave a smudge. Your painting, in this case, will be the same size as your drawing.

120

Make your own transfer paper

This is the old-fashioned way of transferring a drawing. If you are sketching outdoors and want to transfer your sketch to begin painting, you can make transfer paper yourself by using a B pencil on the back of your sketch, putting it over the watercolour paper and redrawing. You will transfer a line to your paper. Be careful when you do this, as it may smudge. Again, your painting will be the same size as your drawing.

Projecting digitally

There are now digital projectors on the market that connect to your iPhone, laptop or other digital devices. With these small mobile phone-sized devices, you can work right from your computer or, if you're on location, from your more portable digital devices.

Overhead projector process

An overhead projector allows you to project a photo onto paper, reducing or enlarging it, or to project a digital image. Perhaps you have already combined two or three photos but the drawing is too large to fit on the projector. In that case, simply photograph the drawing, print it out at the correct size to fit and adjust the projector to enlarge the image. Projectors do distort the image slightly, so if you are drawing buildings, for example, check your drawing for incorrect perspective before you paint.

Bypass the drawing stage?

It is a rare artist who begins a painting with no drawing or mapping at all. This is the person who is able to visualise the placement of each element confidently. Taking this approach has very little to do with speed or efficiency and more to do with a love of the pristine paper.

▼ **Painting without guides**

In *Morning Haze*, Lenox Wallace thoughtfully and painstakingly painted one area at a time with no guiding pencil lines at all. The result is exceptionally pure colour on an otherwise unmarred paper surface. Pencil lines would be a distraction in this hot, white, sunlit scene at the pier.

Tonal value

Tonal value refers to the continuum between white and black and gradations of grey in between. Greys can be described in terms of percentages of black. Value is important in watercolour painting; it can, for instance, indicate the time of day and what the weather is. A strong value design can also lead the eye to the focal point. For this reason you need to be able to assess value in what you see and be able to replicate it.

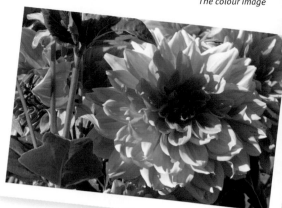
The colour image

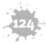

How to see value

There are several ways to see value in a photograph. In each example shown here, two values become immediately apparent. The light on the petals is clear, and the darks are easy to see. Which of these methods you prefer may depend on where your paintings fall on the value scale. Try them all. Each step you take to know your subject better will show in your final painting.

Make a black-and-white photocopy of your photograph. Enlarge it. Darken it to push the values to their extremes.

Turn the photograph to grayscale on your computer. Use the brightness and contrast tools to push the values to their extremes. In both number 1 and 2, you may choose not to paint the extremes, but you will know what the possible range is.

Squint at your photograph to blur it or blur it in your photo-editing program. It will lose saturation but the light and dark values will stand out.

Look at your photograph in dim light. It will lose saturation and the white will pop out. You will not be distracted by the colour.

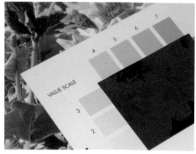

Use a red cellophane value viewer to view the photograph. This simple tool will remove the colour and you will instantly see the white, greys and black.

The values of colours

In this chart, you can see that although most pigments are in the middle, a few are almost black in value, and some are near white. It is no accident that yellows and golds are often used to indicate light, and blues to indicate shadow. The values can be made paler by adding more water to the mix.

Bismuth Yellow	Aureolin Yellow	Cadmium Yellow	Cadmium Orange	Raw Umber	Cerulean Blue

White	10%	20%	30%	40%

Using a value finder

One way to see colour as value is to use a value finder. You can buy one, or make your own (see page 27). Value finders are useful tools for viewing your painting subject (like the landscape, right) with the colour neutralized. Look at the view through the red window and you will be able to see your design in grayscale. If your value finder has a view scale printed around the outside (like the ones shown here), you can then match each colour to an exact percentage of grey.

▶ Looking through the value finder

The areas of high and low value are far more easily identified in monochrome (shown on the left).

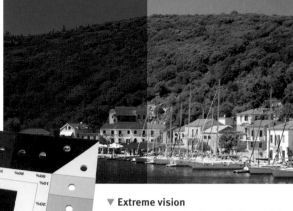

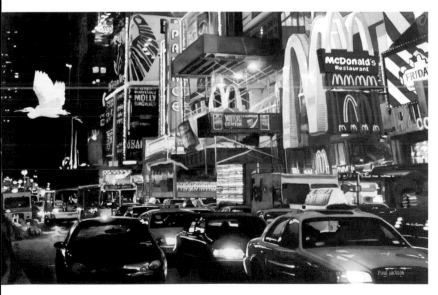

▼ Extreme vision

Paul Dmoch, in *La lumière et l'obscurité dans la Cathédrale*, has created a world of pure light and dark. There is no grey; nothing but light. His brilliant vision of extremes, life and death, truth and fiction, is accomplished by value alone. Even the window in the background is muted to show only light.

▼ Narrative values

Crosstown Traffic by Paul Jackson is a perfect example of using value to support a thrilling story. The darks tell you it is night and set off the bright lights of the city. The white tells you exactly what he wants you to see: the egret. Because there is almost no other pure white in the painting, the presence of the egret against the very dark background fills this story with mystery and excitement.

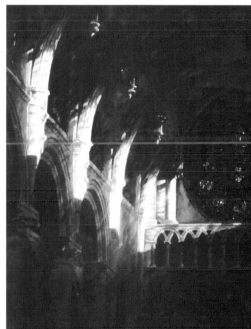

Cobalt Blue	Cadmium Red	Alizarin Red	Burnt Umber	Ultramarine Blue	Winsor Blue	Winsor Green

50% 60% 70% 80% 90% Black

Using value as a design tool

In traditional transparent watercolour, tonal value is the most important tool. What this means is that designing with black, white and shades of grey is critical to creating and retaining light in the painting. Planning the lights and darks ahead of time, when you work out the design, will result in a more successful painting. The darkest values make the lightest values glow; the placement of these lights and darks is crucial.

126

Showing light

Because transparent watercolour does not include white in its choice of pigments, the white of the paper takes on that role. You can protect the white of the paper while you paint by masking areas (for more about this, see page 98) – but before that can happen you must learn to see and make use of the whites in your design.

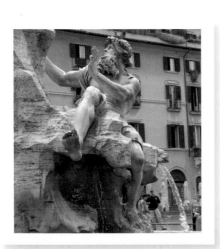

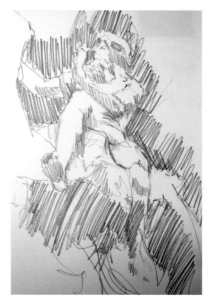

1 This is a quick pencil sketch of the extreme lights and darks of the figure Danube, on top of the Four Rivers fountain in Rome.

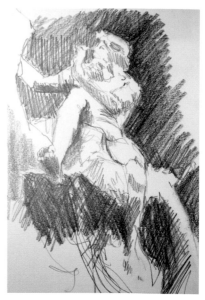

2 To add drama to the two-dimensional depiction of this beautiful sculpture, deeper darks are used around two-thirds of the figure, eliminating all background detail.

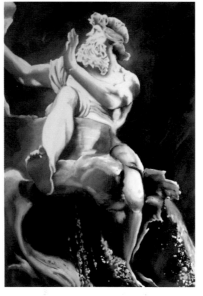

3 An appropriate colour palette supports the design of the final painting (*Danube* by Robin Berry). Here, the lightest areas are the white of the paper, yellow and gold. Deep blues and purples represent the black end of the scale. Notice that there is an alternating of dark and light values, each setting off the other. Also notice that in many areas shadows go over into the next shape, which helps to avoid the colouring-book look.

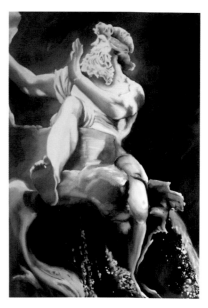

4 Using a computer, a digital photograph of the painting is turned into a grayscale image so that the final values can be checked with the value sketch set next to it. Be sure not everything is the same value.

Changing the mood

In your idea and its design, value is everything. It tells you the time of day, the weather and the mood of your painting. These factors are part of what makes your painting interesting to the viewer. Change value to change mood. Use value to convey a sense of mystery – not everything is seen.

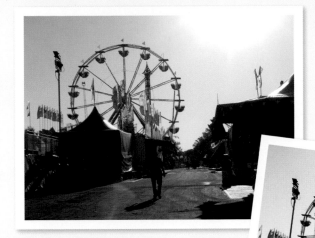

◄▼ Explore the possibilities of value

The original photo was taken as the sun rose over the fairground. This photo was then converted to grayscale. It is always useful to explore the value possibilities of a scene, even if you eventually go with the original.

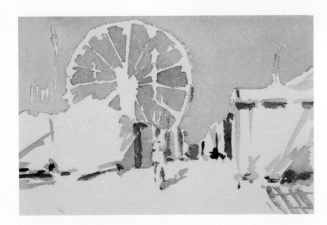

◄ Front light

One simple way to change the value is to make it the opposite of the original – in this case, lighting the scene from the front. Such a lighting scheme would feel very hot and there would be little dark to provide mystery and give the eyes a rest. The sky treatment would determine mood and weather.

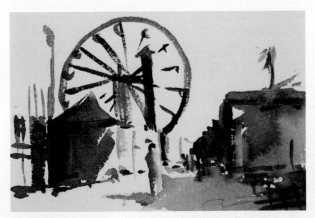

▲ Side light

Lighting from the side of the scene would bring more interest by way of adding darks and grey values to the picture. However, this seems to give a choppy look to the scene.

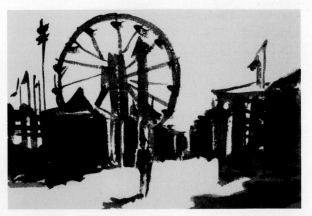

▲ Back light

This is as the scene appears in the photo. It reflects the drama of the fairground as it awakens. There is also a cohesive movement of darks across the picture plane, which in turn create interesting white shapes.

128

Adding drama with value

Value, at its best, is a powerful tool for dramatic expression. A painting that is very dark can be ominous or comforting depending on how the values work in the design. The two figure paintings here have very similar value designs and palettes, yet tell quite different stories.

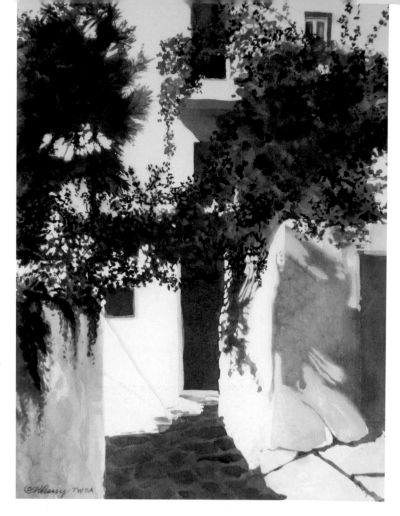

▶**Quiet and serene**

It is not always necessary to up the drama. There may be times when you actually prefer to play down any sense of mystery and simply convey a feeling of safety, sunlight or beauty. In *Mykonos Glory* by Robin Berry the values stay at the higher end of the range and the colours are pure and uncomplicated.

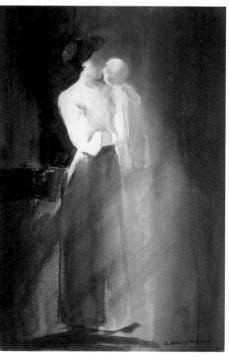

◀**Added drama**

The two paintings at left illustrate ways of using value to bring drama to your painting. On the left, *Mrs. Lovett* by Robin Berry, which was part of a series of paintings exploring a character in the musical *Sweeny Todd*, is cast with an eerie glow. Mrs. Lovett's face is hidden in shadow, her arms disappear in the dark value and her form is described by the glowing highlights against the rich, mysterious background. In *Stella and Doris*, also by Robin Berry, the light on the face of both the mother and child communicates their intimacy. No details are needed, since the addition of a dusky rose colour communicates an emotional warmth.

129

Changing the atmosphere

Another use for the powerful tool of value is as a means to explore other possible interpretations of the scene before you or in your reference photo. Both may be perfectly lovely and yet not express the emotion you'd like to convey in your painting. Several small value sketches will help you to explore the possibilities. Each contains the full value range from white to black, but used differently.

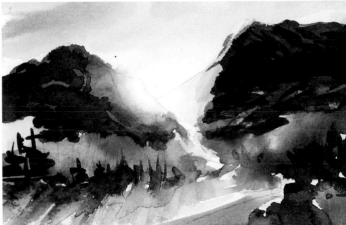
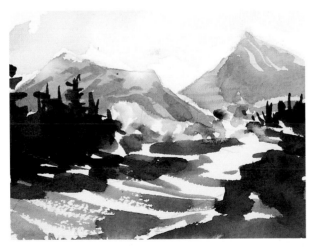
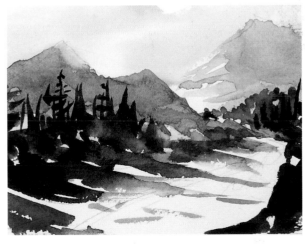

▲ **Exploring moods**
These paintings began with the same drawing. To explore the mood of the day, two different sun placements were tried. At the top, the sun setting behind the mountain enables dramatic colour and value choices. A softer day results from late morning or late afternoon sun placed to the left. The arrangement of values is a gentle progression into the distance with aerial perspective adding atmosphere.

1 The original photograph.

The value of colour

Colours also have value. If you've seen a colour photo turned into a black-and-white photo, you'll have experienced how this works. The lightest colours, such as yellow, are the lightest values; the darkest colours, such as navy, are the darkest. Using a photo-editing program, you can change the value of reference photographs to simplify them, as shown in this sequence. This photo was taken in brilliant late-afternoon sunshine. However, there was too much distracting detail in the photo for it to be used as a reference for a painting.

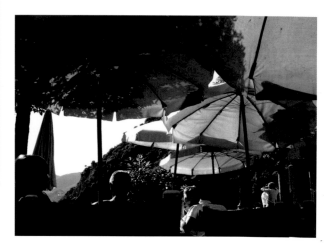

2 The photo turned into a grayscale picture. Notice how the brightest yellow of the umbrellas looks almost white, as does the sky.

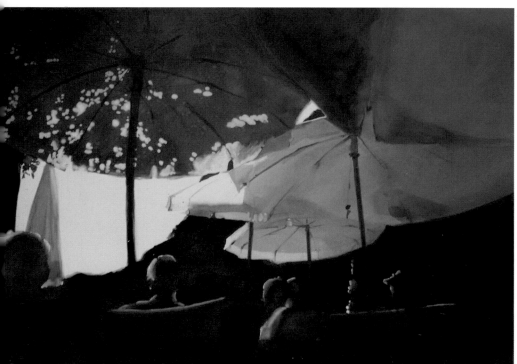

3 Using Photoshop's brightness and contrast palette, the contrast is increased by about 50 percent, eliminating much of the detail, which blended into the darks. It also punched up the light. This became the reference for the finished painting.

Seeing value

Robin Berry's painting, *Vernazza Umbrellas*, illustrates the usefulness of the grayscale photo. Having pushed the reference photo to its value extreme, it has become clear that even yellow, the lightest value, has significant impact on the value design of the painting and can include a wide value range within the colour itself.

Make value sketches

At times you may have several reference photos and be unsure which you would like to paint. Or perhaps you're watching an event or a movie and get an impression you'd like to explore. Whatever the motivation, learning to make many small value sketches will give you endless options for future paintings and also help you to remember the impressions you gained.

▶ **Value sketches**
These sketches were impressions gained from watching a documentary on television. Having just been to Venice and having brought back many such photos, seeing a split-second shot of gondolas in the sunset on the programme was enough to inspire eight small sketches. Each sketch took only a minute or so and is the size of a business card.

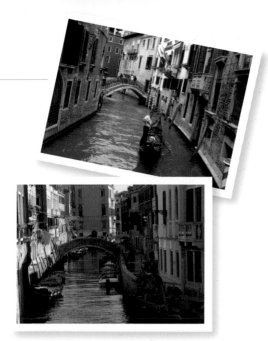

TRY IT
Three-way scene

Take three photos of different aspects of the same scene. Create three different designs using all three photos for each design. This may mean changing perspective, point of view and focal area as well as the arrangements of lights and darks.

Enriching your painting with darks

Step back from the painting to get a longer view – squint at it. Sometimes viewing the painting from a distance makes weaknesses obvious. Most often, if a painting seems boring or unfinished, the solution is that there are not enough darks or that they are too weak. The strongest paintings usually have a value range from white to black or near black.

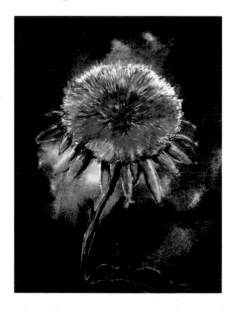

▶ **Dramatic darks**
Janis Zroback, in *Echinacea Coral Reef*, creates a highly dramatic painting by dropping very wet, dark colours around the flower head. She also dropped in lighter colours and moved them around by spraying.

Colour considerations

There are three particular considerations regarding colour to work out before you start a painting. Making value sketches is essential. This is followed by consideration of local colour and decisions about the palette of colours you will choose, and then using them in a colour thumbnail sketch. The values of your colour sketches should match your value sketches.

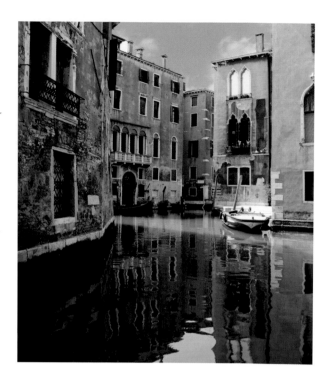

Make one or more value sketches

Making one or more value sketches allows you to explore your subject, the light, shade and mood thoroughly. Each small sketch you make allows you to adjust parts so that they work better as a whole. Once you have made colour sketches (see page 87), make sure you have matched the value of your chosen colours to the value sketch you like best.

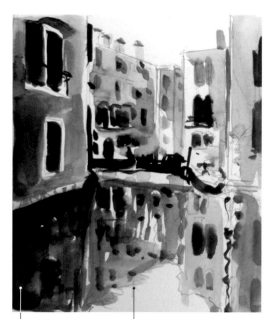

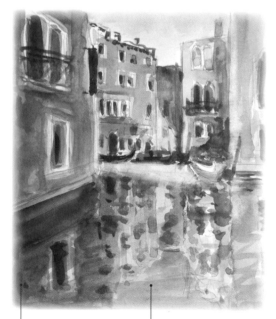

Extreme values were the goal of this sketch. This dark reflection moves up and across the picture plane.

A choice was made to keep the sky primarily white and so the reflection in the water is light, too. The white moves around the painting, giving the sense of a bright day.

Softer, more literal values, in keeping with the original photo, are reflected here in a scene that is peaceful but contains little drama or interest.

Here the water reflects slightly darker than the blue sky.

FIX IT
Editing detail

If, having done a small sketch of a scene, you still have some questions about what to include or you see more possibilities, try the sketch a little larger – 20 x 25 cm (8 x 10 in.) or so. It is best to work out these details either in your sketchbook or in a colour thumbnail to determine how much detail you want to include. It's important not to let a photo seduce you into copying every detail. What works in a photo may actually clutter a painting.

Make colour thumbnails

After you are satisfied with your value sketch and overall design, draw it out again – maybe two more small sketches – and paint it in colour. Try the first one using local colour. Set it aside. Next try a more interpretive impression of the scene. Is it a sunny day? How would you express that? Is it stormy? Or even if it actually isn't, would you like it to be? For the second painting, let your imagination be your guide.

▼ **Guiding thumbnail**
After trying out several thumbnail designs, this one was chosen as a guide. It sticks close to local colour but adds yellows and golden-oranges to intensify the light streaming into the canal.

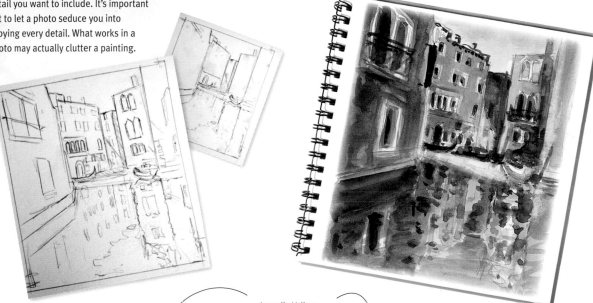

Manipulating local colour

Local colour refers to the colour something actually is. The local colour of a traditional landscape would likely be blues and greens with some brown and violet, for example. As the artist, you choose whether you'd like your palette to reflect the colours you actually see (local colour) or if you'd prefer to add imaginative colour, such as magenta to shadows or golds to the sky. Try your ideas in your sketchbook or thumbnail sketches.

Aureolin Yellow

Antwerp Blue

Clean water runs across

Winsor Red

Phthalo Green

+ Yellow

▲ **Test pouring palette**
Testing triads of colour will show the mood you can achieve with various colour combinations. In this sample, the paint across the centre of the palette was removed with water to test the opacity of the colours. This pouring palette is used in the demonstration on pages 92–95.

TRY IT
Practise colours

Practise the palette of colours for your painting. On several small pieces of watercolour paper, try different triads of colour as selected from your full colour palette (see left) and painted using the intuitive colour wheel technique (see page 48). Make use of other colour wheels, especially the analogous colour wheel, to help you.

Palette

Lemon Yellow

Aureolin Yellow

Winsor Red

Quinacridone Coral

Antwerp Blue

Colours added after pouring:

Winsor Yellow Deep

Alizarin Crimson

Burnt Sienna

Cobalt Blue

Cerulean Blue

French Ultramarine Blue

Phthalo Green

Mineral Violet

Neutral Tint

Materials

Arches 300 gsm (140 lb.) cold-pressed paper stretched onto Gatorboard
HB pencil
Masking fluid
5 cm (2 in.) wash brush
2.5 cm (1 in.) sable flat with chisel end
No. 4 round brush
No. 4 squirrel mop brush
No. 10 sable round brush
No. 12 sable round brush
Scrubber brush
Tissue paper
Dremel tool with sanding bit

ARTIST AT WORK

Pouring a unified underpainting

When painting a specific location, it's important to capture the mood and colours of the place. Pouring is a good technique for this, because complex colours and atmosphere can be achieved through repeated layers of pigment building to colour tones in an underpainting, which will give unity to the painting on top. *A Venice Canal* was painted by Robin Berry with the goal of using pouring (see pages 104–105) to create a unified underpainting, onto which to build the beautiful architectural details to be found in Venice.

Techniques used

Masking (see pages 96–99)
Pouring paint (see pages 104–105)
Glazing (see pages 158–159)
Spattering (see page 150)
Spraying (see page 148)
Scraping away (see page 153)
Scrubber (see page 169)
Dremel Tool (see page 169)

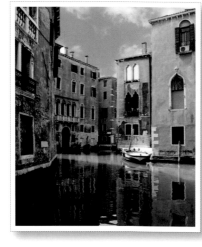

▲ **Choose an atmospheric subject**
An intersecting canal in Venice is a good subject for pouring transparent watercolour, as there is an overall atmospheric feeling in the scene that can best be accomplished through underpainting.

The selected pouring colours were Lemon Yellow, Aureolin Yellow, Winsor Red, Quinacridone Coral and Antwerp Blue.

The pigments in the butcher's tray were tested on a piece of the same paper used for the painting.

▶ **1** A detailed drawing is made of the canal. The artist ensures that major reflections and spots of colour are in straight vertical alignment with the reflecting object. The detail picture shows where masking is applied to protect the whites and the light.

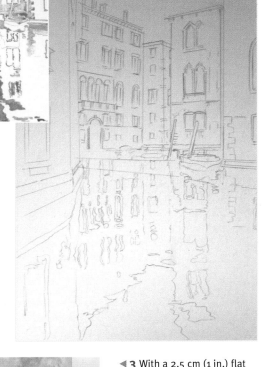

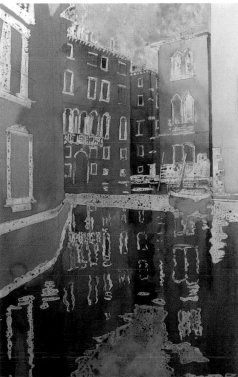

▲ **2** The paper is brushed with clean water using a 5 cm (2 in.) wash brush, and any pooling water is poured off. With the board flat, Lemon Yellow, cool by nature, is poured into the background buildings, and warmer Aureolin Yellow is poured into the water. Excess paint is run off into a pan. While the yellow is still wet, the artist pours Winsor Red and finally Antwerp Blue, taking care to avoid getting these strong colours in the upper right-hand corner. The result of the first pours was a greyed green, so once the painting is dry, a medium mixture of Quinacridone Coral is poured over all but the upper right-hand corner to give the scene a feeling of the real Venice, which is made up of soft, greyed pinks, warm greyss and generally complex colours. The result is a warm, unified underpainting. The greyed pink or rose colour was the result of the influence of the complementary green under the coral.

◀ **3** With a 2.5 cm (1 in.) flat brush, background values and colours are glazed in using two or three steps and different pigments each time; all the time the artist is conscious of the old, greyed feeling of the buildings. With each building glazed, a deeper colour is also laid into the water, which would usually be much darker. Note that the gold tones of the upper right are lost in the water. These will be corrected in a later passage. The golden, sun-washed building is the centre of interest or focus of the painting. It is given another glaze of Winsor Yellow Deep, and the building next to it on the left is given a darker shadow value.

136

Incorporating strong colours

If you have one element of a composition that is strongly coloured, try laying it in first so you can better incorporate the strong colour into other parts of the painting. Unless this bright colour is at the centre of interest, do not put in other bright colours around it. This detail shows the strongly coloured boat and its reflections in the canal.

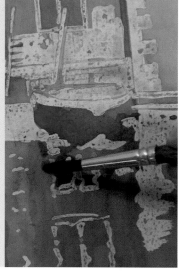

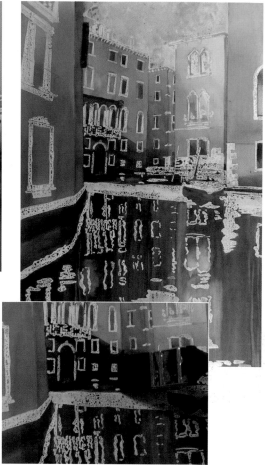

▶ **4** The blue boat is laid in. Then with the same or darker values, the immediately surrounding areas are painted, varying the colour slightly. Below the boat reflection, a stronger colour is painted into the windows and a deeper value, almost black, is used to paint the barely visible gondola with a no. 4 round brush. Once the gondola is dry, a deeper shadow, navy, is brushed over the lower part of the building behind the gondola with a 5 cm (2 in.) wash brush (detail at right). Although this shadow is not in the photo, it is used here to create depth, drama and some mystery as well. The viewer now has to discover the gondola, the symbol of Venice. The dark windows are also painted. Before removing the masking, the intensity of the water reflections is increased.

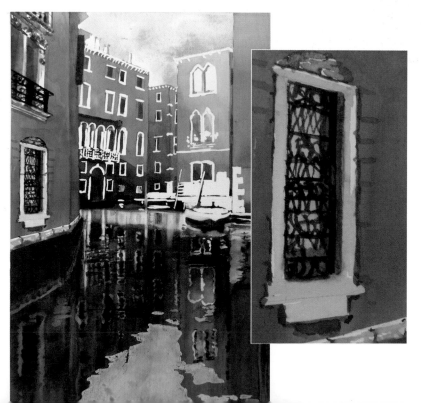

◀ **5** The masking is removed on all but the sky reflection in the water. The white of the reflections in the water is then eased into the painting; the artist takes great care not to lose it. A 5 cm (2 in.) soft squirrel wash brush is used to draw clean water down over the entire water area, beginning below the white horizontal sun stream and gently pulling it down to blend paint from the water into the white areas. It is thoroughly dried, then the yellow-green sun streak is painted, gently overlapping the edges above and below it and softened with a scrubber brush. Details are added wet-into-wet before the paint is dry. Next the painting is turned upside down and the sky painted wet-into-wet with a no. 4 mop brush. White is left for clouds and dabbed with tissue paper to soften.

137

Adding authenticity

An important element of this painting is the painting of the windows of the building furthest to the left. Spots of colour were put in to indicate peeling paint, and the balcony and grillwork were painted with a no. 4 round brush. The edges of the white frame were defined by a slight, dark line. Architectural details such as these help give the viewer a sense of place and add authenticity.

▲ **6** A critical consideration in painting the buildings of Venice is their age and texture. Here, with nearby areas covered for protection, darker colour is thrown and spattered into the walls with a no. 4 mop brush. The paint is allowed to sit for a minute or so, and then, using the bevelled plastic end of a brush and keeping perspective lines in mind, the indication of brickwork is scraped in. Remove the masking from the sky reflections and paint in the sky using a blue slightly darker than that of the sky. Finally, a Dremel tool with a sanding bit is used to nick some pure white back into the water reflections. The edges of the background windows are straightened, and the shutters, the flower boxes and the balconies of the yellow building are completed.

A Venice Canal
448 x 295 cm (176 x 116 in.), on Arches cold-pressed 300 gsm (140 lb.) paper stretched onto Gatorboard.

Robin Berry

Protecting the white of the paper

In transparent watercolour, keeping the white of the paper pristine is a major goal. Because white paint is rarely used, sparing the white of the paper and using very light-value colours are the way both white and light are best expressed.

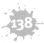

Avoid the white/light areas

The most common method of avoiding whites – by painting around them – works especially well when large shapes will be left unpainted.

◄ Immediacy
Painting around a white shape allows you to immediately go back in with the paint on your brush and add shadow and reflected colour. Masking the vase would not allow this immediacy.

Use artists' tape

Artists' tape is useful for creating straight lines. The tape can be torn to simulate the roughness of bark or left hard-edged for elements such as buildings.

With the basic colours painted in and the painting dried, the tape is removed to leave the white of the paper just where it was required.

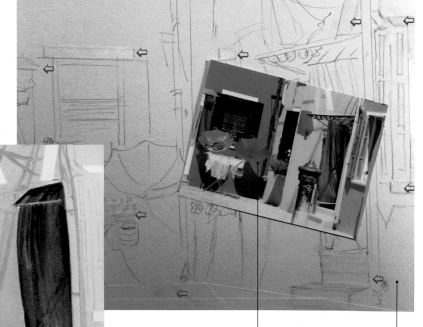

Notice that there are quite a few regular-shaped white areas in the photo. This is a perfect setup to mask with masking tape.

The drawing is annotated with arrows to show where the masking tape was placed.

140

Texturing with an atomiser

An atomiser (see below) is an old-fashioned tool that hasn't changed much in 100 years. Place the short, uncapped end in liquid and blow into the long, black-tipped end. The nature of the spray depends on how hard you blow.

CAUTION: Do not inhale spray of any kind. Take a breath with your head turned away and then resume blowing.

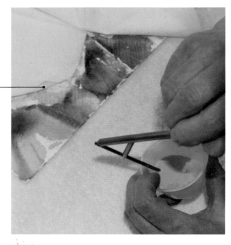

Here tissue was used and folded around the curves of the flower to be protected. Since the spray was light, no weight was needed. When finished check under the cover and, if any paint has slipped under, remove with a damp brush.

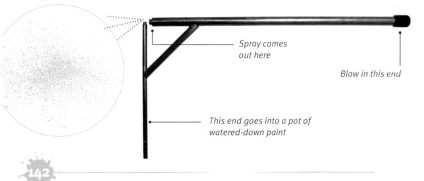

Spray comes out here

Blow in this end

This end goes into a pot of watered-down paint

141

Cover when atomising

If, when your painting is nearly done, all the masking has been removed, and you decide to spray on some texture, you'll need to devise a quick cover. Usually sheets of paper towel or scrap paper will do. It may be necessary to weigh the paper down if the atomiser or spray is too vigorous. Remember that some paints are toxic when inhaled and should never be sprayed (see page 16).

142

Use clear frisket sheets

When you need to protect large areas, particularly if the area is to be covered, uncovered and covered again, frisket sheets are a good choice. These come on a roll and can be cut to size in any shape you want. Cut just inside the shape to be protected and seal the edges with masking fluid.

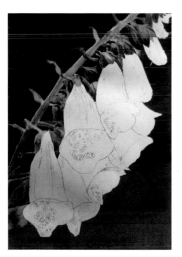

1 If the painting you're working on calls for a large area to be masked, first make a detailed drawing on the watercolour paper.

2 Place the sheet of clear frisket film over the drawing and gently cut around the form to be masked, staying about 3 mm (⅛ in.) inside the lines. Seal the edges to the edge of your drawing with liquid masking. Paint freely across the entire picture.

3 When everything is dry, remove the masking and the film. You will still be able to see your drawing.

Masking fluid

Using masking fluid, also known as liquid frisket, is one way of protecting areas of your paper while painting freely and colourfully right over the top. All liquid masking mediums are rubberised or latex solutions, soluble either in water or a solvent when fluid, but waterproof when dry. Masking fluid is easily removed with a rubber cement or homemade eraser.

Masking preparation

Before beginning to mask, dip your inexpensive, synthetic, clean brush into liquid dish soap. Rub it in and wipe it off. Pour the approximate amount of masking fluid into a dish. Don't use too much, since it will dry out and unlike watercolour pigment, it will not rehydrate. Mask your painting (see opposite page).

Choosing your masking fluid

There are several different coloured liquid masking brands. Some are yellow, others white, blue, pink, grey or clear. Don't be fooled by the colour. They all function the same way. Some artists prefer one over the other based on whether they want to be able to see the masking or not. Many find the grey masking easier to apply because it is thinner. If masking is too thick, attempts at thin strokes, such as for grass or lines, will be clumsy.

Make your own masking remover

Roll the masking up on itself as you remove it to form a ball. It removes itself! It won't save you much money, but it's lots of fun.

Cleaning your brush

Do not allow masking fluid to dry on the brush, since it will form a hard rubber and ruin your brush. To clean your brush, wet it, dry it off, then dip the brush into undiluted dishwashing liquid or rub it on bar soap and work this through the bristles with your fingers. Wipe the brush again so the soap doesn't drip into the masking fluid. When you're finished, wash it under running water using a little soap.

Working with precision

Masking fluid can be applied with a Masquepen, a bottle with a built-in applicator that allows for precise marks.

Pour a puddle of masking fluid. It will be lighter when it is wet. Let it dry. Roll the dried masking up – the result is a homemade masking remover.

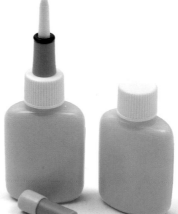

Applying masking fluid

Patience in the careful application of masking fluid will be rewarded – once it's removed.

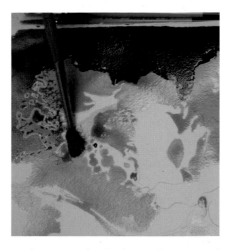

1 Paint the masking fluid onto your drawing wherever you want to have white or a light value protected. Follow your value sketch and reference material. Make sure the masking is not too thin or it will be difficult to remove once it has dried.

2 Paint your washes freely over the paper and masked surfaces.

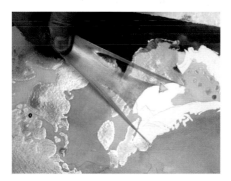

3 When dry, gently lift the masking with a rubber cement eraser. Smaller areas and lines can be gently rubbed and peeled with the fingers to remove.

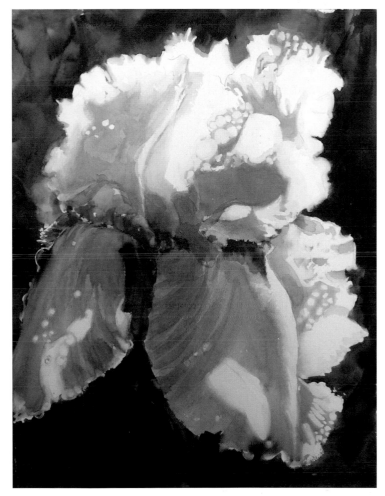

▲ *Iris Light* by Robin Berry illustrates just how useful masking fluid can be. It will protect both small spots of white, such as in the water drops, or large areas. The part of the painting that has been covered will glow when the masking is removed.

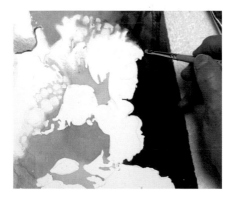

4 Soften the hard edges left by the masking fluid by gently rubbing the paint edge with a damp brush.

Palette

Phthalo Blue	Burnt Sienna
Manganese Blue	Yellow Ochre
Cerulean Blue	Cobalt Blue

Materials

Hot-pressed 425 gsm (200 lb.) watercolour paper stretched on board

2B pencil

Masking fluid

Old brush

Paper

5 cm (2 in.) wash brush

6 mm (¼ in.) bristle brush

No. 1 rigger brush

Techniques used

Masking (see pages 96–99)

Taping (see page 96)

Spattering (see page 150)

Scraping away (see page 153)

ARTIST AT WORK

Masking for rich texture

In his painting, *Old Blue Door*, David Poxon demonstrates the use of masking fluid, tape and granulating pigments to create the textural effects of old wood and stone. When used together, this powerful combination gives a richness to the painting that would be difficult to achieve any other way.

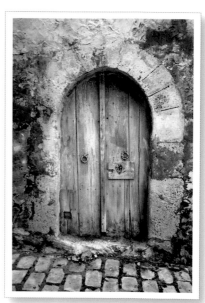

▶ **1** Using a 2B pencil and as few lines as possible, the door is drawn with a minimum of detail. Getting the right proportions is vital. Tools that you have at hand can be used to define edges or draw curves. Here the artist uses an old spanner that happens to have the curve he is looking for.

149

Applying masking fluid

Never use your best brush to apply masking or it will be ruined by the masking fluid. You can use an old brush, a sharpened stick, a toothpick, expired pen or even a piece of plastic cut from an old credit card.

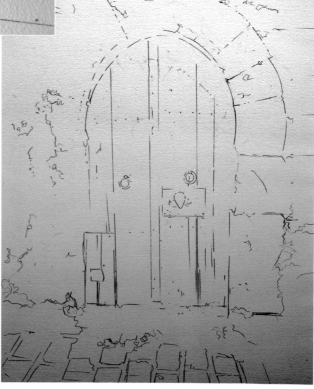

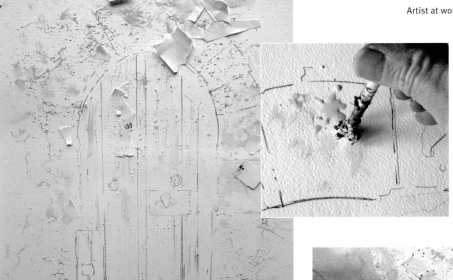

This detail shows the use of an old brush to apply textural masking. Not only have the bristles been trimmed, but dried masking beads also give the added effect of randomness.

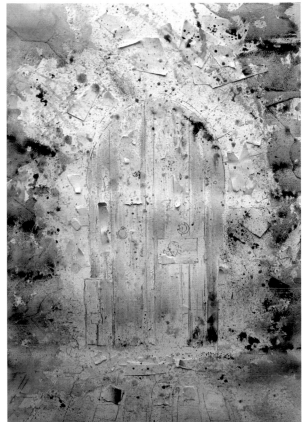

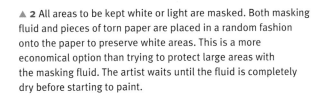

▲ **2** All areas to be kept white or light are masked. Both masking fluid and pieces of torn paper are placed in a random fashion onto the paper to preserve white areas. This is a more economical option than trying to protect large areas with the masking fluid. The artist waits until the fluid is completely dry before starting to paint.

▶ **3** A multiple glazing technique is used as several washes are placed on top of one another, resulting in great tonal range and depth. This requires some patience, but the end results are rewarding. First the washes are mixed to the consistency of milk. Wash one is a transparent mix of Phthalo Blue and Burnt Sienna. Wash two uses Manganese Blue and Yellow Ochre. Wash three is Yellow Ochre only. The round brush is held at an angle to the paper and the wash applied. Keeping the board flat allows the paint to granulate. The artist works quickly to apply these first washes, encouraging the colours to merge and blend by rocking the board slightly. It dries flat.

150

Granulating blues

'Granulation' is where tiny particles of pigment settle in the small hollows of the paper surface, resulting in a speckled effect. Not all pigment granulates, though. Popular granulating blues are French Ultramarine and Cobalt Blue.

▶ **4** A stiff bristle brush is used to spatter a darker mixture of the same colours into the damp wash. Then, using the same bristle brush held horizontal to the paper surface, flecks of paint are gently pulled in the direction of the grain on the wooden door.

Next, the same brush is reversed, and the end of the handle pressed down into areas of damp wash on the stonework. This indents the surface; small puddles of pigment will collect in the hollows, making even darker areas of colour. The artist repeats this several times, letting the paint dry after each application.

Manipulating paint

Fine and pointed, the rigger is the perfect brush for steering puddles of paint into position on the crumbling stonework.

◀ **5** When the paper is dry, the artist removes the masking fluid and torn paper. A no. 1 rigger and a stronger mix of blues are used to work on the door, following the direction of the grain. More texture is spattered onto the masonry, using torn paper towel to protect whites.

Removing paint

If you need to remove any paint, apply clean water to the dry paint. Gently stroke the paint to get it back into a liquid state. Using a clean paper towel, gently dab the area to lift off the colour (see detail).

153

Adding shadows

Use a rigger to go over the fine details where a shadow is required and always keep the position of the shadows consistent with the location of the light source. Here, the shadow colour is a mixture of Phthalo Blue and Burnt Sienna.

▶ **6** This final view shows the finished effect of careful glazing to build up transparent layers. The old door took a long time in real life to become such an interesting and inviting subject for the artist. It is rewarding to take the time to enjoy rebuilding its wonderful character in a painting.

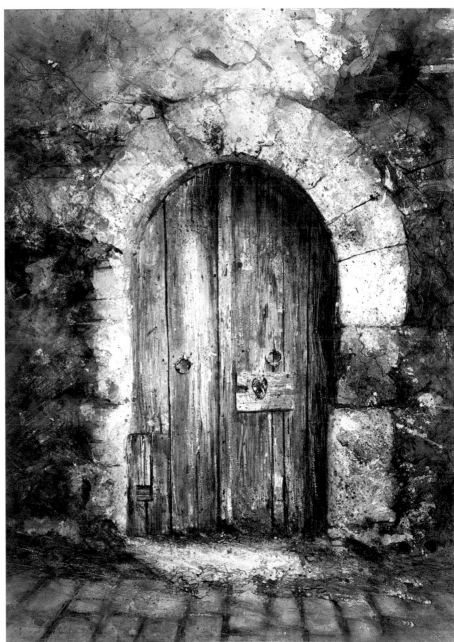

▶ *Old Blue Door*
66 x 46 cm (26 x 18 in.), on hot-pressed 425 gsm (200 lb.) watercolour paper.

David Poxon

Pouring paint

Breaking away from the traditional way of applying paint with brushes, to pouring rich, thick colour onto tightly stretched and pre-wet paper is one of the most exciting ways to experiment with watercolour. While at first you might feel that the painting is completely out of your control, with practice you will certainly achieve glowing, lustrous results. You must be bold and not settle for weak mixtures of paint. Watercolour dries lighter than it looks when wet.

Pouring paint onto a masked painting

Use a half-size butcher's tray to hold, mix, and pour the paint. In the example shown here, it contains four pigments: Aureolin Yellow, Antwerp Blue, Quinacridone Coral and Quinacridone Rose. Two reds were chosen, one warm and one cooler shade.

AT A GLANCE
Pouring tools
• Masking fluid
• Half-size butcher's tray
• Tubes of primary colours
• Old brush to mix paint
• Rubber cement eraser or masking remover
• Synthetic scrubber brushes
• Tissue

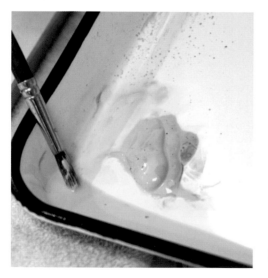

1 Make the preparatory drawing, then mask the areas you want to reserve. Make your paint into a pouring consistency by squeezing a little paint from the tube into the tray, and mixing in enough water to make it the consistency of thick cream. It is important that the paint is mixed well with no lumps, because bits of pure pigment will mar your wash and be hard to hide.

2 Secure the pre-masked paper on a board and wet it well, either with a spray bottle, a sponge or a wide brush. Tilt the board to make the water run evenly across the surface. With the board flat, pour yellow into your painting at the centre of interest. Tilt the board to move the paint or gently brush it into the area you want to be the warmest.

3 Next pour a warm red on one side of your painting and a cool red on the other. Pour in blue, keeping it away from the centre of interest and concentrating it in the outermost background areas.

4 With all the colours now poured, tilt the board in all directions until you have the effect you want. Place your painting on a flat surface and let it dry thoroughly. You may choose to repeat this process one or two more times until the colours have the intensity you like. When the paper is completely dry, remove the masking, soften the edges (see page 99) and finish the painting in your own time.

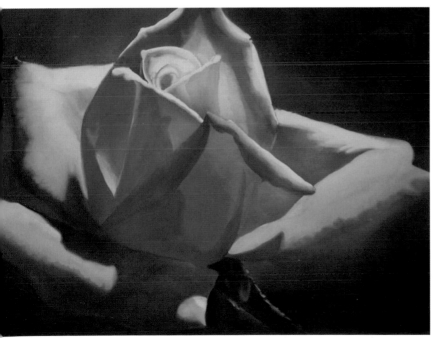

▲ **Pouring perfection**
Inner Glow, by Robin Berry, is the end result of the process shown on these pages. Although intense primary colours were poured over the paper, the blending process created a unified underpainting, which gives both atmosphere and harmony to the painting.

155

Don't over-spray your paper

While you may find it necessary to spritz and spray the initial pours to keep them moving as you tilt the board, over-spraying will dilute the colour and defeat the purpose of the strong underpainting. If you inadvertently get the first washes too light, dry the painting thoroughly and repeat the pouring.

Looking at a picture plane

On your two-dimensional paper, anything on the vertical plane casts a shadow and anything on the horizontal plane is parallel to the earth. But this is not the only way to view the illusion of three-dimensional space on a flat surface.

Show distance by value or colour?

Many artists separate background, middle ground and foreground either by value or by colour. If you are clear about the value of each receding layer, you can use any colour that represents that value. However, if you choose colour as the most important element, value can take second place. Whichever you decide, it's important to choose your main method. Colour adds excitement and a wide value range stimulates.

Linking shapes

One way to look at a picture plane is by clumping shapes together to form larger shapes. By linking shapes of similar values, the painting will have a looser or more abstract feel, even if the main subject is not abstract at all.

Remember the photograph of the fairground on page 85? Here is another trick to decide which lighting plan gives you the strongest design.

Painting value
Although a lovely photograph, it, of itself, does not convey the excitement desired for the painting.

When viewed in grayscale, it is obvious that the exciting thing about this reference is the tunnel of light through the archway of trees. This became the design.

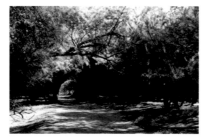

When the painting is viewed in grayscale, you will see it bears a strong resemblance to the values in the grayscale photo.

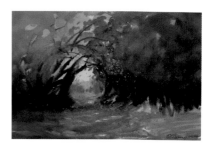

▶ **Prioritizing value**
In her painting, *Canyon de Chelles Path*, Robin Berry made the decision that value would be the guiding element in the design. When value becomes the priority, colour can be anything you choose. Thus in this painting, the desire to show the excitement of this travel adventure as well as the depth of the scene led to the choice of a very hot palette.

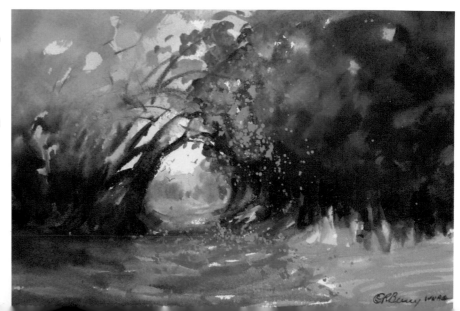

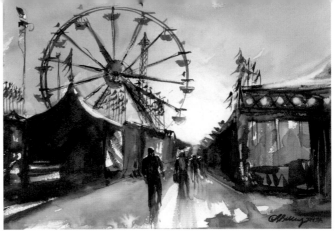

▲ Combine shapes in a single value

Take a black-and-white printout of the photo and, with paint or a marker, darken all the major shapes, ignoring all detail. Evaluate the shapes. You can see that extra people were added to break up the strong white arrow formed by the white path.

▲ How does it work in colour?

Robin Berry chose a primary triad for *Midway*: Yellow Ochre, Winsor Red and French Ultramarine Blue. The red and dark blue are of similar values and if you squint at the result you will see

that, regardless of the colours in the painting, the value pattern remains the same.

Painting colour

This is the actual photograph of the scene. You will see a somewhat normal landscape photo that would not have made a very dramatic painting.

Looking at the grayscale photo of the scene, you will see a pleasant, but non-dramatic picture. There were two options: to paint value or to paint colour. Since the value design is uneventful, colour was chosen. When colour becomes the priority, value can be anything (or nothing) you choose.

In this grayscale view of the painting, you'll see that shapes have been combined to simplify the painting. It is quite unlike the photograph used as a reference.

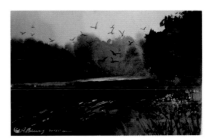

▶ Prioritizing colour

Colour was the dominant element in designing *New Mexico Ditch*. In this painting, Robin Berry flattened the picture plane to emphasise only a single element – the red trees in the distance. Every other colour decision supported this one, including the complementary green 'underlining' the red trees and the choice of warm colours in the tree area to pull the viewer into the painting.

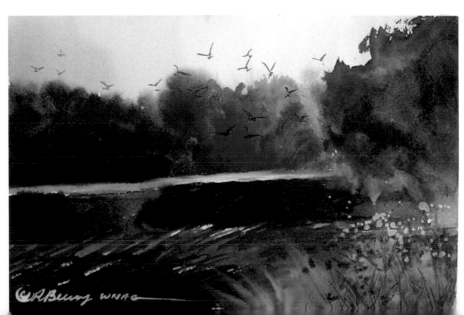

Brushstrokes

A painting is made up of dozens, hundreds or thousands of brushstrokes. Learning to use your brushes to their best advantage is critical to the success of your painting. As you paint, your skill will build naturally. But it is well worth the time to simply practise with the brush, so that even in your early paintings, you will have the skill to make the paint do what you'd like it to.

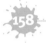

158

Types of brushes

Although it is theoretically possible to get by with one or two brushes, you will find there are good reasons for using other brush shapes and will find your own favourites. For example there is a brush known as a mop. This brush holds a great deal of water and yet tapers to a very fine point, allowing it to render lines from very fine to very full in a single stroke.

Each brush in your collection is built the way it is for a reason. A flat gives a fine, flat edge of a measured width to make a smooth, even stroke in a wash-like passage. But until you try it you might not realise that, used sideways, it also makes lovely, varied lines.

▼ **Brush strokes**

1 5 cm (2 in.) squirrel wash
2 2.5 cm (1 in.) sable flat
3 2 cm (¾ in.) synthetic blend flat
4 No. 24 round synthetic
5 No. 14 round synthetic
6 No. 12 round sable
7 No. 10 synthetic blend
8 No. 22 squirrel oval
9 Rigger
10 No. 10 squirrel mop

TRY IT
Varying your strokes

- Broad, sweeping from the shoulder – for starting a large painting.
- From elbow to brush – putting exuberant energy into the movement.
- From wrist to brush – contained, controlled.
- With the fingers – fine detail.
- Flicking the wrist – spattering and throwing paint.
- Remember, twisting the brush to use all parts of it adds to the variety.
- In a single unbroken passage of paint, try using several brushstrokes.

TRY IT
Play with brushes

On a piece of paper, see what your brushes will do. Be bold. Try loose and overlapping brushstrokes in different colours. This is not a waste of time but it is where discoveries are made that give you ideas and may even change your painting life.

1 2 3 4 5 6

159

Making dry brushstrokes

Drybrush, which involves working with very little paint on the brush so that the brushstrokes settle mainly on the surface grain of the paper, is most commonly used for grasses and foliage. Splay out the hairs of the brush between your thumb and forefinger to create a brush mark that consists of a series of tiny parallel lines, which can follow any direction you choose.

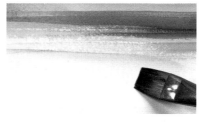

1 For the sea, drag grey-blue lightly across the paper with a dry round brush. Wash your brush and do the same for the sand, using a yellow wash.

2 Having painted a wash for the sand and allowed it to dry, take a flat brush, with the hairs slightly splayed out, and make upright, slightly curling strokes to paint in the marram grass.

3 When the first layer is dry, build up subsequent layers in the same way, drybrushing progressively darker colours over the original yellow. To create a more subtle effect, work each new layer before the previous one has dried thoroughly.

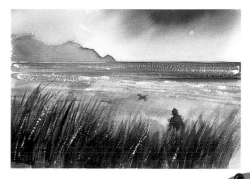

4 To complete the painting, use white gouache (opaque watercolour) to create highlights on the sea, then scratch out linear highlights on the grasses with a craft knife.

160

Feel your stroke

When you paint, feel it from your shoulder down through the arm to the point of the brush on the paper. Resist the temptation to hold your brush like a pencil. When your hand moves, feel the space flow around the brush as if it, too, were fluid. Every movement of the brush modifies the space on the paper.

◄ **Holding a mop brush**
A large mop brush is held at the far end in painting the majority of a painting. This leaves it free to move, swing, flick and sashay across the paper. Choking up on this large brush would feel awkward and reduce the exceptional movement of which it is capable. Try to hold all your brushes, except the smallest, by the handle.

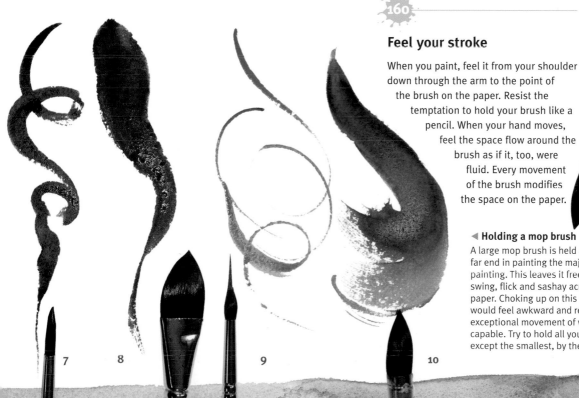

7 8 9 10

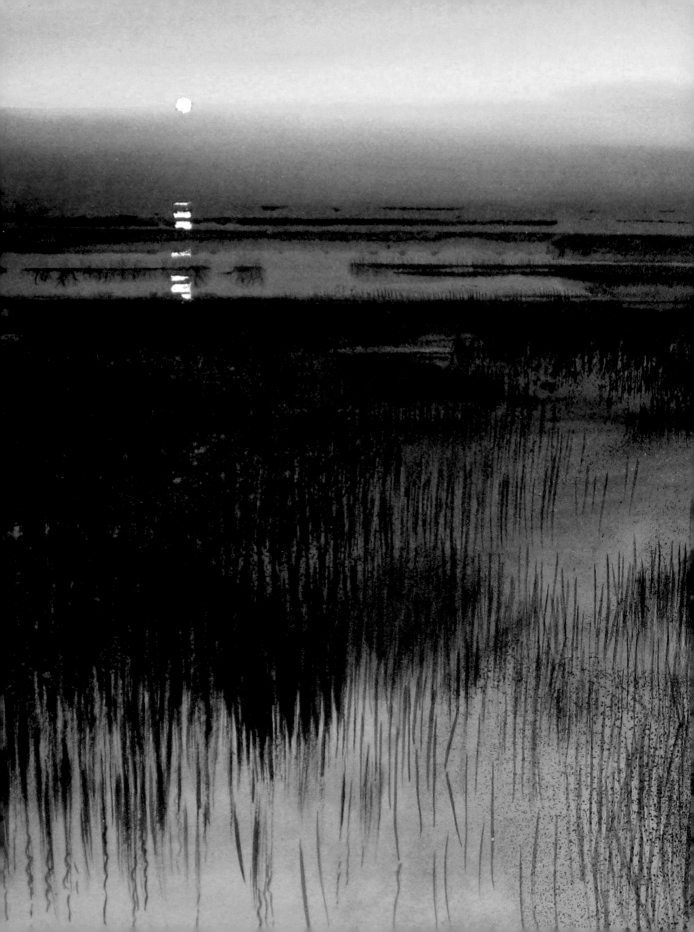

3

Choosing a Subject

In this chapter you will find tips and techniques to add excitement to the subjects you love to paint and ways to expand your artistic vision, taking inspiration from other artists who paint your favourite subjects, too. The artist in you will also find new ideas and plenty of tips to begin exploring them.

Awe-inspiring subject
A good subject is magic in the hands of the artist. In *Marsh Moon*, Naomi Tydeman brings all her considerable skills to bear to show the viewer the awe she felt as she looked upon this scene. Technically, her use of intense, dark colour gives the painting a somber-feeling.

◀ **Vision of light**

A master of painting light, Paul Jackson paints his glass collection as it glows in an unseen light source. In *Aurora*, a fleeting moment is captured as light pushes colour through the glass and into the long shadows. Although the objects in the painting are clearly recognisable, the star of the scene is the light, reflecting Jackson's vision as an artist.

Still life

Since the late nineteenth century, still life has been a powerfully expressive style of painting. In most paintings, the artist accepts the scene as it is and works with what he is presented with: the weather may fluctuate, the birds will fly off at will and the landscape will likely change. But in still life, the artist chooses and arranges the scene – and it remains still. Most people have objects they value or find interesting. In still life, these can be arranged and rearranged, lit and photographed from all angles, then rearranged, relit and photographed again. This is a good way for a still-life painter to build a body of reference material.

162

What to paint?

Try asking yourself these questions:
1. What do you own that you love? (Glass, old toys, antique jewellery?)
2. What do you buy regularly that excites you? (Fruits, vegetables, flowers?)
3. What feelings do you want to express? (Dramatic, serene, complex, sense of antiquity?)
4. In arranging a picture, what point of view do you prefer? (Vertical, horizontal, square?) And what relationship to the viewer? (Close-up or subject pushed into the distance?)
5. What is the setting? Do you have a background or not?
6. How will you preserve flowers or fruits? (Work fast or photograph?)

TIP

All principles of composition and design apply to still life and take on even more importance because the space that holds the arrangement is limited. Because the artist can arrange the relationship of objects, however, still life painting offers the advantage of more control.

161

Master watercolour skills

Mastering watercolour skills, such as paint application methods and design consideration is most important with still life because it is all about the close-up. Whereas in a landscape the viewer takes in the whole image or follows a path of light, still-life paintings tend to be examined for the interest of the objects.

◀ **The challenge of hyperrealism**

In Denny Bond's painting, *Guardians of Time*, the lightest lights and darkest darks are placed at the hot spots on the painting (see page 69) and the quiet space where the rings meet near the centre – a place to rest. The composition uses interlocking circles and invites endless inspection.

163
Choose a single idea

It's a good idea for a still life to have a single theme (such as light) or subject (such as glass bottles).

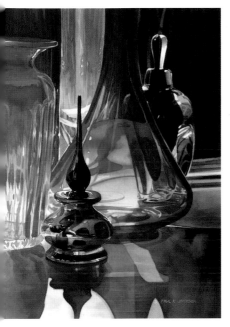

▲ **Clear theme**
Paul Jackson's painting, *Hide and Seek*, is an example of a clear theme and aesthetic, artfully arranged.

164
Choose assorted objects

You can successfully assemble a combination of seemingly unrelated objects. To create a good design, however, it's still best to explore your main idea or theme.

> **TRY IT**
> **Experiment with lighting**
> Assemble several objects of your choice against a simple background, such as a sheet, tablecloth or wall. With a light source that you can move up, down and around your arrangement, such as a trouble light used by carpenters to see into dark spaces, look at how the highlights and shadows change in the scene as you move the light. Photograph your options, take time to make sketches, rearrange and then try another view.

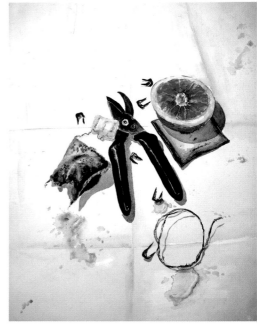

▲ **Exploiting an object**
In *Still Life with Picture Wire,* Janis Zroback added to the realistic depiction of her arrangement by squeezing actual tea from the tea bag onto her paper. Note the long cast shadow of the grapefruit, as the light source is positioned at top left.

165
Explore the meaning of your arrangement

The objects of a still life are often sentimental and personal. Flowers may be added to bring life to the arrangement. Food items do the same, adding an indirect human connection. Endless combinations are possible, and seemingly endless styles employed. In *Pink Tulips* (opposite), artist Brian Innes was first inspired by the dramatic shadows in the scene. He took advantage of a natural setting: a birthday card on a kitchen table next to flowers. In this painting he used complementary combinations before adding ink line to illustrate structure and detail.

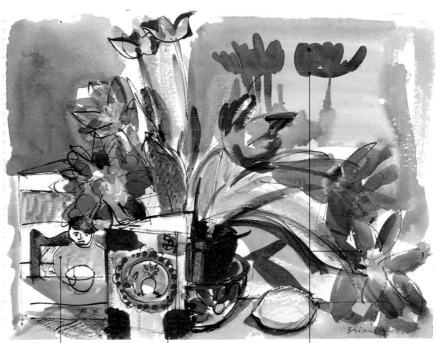

Not all things have to make sense. Is this a child or a doll?

Personal items, such as a birthday card, are included.

Flowers can create movement, structure and colour in the arrangement.

Landscapes and light

Nature is the most traditional and still the most popular subject matter for watercolour. Inspiration is everywhere, from your garden to a glimpse out a car window – from land to sea to city. When painting outdoor subjects, light is always in play. Designing your paintings with light and shadow in mind will assure you of strong compositions and dramatic outcomes. Let mood or atmosphere take priority in your painting, rather than simply copying a photo.

166

Evoking sky and clouds

How you paint the sky of a landscape will dictate the whole mood and atmosphere of a painting. Before beginning, think about the mood you want to convey. Don't try to duplicate the exact sky you see before you or in a photograph; that would make your painting stiff. Clouds have soft edges because of their wet, misty nature, and even those that are well defined can't be painted with a wet-into-dry, hard-edged technique without stifling the fluid nature of watercolour.

TRY IT

Cloud composition

Cut out or tear cloud shapes from a soft material, such as tissue. Arrange and rearrange them on a darker surface until you find a natural and pleasing design. Clouds appear smaller and closer together as they recede into the distance.

▼ Designing with clouds

Bridget Woods's painting, *December 2 Cloudscape,* achieves considerable drama. The design is weighted to the left by the shadows. The white streaks that take the eye right make it feel as if the storm is coming into the picture frame.

▲ Choose the mood first

In her painting, *Landscape,* Adrienne Pavelka has deliberately suppressed any detail to create a sense of grandeur and drama. The sky is manipulated to create a dramatic scene. Because water reflects sky, the two together, using a complementary colour scheme, add atmosphere to the scene.

Dark clouds provide weight to both the design and the atmosphere.

The darker values on the ground provide an overall stability to the scene and anchor it in place.

A block of clouds makes a weighty and dramatic statement about this landscape, setting an uneasy tone.

The upsweeping clouds relieve the tension and appear to push the dark away.

FIX IT
Avoiding flat blue

The sky is accomplished with a flat or gradated wash, and clouds are often done immediately by gently dabbing through the wet wash with tissue. White can also be left in the sky by simply not painting an area or painting it wet-into-wet. Resist the temptation to simply paint the sky blue. Think instead of layers of light against dark against light. Think, too, of painting the large shapes generally at the top of the composition first, and working down to smaller shapes in the distance as befits the design of the sky.

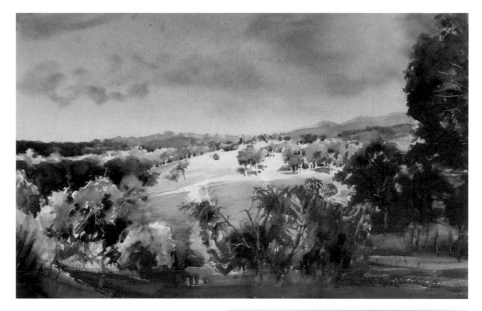

▲ **Plein air landscape**

In *Light Before the Storm* by James Boissett, the light value of the last sunlight is surrounded by dark values and complementary violets, providing instant drama and telling the story of the sudden weather change during this painting session.

TRY IT
Clouds are not just white and grey

Clouds can be almost any natural colour created in the sky by the sun (or the lack of it), so don't limit your palette when creating skyscapes.

167

The sky over the ocean

In a seascape, the sky is everything. It shows the weather, the sunlight or lack of it, the wind and the mood of the day. To paint an exciting sky in a seascape, wet the sky area randomly with a large brush. Think about the movement of the waves and duplicate it with your arm movement, or if the sky has a definite shape from the clouds, move in that direction. The sky is almost always active over the ocean, so make it exciting. For your first wash, dip your largest brush into a colour such as Yellow Ochre or Raw Sienna. With a medium-value wash, duplicate the movements you just made with plain water. Leave white areas. Next pick up some violet and begin to define the shadow side of the clouds while dabbing white highlights with tissue at the same time. Become an observer of sky patterns, and you will never paint a dull sky.

▶ **The water reflects the sky**

In *Dramatic Sky – Iceland,* Bridget Woods makes use of the water below to underline her dramatic sky activity. Not only are the colours of the sky repeated in the water but there is also a strong vertical movement downwards.

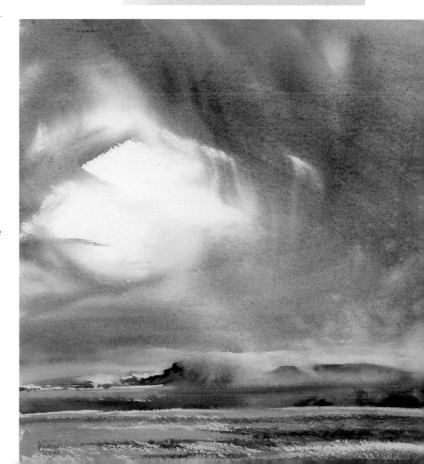

Landscape details

Landscapes generally take the long view of a natural scene. Although this sounds simple, and it can be, there are certain details that the artist must consider in a well-thought-out design. Landscapes always involve light or the absence of it, as well as weather, time of day and mood. This begins in the sky but must be carried throughout the scene.

168 Mountains, bluffs and rocks

Very large rocks and mountains in a landscape obey the principles of aerial perspective. The exception is when an object is backlit, though – in that case it is simply darker than the lighting behind it. Avoid painting mountains as triangular shapes. Give them interesting edges. Rocks – smaller and usually closer – are pitted and cracked and have unique shapes. Think of them as boxes with creases and crushed corners.

▼ **Working back to front**

This landscape of Yosemite National Park by Robin Berry is painted from the distance to the foreground and from light to dark, because colours become more saturated as they come towards us.

169 Grasses and bushes

Grasses and bushes offer a great opportunity to explore value differences between layers in the landscape. As layers of grassy landscape move from foreground to background, they obey the laws of linear perspective by getting closer together, and aerial perspective by becoming lighter and greyer unless the lighting dictates otherwise. Drybrush to indicate grass is effective if not overused (see page 109).

Masked grass tips

▶ **Capturing grass**

Breezy Seagull, by Katrina Small, shows a treatment of grass that is both simple and effective. With highlighted grass tips masked, she could freely paint wet-into-wet washes to build up the values in the grass.

▶ **Simplifying the scene**

In *Mesopotamia Station*, Adrienne Pavelka has eliminated the detail in the landscape. This has simplified the scene and placed the focus on the light in the sky and the landforms.

Sky painted first with wet-into-wet washes.

Attention paid to the shape of the darker conifers.

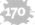

No two tree trunks are alike, and all are unevenly spaced and natural looking.

Backlit colour adds atmosphere and warmth to the scene.

Placement of branches based on careful observation of species.

▲ Achieving backlighting

Northwoods Evening, by Nancy Emmons Smith is a highly accomplished depiction of trees. Elements of design in play are repetition and variation. As in nature, no two trees are quite alike. The sky and background were painted wet-into-wet, then the pines and foreground were painted while the paper was still wet. Appropriately sized brushes completed the trunks and branches, with great care being taken to shape them one by one.

171 The structure of trees

If the sky is a horizontal force in a scene, trees provide a vertical balance. Every tree has a characteristic silhouette, trunk texture, branching style, canopy shape and colour. When you put trees in your landscape (and most landscapes have them), you have a choice – to paint free and fuzzy generic trees or to paint trees specific to the location. You don't have to be a botanist, but you do need the patience to carefully observe and record the trees in your scene, whichever approach you choose. Otherwise, you may be lured by geometry – triangles for fir trees and lollipops for deciduous trees. When simplifying trees, add character through your colour choices and brushstrokes.

170 Tips for realistic trees

The tree should be embedded in the ground rather than stuck on top of it. Create this effect by having the ground and grasses rise unevenly up and around the trunk. The canopy of the tree is rarely a single shape, so design clusters for the canopy, letting branches and sky show through. For a softer effect, paint wet-into-wet and drop in various colours, remembering to shade the undersides. For crisp edges, paint wet-into-dry with a single colour and drop in other colours. Add texture to the foliage with careful use of salt (see page 148).

TRY IT

Tree trunks

- Dip one corner of a 2.5 cm (1 in.) flat brush in a red-gold paint and the other tip in a darker, blue-brown pigment. Then stroke the trunk shape. This gives a clean, sculpted look with only one pass of the brush and gives the trunk a more rounded look, with darks on either side of a lighter space.
- Another technique is to have the flat brush wet and dip one corner in rich, dark pigment. Then stroke the trunk.
- For silver birch trees (see Robin Berry's *Merced II*, right) there are several interesting techniques you can employ. Stroke the trunk area with clear water. Then, with either a calligraphy pen nib, a palette knife or a rigger, pick up a little dark or red-brown colour and, going along the edge of the trunk, lay in small patches of colour. Even a scrap of mat board used on the edge, dipped in paint and laid onto the edge of the trunk would do nicely. The white is the white of the paper.

Weather

The weather comes from the sky to the land or water. For the painter, the trick is making the link between the two. Your sky affects the entire scene. Thinking of the sky as a cover and the land as a floor, the weather fills all the space in between, be it with sunshine or rain, mist or fog. Learning a few techniques to help you represent the weather will give you more control over the atmosphere of a painting.

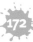

Creating realistic mist and rain

Pull a stiff bristle brush or a comb-like tool through a wet wash with a movement that would indicate rain. If the marks disappear right away, the wash is still a bit too wet. Wait a minute and try again. Once this texture is established, mist over it with a very fine spray.

▼ Depicting rain

In *La Tour Eiffel – I*, Robin Berry painted a rainy Paris night. Notice how the rain comes between the viewer and the background on the right but is less noticeable nearby.

Diagonal wash over sky.

Bristle brush pulled through sky area.

Lights masked but edges softened when masking removed.

Some detail is in focus and backlit.

Bristle brush pulled through background washes to push into background.

Spritzed water left to run.

Snow techniques

Spray liquid masking in a fine mist over the area where you want to show snow falling. Immediately wash the masking fluid from the sprayer, and let the masking dry completely. Apply paint with a wide wash brush. (Remove any masking that falls where you don't want it by rubbing it with your finger before you paint.) An alternative technique is to make a very smooth mixture of the snow colour you want and spray it on with an atomiser or from a spray bottle that sends out a fine mist. Mist it from a distance with clear water. Practise either technique on scraps of paper before trying it on your painting.

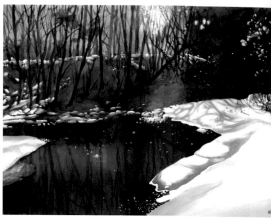

▲ There is colour in snow

Snow is never just white. Its colour is always affected by the time of day, the sky and what is nearby. In *Winter Creek*, Robin Berry includes all the colours of the painting in the snow shadows.

TRY IT
Catching spray

Spray paint up in the air over your painting and catch the falling drops on the paper. What kind of weather effect do you get?

Observing surface effects

When forces such as wind, rain, currents or objects act upon it, the surface of water changes. A reflection may be broken up by shapes showing the sky or may not be present at all if the waves are too large, in which case the colours visible would be sky and water in an undulating motion. Hone your powers of observation and note the characteristic shapes, colours and textures of a body of water in all its incarnations.

▼ **Observing white caps**
Rough Sea – West Wittering by Bridget Woods shows what happens when the water's calm surface is broken up by wind action.

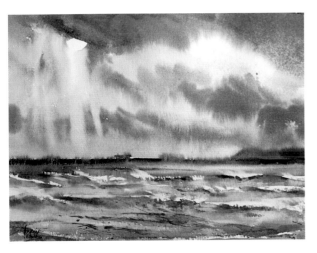

Brilliant light

The brighter the light, the stronger the contrast. Backlit objects appear nearly black when there is strong light behind them. If the sun is behind an object, it will take a bite out of an edge. This effect can be accomplished when the painting is dry by gently rubbing the bite out of the edge of an object with a toothbrush dipped in plenty of water. Dab with tissue and repeat if necessary.

The bright sun behind the tree literally takes a bite out of the tree trunk.

▼ **Taking the bite**
Bridget Woods's painting, *Low Autumn Sun,* is an excellent example of leaving stark whites in an area of soft edges at the brightest spot.

Depicting fog

Wet the paper, let it dry until it loses its sheen and then paint with diluted, muted colour into the dampness. This will take practice, but the results should produce greyed, soft-edged images that seem to fade into the paper. As an object in the painting gets closer to the foreground, it will be a bit darker. Paint from the background to the foreground. The closest objects may even show some colour.

◀ **Softening the edges**
Fog envelopes the boat in *Foggy Morning* by Naomi Tydeman. Wet-in-wet techniques are used to blur the vessel's edges and merge the horizon line with the surface of the lake.

Water

Water is transparent, colourless and mirrorlike. It can really only be seen in the context of what is above, around or below it, or what it is reflecting. It usually gets its 'colour' from the sky, reflections from nearby objects, and the river- or seabed if it is shallow enough.

HOW TO PAINT A STANDING WAVE

- Notice that, at the base of the wave, on the horizontal plane parallel to the sky, you see sky colour.
- After painting, dab the edges of this base with tissue to keep them soft.
- Before the paint dries, pick up a dark colour such as a green mixed with Ultramarine Blue and a touch of Alizarin Crimson and paint up from the base about one-third of the way.
- With a lighter mixture, but not watered down, paint up the next third, tilting your paper away from you to avoid backwash into the previously painted area.
- With a light colour, paint the top of the wave, again tilting the paper away, leaving a varied line of white at the top.
- You can mask the white foam or paint around it, but be sure to save white.
- Notice that the foam has shadows and drop them randomly into a wet area for a natural look.
- When painting a breaking wave, move your brush in keeping with the movement of the wave.

Understanding waves

If you are a lover and observer of waves, you will know that in all of history, there have never been two identical waves. The attraction of a seascape is the attraction to that which is vast and mysterious. Let this idea give you confidence as you begin to observe, draw and paint waves. They are completely free and organic. However, whether you choose to paint waves close-up or breaking on a stretch of beach, there are a few accepted observations that will help you capture their essence.

▲ **Wave rhythm**
Surfscape, by Robin Berry, was the result of several hours of sketching to capture the rhythm of the waves rolling into shore and the gleam of the sun on the curved surface.

FIX IT
The colours of waves

There are four colour sources to consider:

1. Sky colour, which in turn is influenced by the position of the sun and the weather.
2. Water colour, which can range from ochre in a mountain stream to turquoise in Hawaii.
3. Bottom colour – sand, iron ore or coral, for example.
4. Shadowed white of the foam and white caps as well as the bright white of the highlights.

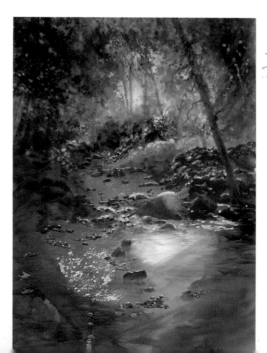

178

Showing running water

Running water will take on all the colours that surround it as well as the colour of the bed of the stream. The motion also blurs the detail. Brushstrokes run in the direction of the flow of the stream.

◄ **Adding colour for effect**
In the painting *Hidden Creek* by Robin Berry, imagination was allowed to expand the colour scheme. Orange was added to the sun spot and red into the background to draw the eye along the stream. The painting was poured with all highlights masked in advance.

179

Painting reflections

Only calm water or calm patches of water reflect. Then water acts as a mirror, giving you almost complete information about the day (foggy, misty, sunny, cloudy) and the surroundings (sky, trees, buildings, boats, rocks and so on). Reflections are painted straight down from the object being reflected, not to either side – the position of the sun does not affect the angle of reflection as it does shadows. The reflection will also be the same proportions as the object.

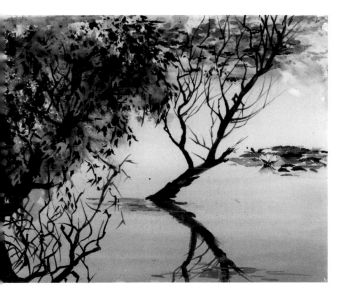

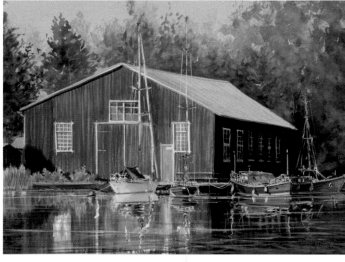

◀ **Simple reflections**
Diamond Lake Reflection by Robin Berry is a simple sketch of a reflection in calm water. Notice how all visible reflected elements are directly below their real-life counterparts.

▲ **Late-night light**
14th March 2008 by Terry Jarvis shows a mirror image of an old Finnish harbour building in calm water. Only a few streaks disrupt the reflected image. The light is key in this painting, painted at 11:30 P.M. in the 'land of the midnight sun'.

180

Showing falling water

Falling water is motion taken to the extreme. Observe the edges of a waterfall; where are they hard and where are they soft or misty? The thing that makes them hard or soft is the nature of the motion of the water or the presence of mist. Resist the temptation to include detail in the water, or it will look static. Do, however, include shadows over the falls, even if you have to make them up.

Shadowed water is dark.

Shadows on the foam show movement.

Falling water appears blurred.

Hard edges are used where there is dark rock.

Water is translucent and colour from rocks shows through.

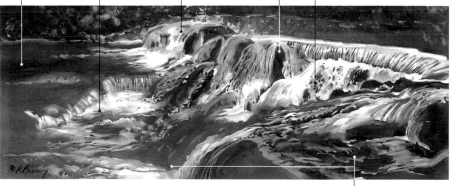

The water varies in colour.

▲ **Observing white caps**
Fall Falls (detail) by Robin Berry is an example of how to paint falling water. If you paint too many hard lines, the action of the scene will stop and the water will not fall. Let your edges be a mixture of hard, soft and lost (see page 164). You will also see a few areas of reflected colour and a few where the colour of the rocks peeks through. If it's sunny, there will be shadows in and on the waterfalls.

Flowers

Flowers are an excellent subject for painting in watercolour. They are filled with colour, and, in their natural setting, they are also filled with light. They exist everywhere in great variety. Flowers can be painted in portrait mode, up close and showing a great deal of detail, as bouquets in vases, as part of a still life or outdoors in the garden with other flowers. However you choose to paint them, flowers will give you the excuse to fill your palette with many pure, bright colours.

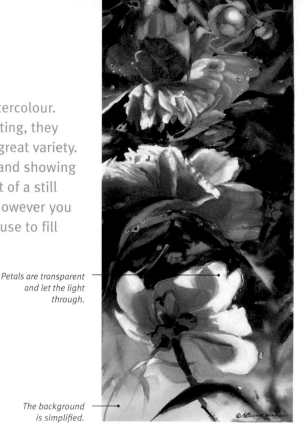

Petals are transparent and let the light through.

The background is simplified.

Making a flower portrait

A flower portrait should show the flower off at its most glorious. Approach it in the same way you would a human or animal portrait – aim to capture the personality or essence of the flower. The paintings on this page will help you do this.

▲ **Unusual treatment**

Mary's Peonies II, by Robin Berry, is a portrait of a different kind, combining several views of peonies in an almost botanical study, as if one were turning a single flower, the movement caught in stop-action shots. It is not always necessary that your flower portraits be a standard rectangle. In this case, the tall, narrow format worked better.

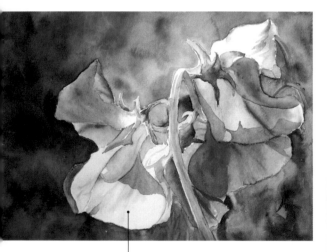

Shadows will range in colour from the colour of the petal or leaf to deep violet, gold or green.

▲ **Capturing light and lightness**

In *Pretty Peas* by Ruth S. Harris, the character of the flower was essential to the success of the painting. This delicate sweet-pea flower was painted wet-into-wet until it was time to define its shape. The technique of glazing was used to retain the feeling of light and lightness in the petals.

Remember, shadows make the light pop.

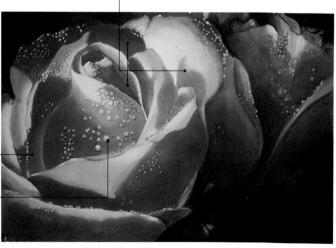

The flowers fill the frame.

Water drops give the light an excuse to dance.

▲ **Plan ahead for selective masking**

In watercolour certain effects would be nearly impossible to create without the use of liquid masking fluid. In *Venetian Rose*, by Robin Berry, the water drops, coupled with smooth, velvety washes, are a good example of this. Think about the most interesting point of view when planning your painting.

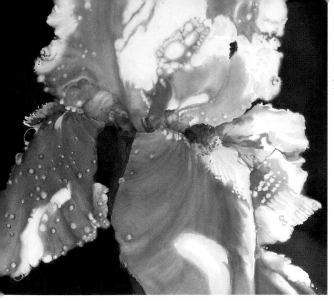

▲ Light over colour

Robin Berry's painting, *Razzle Dazzle* (detail), is about light and the magical, glittering effect it has on the petals of a wet iris. Local colour has been ignored in favour of light. Notice that the drops of water vary in colour and nature. They will take on the colour that is near, behind or under them.

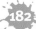

Painting water drops

Water drops on petals are great fun to paint and easy, too. Follow these simple steps:

1 Mask all highlights and spots of white. Paint the flower freely, following your reference. When dry, remove masking.

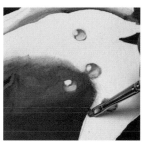

2 Soften all edges except one bright spot on the drop.

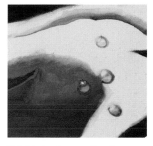

3 Add shadow on the drop on the side opposite the light.

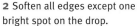

Working out composition

Bringing in fresh-cut flowers from the yard, arranging them in a vase and setting them in sunlight is a ritual of spring and summer for most flower lovers – and offers the perfect subject. One way to begin is to photograph your arrangement from many angles and in different settings. The biggest challenges in painting a floral bouquet are placement of the vase of flowers in the picture plane (see page 70), what to do about the background and how to break up the negative space around the bouquet. Thumbnail sketches are a great way to test out different options.

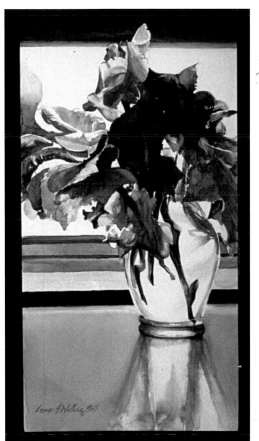

◄ Capturing light and lightness

Backlit Floral by Lenox Wallace boldly sets a strongly coloured floral bouquet in an otherwise all-light setting. Composition becomes critical in making the strongly contrasting values work.

TRY IT
Painting in the garden

Think of your garden as a landscape with flowers. There may be no greater joy than setting up your paints outside in your garden and simply painting what you have spent all spring cultivating. By using techniques such as spattering paint (see page 150), lots of flowers can be added to grassy areas.

Urban areas

In cityscapes the viewer is usually located within an urban canyon, a complex combination of shapes and objects, light bouncing off several surfaces, people and vehicles. These scenes offer the watercolourist opportunity for unlimited excitement and interpretation.

Capturing cityscapes: Perspective

Cityscapes, also known as urban landscapes, can be great fun. Lack of knowledge of linear perspective need not stop you. Many artists enjoy distorting the perspective of a scene, giving the painting a loose or funky look. However, understanding perspective is one of the skills to add to your toolbox. You can project the reference material onto your paper using a slide or opaque projector. Whichever method you choose, don't be daunted. Cityscapes are full of fun!

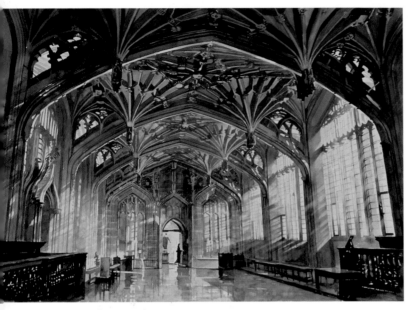

▲ **Beyond perspective**
Intérieur, Divinity School, Oxford, Angleterre, by Paul Dmoch, is a beautiful example of one-point perspective – a single vanishing point, in this case, through the door at the back. Although there is much more to see in this painting than perspective, a small ruler will show you the basics of this lesson.

Eye level

Vanishing point

▲ **One-point perspective**
All lines converge at a single point, like looking into a tunnel. There is a single vanishing point and all lines meet there, creating the illusion of three dimensions on a two-dimensional paper. Where that vanishing point is always depends on your eye level.

Vanishing point — Eye level — Vanishing point

▲ **Two-point perspective**
In two-point perspective there are two vanishing points. Where the vanishing point lies depends upon your eye level. Once that is determined, find the angles from the roof line and foundation line going off in two different directions and extend them to meet at the eye level line.

▶ **Three-point perspective**
Taking it further, three-point perspective can be similarly calculated. This dramatic angle will give a low eye level and the horizontal converging lines will be projected above it. With such an upward composition the verticals can also be calculated to a vanishing point in the sky.

Vanishing point — Eye level

185

Painting iconic landmarks

The well-known landmarks of every big city have been painted countless times; and they are still wonderful subjects. To express your own feelings about them is an easy way to avoid cliché. The most expressive way to paint a well-known subject is to draw it accurately first and then put aside all reference material and begin to paint. This way you have the best chance of capturing its essence.

▲ **Appreciating detail and the whole**
In Paul Dmoch's painting, *Rosace, Sagrada Familia, Barcelona, Espagne*, one is given a view both of a remarkable architectural detail – the window – and through that window as well. To look closely at such a detail is to appreciate the aesthetics of the whole. Careful rendering and thoughtful interpretation are called for.

186

Adding architectural details

Doors, fountains, staircases or signs are a few of the many details that enliven an urban landscape. These may be incidental or the centre of interest. The viewer's eye will be drawn to the element that is clearest and brightest, so make sure that you do not include too many details. The painting may feel scattered as a result. Remember to paint the shadows in the scene – add them if they are not there as they bring the light to life.

▶ **The essence of place**
In *Mykonos Red*, Robin Berry chose a single architectural detail, one of the most characteristic features of this small island.

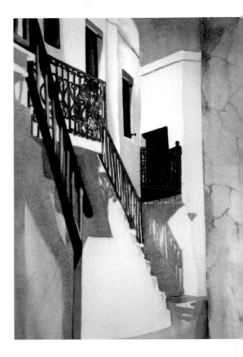

187

Adding figures

Adding figures to your urban landscape not only has the effect of injecting human interest but will also give scale to everything else. A loose treatment of the figures, even clumping groups of people into a single value showing only heads and legs, will put them into your scene without drawing too much attention to them. Learning to clump and abstract people in a casual setting will serve you well. Detailed rendering of people in a scene where they are incidental is a distraction and pulls focus from your centre of interest. If you want them to stand out, add a little colour to the clothing, show more movement or position them prominently in the scene.

▼ **Adding figures**
Detour, by Paul Jackson, is a great example of how figures give a painting scale and focus. The figures on the right are shown in just enough detail to show their movement through the position of the legs. Other figures are added in scale to their position in the painting. The pelican in the foreground not only adds a touch of humour to an otherwise traditional New York scene, but invites the viewer into the painting.

Vanishing point

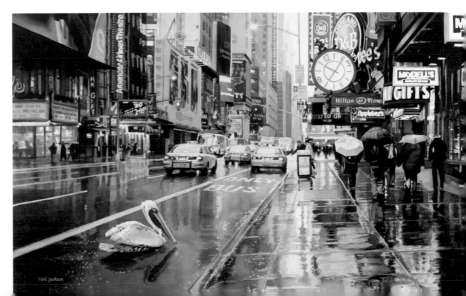

The human figure

There is no subject we intuitively know better than the human figure. One would think this would make figure drawing and painting easier, but it seems to make figures as a subject more intimidating.

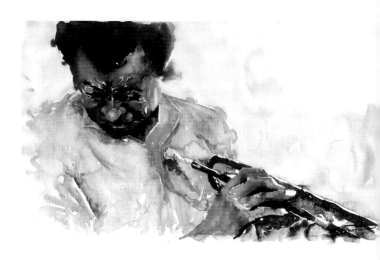

Making the figure the subject

To make a figure the main subject of your painting obligates you to only one thing: that your subject be recognisable as such. Otherwise, the construction of the painting is up to you. Eliminating the background, other than simple, expressionistic washes, makes it easier to push the figure into the foreground. You don't have to deal with anything but the light and shadows that fall on the figure – the character, expression and mood of the person. Discard distracting details.

▼ **Signifying the subject**
In Denny Bond's painting, *Isolated*, the woman is clearly meant to be the subject of the painting because the artist has carefully and sensitively painted her face in great detail. Had the subject been the dotted cloth, it would have been necessary to subdue the facial features or not show the face at all.

▲ **Capturing a moment**
In *Miles Davis 7*, Yuriy Shevchuk has posed his figure in a moment of stillness, yet the viewer knows something is about to happen. Note the lack of background. The important thing is the face of the musician, placed in the Golden Mean hotspot and underscored by the deeper yellow next to it.

TRY IT
Thumbnailing the figure

The posed figure requires a level of drawing skill. Sketching to get the proportions and details correct is important. To turn your sketches into a painting, it is also worthwhile to paint different thumbnail versions of the same figure.

Drawing the viewer in

Putting figures into paintings guarantees they will be looked at. As humans, we are drawn to other humans – figures and faces, moods and activities. Taking a close-up look at a figure offers the artist an opportunity to explore character and personality. Give your figure something to do, even if it is simple. Have something to say. Perhaps your interest is in recording a moment in the life of your subject. Your job is still to entertain and engage the viewer in what is happening in the painting.

Two faces form a strong centre of interest.

Lack of background allows the figure to be the only important element.

The only bright colour draws the eye to the primary face.

Textural interest gives the viewer an idea of the era of the clothing.

Splashes of colour add warmth and appeal.

The woman is engaged with the cat. The cat is engaged with the viewer. This adds a bit of mystery.

▲ Holding the viewer's attention
Robin Berry's portrait of Lori Maxwell uses colour to draw the viewer into the moment of this painting, but it is the smiling face that holds the attention. In portraits, much of the message is in the attitude of the subject – solitary or open, intimate or distant. While the message may differ, the techniques used are often the same.

▲ Engaging the viewer
Robin Berry's painting *Doris and Buzzer* uses several techniques to draw the viewer in.

Value and colour are messengers

Where you place your figure in a painting and how you design the values and colour in relationship to the figure is how you get your message to the viewer. If your intention is a moment of joy or celebration, give the figure light and colour and make everything else serve only that. Perhaps it is a sombre moment. Then the colours would be subdued and the values leaning to the middle range.

▶ Placement is important
In a painting that features a figure as the centre of interest, it is possible to characterise the figure in any number of ways. In David Poxon's painting, *Roman Bath*, the implied theme is solitude and introspection. The figure is placed behind the middle ground and isolated in shadow. It is clear the viewer is meant to look quietly at her as the focus, because she is centered between the lightest lights and darkest darks.

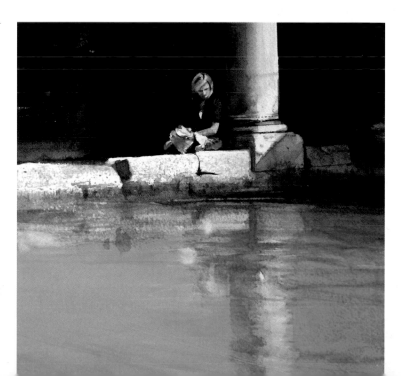

Palette

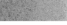
Viridian Green

Cobalt Turquoise

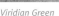
Lamp Black

Raw Sienna

Ultramarine Blue

Venetian Brown

Gamboge Yellow

Raw Umber

Cadmium Yellow

Cadmium Red

Permanent Red

Phthalo Blue

Materials

Arches Bright White Coldpress
300 gsm (140 lb.) paper

Pencil

4 cm (1.5 in.) flat brush

Hair dryer

Masking fluid

Nib pen

Round white sable brushes: no. 0,
no. 2, no. 3/0, no. 4, no. 6, no. 8

Tissue

X-Acto knife

ARTIST AT WORK

Capture the moment in a portrait

This subject was seated in a restaurant with excellent lighting and visual balance. The artist, Denny Bond, thought the painting had been destroyed by applying the dark shadows to the face, but when all the other elements were darkened, the contrast worked. Viewing one element removed from its compatible surrounding elements may alter its visual appeal.

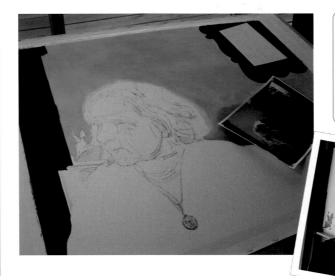

Techniques used

Masking (see pages 96–99)

Wet-into-wet (see page 59)

Glazing (see page 158)

An intriguing composition for a portrait, offering a head and shoulders and a reflection in the mirror.

▲ **1** Having the initial sketch in place, an overall solid wash is needed for the background. Propping the board at an angle, and using the flat brush, the first wash of Viridian Green with a hint of Cobalt Turquoise is quickly applied wet-into-wet, top to bottom. It is dried using a hair dryer, but without pushing the paint. Dark background areas of Black mixed with Ultramarine Blue and Venetian Brown are also blocked in. To enhance the reflective quality of the woodwork, Gamboge Yellow is applied along the edges of the woodwork. Several layers for each of the colours were necessary to reach the desired hue.

The highlights are mastered using the nib pen. Masking fluid in the face and hair maintains white light hitting the area, which can be softened later.

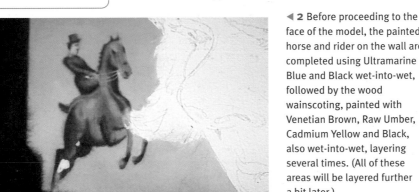

◀ **2** Before proceeding to the face of the model, the painted horse and rider on the wall are completed using Ultramarine Blue and Black wet-into-wet, followed by the wood wainscoting, painted with Venetian Brown, Raw Umber, Cadmium Yellow and Black, also wet-into-wet, layering several times. (All of these areas will be layered further a bit later.)

191

Work quickly

When using liquid watercolour for glazing layers into an area of the painting, execute the passage quickly and avoid puddles of colour, which will form blooms. Use masking to cover areas to be kept light so as not to slow down your glaze application.

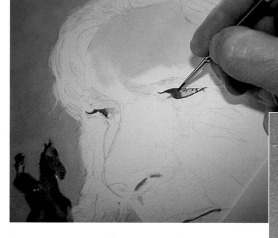

▲ **3** Faces are fascinating subjects. With some facial colour added to the forehead using Venetian Brown, Cadmium Yellow, and Permanent Red wet-into-wet, the immediate attention goes to the eyes. Completing the eyes gives a sense of the success of the portrait. Using Black and Ultramarine Blue, the darks of the eyes are painted first wet-into-dry using a no. o brush, then darkened by layering, wet on slightly wet and avoiding harsh edges. The nostrils and the shadows of the lips are also applied.

The skin tones having been laid in with Cadmium Red and Gamboge Yellow, next to the area around the right eye is painted wet-into-wet using Gamboge Yellow with a little Black for shadowing the eye.

Applying a dark shadow usually adds good contrast to a painting.

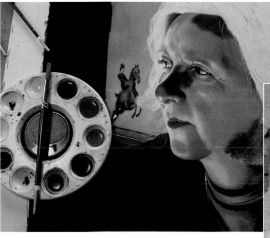

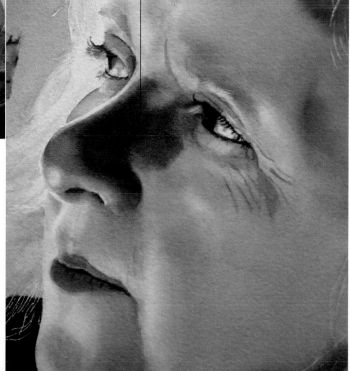

▲ **4** With the right eye complete, the artist continues across the face, glazing six delicate layers of flesh tones. To maintain the soft highlights, areas are dabbed with a tissue. When the face is complete, a deep shadow mix of Ultramarine Blue, Cadmium Red and touches of Venetian Brown is applied to the side of the nose and other selected places on the face. The jacket and blouse are painted with Black and Ultramarine Blue, wet-into-wet. Finally, the masking is removed from the saved highlights on the face and softened to blend into the whole.

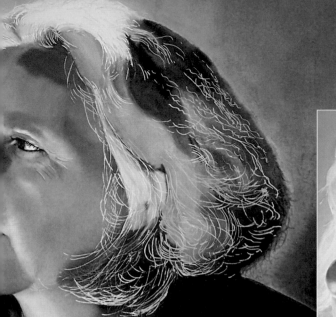

▲ **5** Using Gamboge Yellow, Black, and Raw Sienna, the hair colour is applied wet-on-wet. After drying with a hair dryer, the masking is removed and painted in shades of yellow, while some masking remains in the bright whites of the highlighted hair on the top of the head.

Edges around the mirror frame are softened by wetting the paper slightly and applying Black and Ultramarine Blue directly to the edge of the frame using a no. 4 brush with very little paint. Too much paint would bleed into the area too much.

▲ ▶ **6** Without completing the facial features and hair, the framed mirror on the wall capturing the buildings across the street takes the artist away from the portrait and into a landscape, allowing for a break before proceeding with the finer detail of the face. Using wet-on-dry for the initial layer, and wet-into-wet for subsequent layers, the smaller landscape is painted using Ultramarine Blue, Black and Phthalo Blue, with brushes ranging from a no. 8 to a no. 3/0.

▼ **7** Returning to the face and hair, more flesh tones in light layers are applied. An overall layer of very weak Permanent Red is applied wet-into-wet to the entire face, avoiding the highlighted areas. Shadowed areas in the hair are darkened and highlights of the hair strengthened by using an X-Acto knife to scrape the surface. The necklace is detailed and the jacket darkened. At this stage, the artist softens all areas by applying the colour wet-into-wet with a no. 3/0 brush. The finished painting has a great narrative quality with bold, interesting contrast and a composition that keeps the viewer engaged.

Apply shadows carefully

Applying dark shadows to a light face may be intimidating. Test the transparency of your colours on scrap paper and, once the passage is painted, dry the painting, stand it up and walk away to determine the effectiveness of the shadow. Then finish the features, bringing all colour and values to their final strength. Again walk away. The final effect must be viewed as a whole.

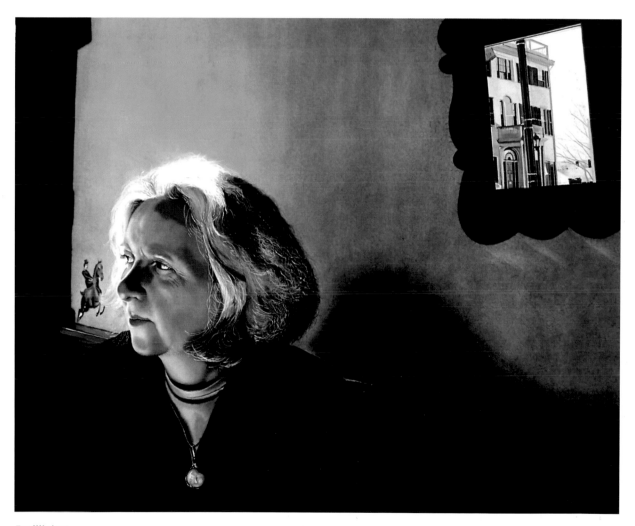

Equilibrium
86 x 70 cm (34 x 27 in.), on Arches cold-pressed
300 gsm (140 lb.) Bright White paper

Denny Bond

Birds

Birds make terrific subjects. They are mysterious and can do things we can't do, such as fly or perch in trees. It is exactly these attributes that also make birds hard for us to observe and paint. To paint birds, go where the birds are – the desert, the beach, the wildlife centre, your bird feeder. The more you can observe, the better. Watch videos and pause them to sketch. You will need more reference material than you'd need for people.

²d Reddish Egrets ©RBerry 3/15/02

▲ **Quick impressions**
Robin Berry's painting of reddish egrets canopy feeding was a result of a long day sketching the birds flit through the water. Detailed drawing is not possible in this setting. Quickly expressed impressions are often more accurate.

TRY IT

Bird-watching with a sketchbook

Sit in a place where there are many birds. Have a large enough sheet of paper to begin several sketches. You may need to stop a particular drawing and begin another if the bird you are observing moves. It helps to know a little about the species you are watching to make the movements understandable to you. For example, the reddish egrets in the sketch at the top of the page are canopy feeding – using the shade of their wings to attract fish.

193

Painting birds on the beach

The beach is a stage with backdrops of wind and waves, motion, colour and light – and above all, birds! The star in a scene can change from moment to moment. It may be a romantic osprey in an aerial courtship dance or a pair of yellow-footed snowy egrets darting in and out of the surf. Be prepared to seize your moment when a good subject arrives.

194

Look fast

A bird's world is immediate, with only moments to look for food between breaking waves, or before it scuttles into the desert sand or flies away. You will have to be equally swift in your attempts to capture it.

▲ **Apparent spontaneity**
Crow and Marley, by Sarah Rogers, skillfully expresses attraction towards this alert and social species. Although it appears to be a quick sketch, it should be noted that many sketches and daily observations over time have gone into perfecting the spontaneity of moment.

◄ **Economy**
Seven strokes make up *Willet*, by Robin Berry: they took 5 to 10 seconds. The key to such a sketch is practised observation, drawing over and over, until the eyes take in the whole and the moment is captured.

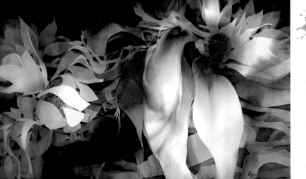

Exploring the spirit
Exotic Friends, by Ann Smith, is an exploration of the spirit of tropical birds following a trip to Hawaii. Using many layers she eventually carved out these dramatic birds and flowers using negative painting.

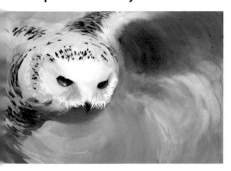

195

Tips for avian eyes

Often our first impression of a larger bird comes from the eyes. Painting eyes requires good reference material, as one can rarely see them clearly and quickly enough to capture in sketches or even photos. The colour of eyes is complex – not just the colourful iris, but the sculpting of the orb into its feathered location. There will be shadows on the eye and around it, as well as highlights and reflections. If you forget to leave the light in the eye, you can pick it out later with a sharp edge.

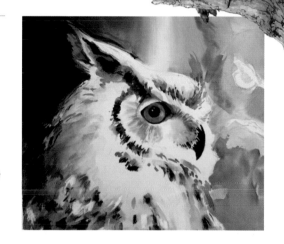

▲ **Potential action**
In *Oz Dreaming*, by Robin Berry, the golden eye is at the centre of interest, and its detail shows the intensity of focus in the bird.

▶ **Eye direction**
Laura Grogan's painting, *Suspicion and Disquise*, makes the eye direction clear using only a single dot of light exactly where the eye of the left bird is looking.

TRY IT

Ten-second sketch

In painting birds, a critical skill is the ten-second sketch. You are forced by the speedy intensity to focus clearly. If you are in a position to watch a bird for a time, just sit and observe it. This will later enable you to capture its gestures in a moment. Let your eyes see the shape change as the bird moves. Let its energy run from your eyes to your shoulder, down your arm, into your hand and out of the pencil or brush onto the paper.

196

Depicting feathers

Even in a bird that is completely still, as is Samantha in this unfinished painting, *Great Horned Owls*, by Robin Berry (right), the feathers will continue to move, making it difficult to see too much detail. Keep the feathers soft, only indicating significant markings.

197

Showing wing motion

Flight is motion – and the motion of birds is most clearly seen in the wings. In some birds, such as a hummingbird, the movement of the wings is visible only as a slightly grey shadow in the air above the bird's body. In larger birds that move more slowly through the air, some wing detail will be discernible. Paint the wings in minimal detail, adding only significant markings. Painting onto damp paper, move your brush in the same motion as the wings, going back and adding selected detail as the paint dries. Just above and below the wings, with water or a very light wash, paint the shadow of the previous motion.

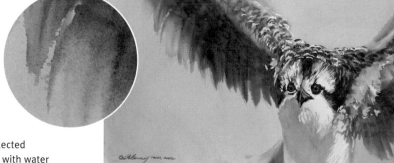

▲ **Pre-wetting to show motion**
Robin Berry's painting, *Captiva Osprey*, shows the wings of the bird in motion. There is minimal detail in the primary wing feathers. The inset illustrates the effect of fading the feathers into an area pre-wet for this purpose.

Animals

Painting animals, especially in the wild, has great potential for drama. When you can't get out into the wild, remember that your cat still retains a wild side, and your dog was once (many generations ago) a wolf. As warm and affable as our pets are, one can still see a bit of wild drama in their eyes, coats and movements.

▲ **Point of view**
In *At Rest*, Denny Bond chose to pose the sheep in profile, which in this case gives the animal a regal appearance. Point of view establishes what the artist wants the viewer to feel about the subject, in this case, admiration.

 198

Avoid black pigment

Black animals are difficult to paint. Rendering the coat literally will result in a dull painting with no place to go for shadow, so avoid the use of black pigment. Instead, think about how you can use other darks (and lights) to represent the fur, showing all the highlights and shadows.

TRY IT
Adding colour

Adding red, blue or violet into black fur will often make it more lively.

 199

Creating pet portraits

Pet portraits are both fun and challenging to paint – challenging because you usually know the animal well and will know if you don't get it right. But pets are also readily available to sit for portraits. The eyes, all-important, require your pet to stay awake long enough for you to observe its eyes (or require good reference material). If possible, in good light or from a clear photo, study the eyes in detail and make several drawings so you understand what you are seeing. You don't need to paint every hair of fur or hide – nor any, if you so choose. Painting the coat in soft strokes (as you would feathers, see page 133) will keep it from being a distraction. What is important is that you capture the essence or the attitude of the animal you're painting.

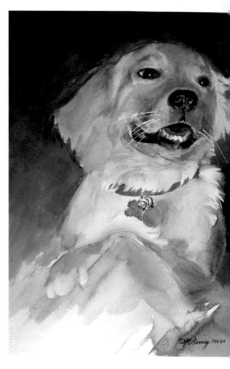

▲ **Colour to enliven**
Gracie, by Robin Berry, depicting a tan-coated dog, has reds and blues added to the coat both to liven up the shadows and to reflect the colour behind her head on the left.

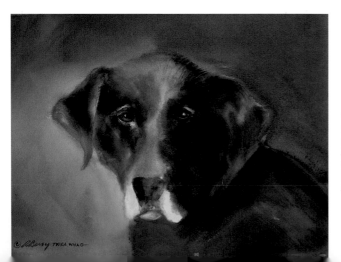

◄ **Believable colour**
In *Gus*, by Robin Berry, the black coat of the dog is painted using a mixture of reds, blues and greens, letting actual colour show through the mixtures in various places. Two elements are critical to making this portrait believable and personal: the eyes, warm and focused, and the white muzzle, indicating age.

How to approach eyes

In animals, as in people, the eyes are critical to making the subject seem real. It's not just that eyes carry that spark of life we all recognise, but that the nature of the gaze, the hue of the highlighted and shaded eye and the placement on the face and in the socket are all highly individual. Spend time sketching eyes. Divide the surface of the face into planes, first large and then ever smaller, until the roundness of the eyeball itself is seen. Study how the shadows embed the eye into the head. Look closely at the colour of the iris and how its inner border at the pupil has soft edges, and at how the iris itself is flecked with colour.

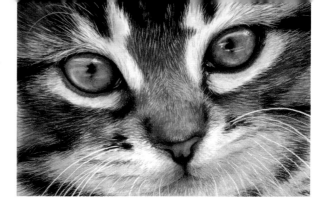

▲ **The complexity of eyes**
Tracy Hall's painting, *Kitten,* shows just how important eyes are. Notice the complex detail of the colour, shadow and highlights.

FIX IT
Recovering light

If you lose the light in the eyes, there are several ways to recover it.
- With a small brush, wet a tiny dot and dab it with tissue.
- With a small, wet scrubber, lightly remove a tiny dot.
- With the sharp point of a mat knife, gently pick the surface of the paper back to white.
- Add a dot of Chinese White or white gouache.

Use your imagination

Have fun with pet paintings. Often, putting the animal in an unusual setting brings out its personality. To do this successfully does require first-hand knowledge of the animal and a familiarity with its ways.

▶ **Reality enhanced**
Robin Berry's painting of *Sharkey* is half fantasy, half portrait. The black-and-white dog was in fact on a black and white couch, but in a living room, not floating off to dreamland.

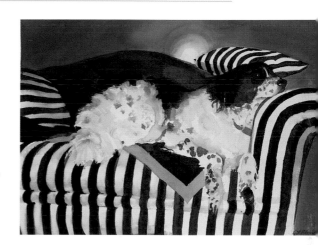

*Lost edges
(few hard edges)*

*Relaxed and
unseen (therefore
unthreatening) eyes*

Fresh paint

Spontaneous brushstrokes

Painting wildlife

If you want to paint wildlife, many new factors enter in. Purists not only demand accuracy but also want to see the animal in its native environment – although portraits are often set against a neutral background. Good reference material is an absolute necessity. Many factors surrounding an animal in the wild will come into play, including painting the landscape.
- Study the eyes first. They will give you a feeling for what the animal is experiencing. Is it alert, fearful, sleepy or playful?
- Decide what distinguishes this species from all others and do practice sketches.
- Finally, work on integrating the animal into its native habitat.

◀ **Relaxed pose**
The tiger in Stephie Butler's *Contentment* is painted loosely, with spontaneous brushstrokes that add to the animal's relaxed state.

Palette

Yellow Ochre

Burnt Sienna

Winsor Green

Alizarin Crimson

Cadmium Red

Cobalt Blue

Aureolin Yellow

Winsor Yellow Deep

Cerulean Blue

Cadmium Orange

Mineral Violet

Neutral Tint

Materials

Arches 300 gsm (140 lb.) cold-pressed paper stretched onto Gatorboard

HB pencil

5 cm (2 in.) squirrel wash brush

No. 4 squirrel mop brush

Water spray

Tissue

No. 3 sable detail brush

X-Acto knife

Techniques used

Underpainting (see page 59)

Wet-into-wet (see page 59)

Wet-into-dry (see page 59)

Spritzing (see page 148)

Scraping away (see page 153)

ARTIST AT WORK

Save the light without masking

The strongest elements in this photograph are the backlighting and the deep shadow. Next, the wonderful composition of the triangle set comfortably into a rectangular base asserts a feeling of comfort and safety. Retaining the thin edge of light around the cats without masking was the biggest challenge. For Robin Berry, the goal was to paint a spontaneous and fresh watercolour of this tranquil scene.

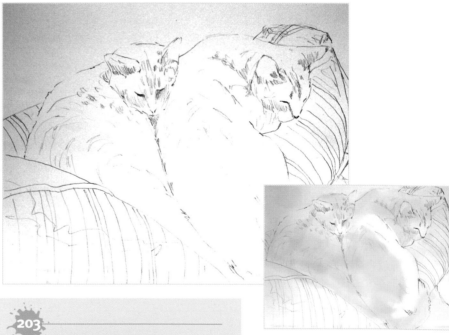

203

Get your darks in early

Watercolour is traditionally painted light to dark. However, if you do a value study before you start, you will know where you want your darks, what the focus is to be and what whites must be preserved. Knowing this, try putting in your darks early so that the values between white and dark can be balanced during the painting process.

▲ **1** A detailed drawing is made of the photograph, making sure that the weight and direction of the cats is downward, sinking into the cushion. No masking is applied to the painting. The paper is wet with a 5 cm (2 in.) wash brush so that it is damp but doesn't have pooling water. The detail shows the thin wash of Yellow Ochre that is brushed in with random strokes and allowed to dry.

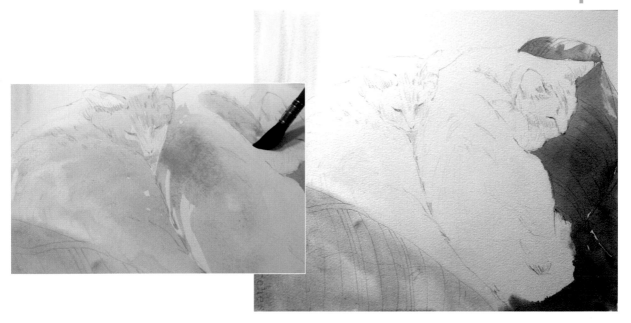

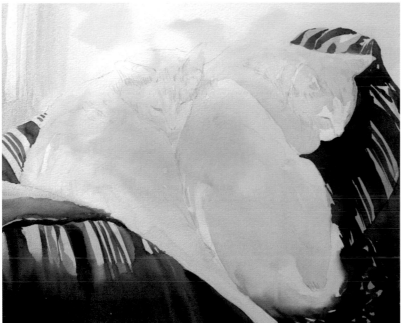

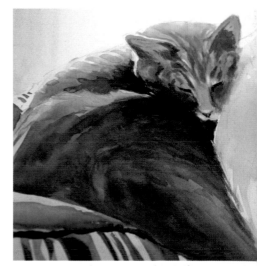

▲ **2** To establish the movement of colour throughout the painting, light washes of local colour are applied wet-onto-dry; the artist takes care to paint around all areas to be left white. The detail shows that the coats of the cats are washed in light Burnt Sienna to establish the glow of the light. By using a full-bodied no. 4 squirrel mop brush, a great deal of free and continuous painting is accomplished without stopping to refill the brush, giving the passages a spontaneous look.

▲ ▶ **3** Next, the darkest darks are put in. First a light local colour mixed of Winsor Green with a touch of Alizarin Crimson is washed into the pillows and allowed to dry. Next, with a cream-strength mixture, the stripes and shadows of a deep mixture of Winsor Green and Alizarin Crimson are applied in a single passage, keeping the weightiness and downward movement in mind the whole time. The detail shows the first paint put into the left-hand cat, including shadows and scruffy fur. The colour of the cat stands out in a startling way because it is set against its complement, green.

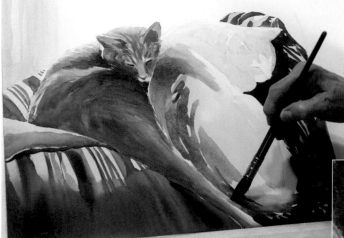

◄ ▼ 4 Still using the no. 4 mop brush filled with Burnt Sienna, with a little Cadmium Red added for the back area, the fur of the second cat is quickly laid in – again, avoiding all areas intended to be white or light. Before the fur dries, a little Cobalt Blue, mixed into the Burnt Sienna to make a deeper brown as shown in the detail, is quickly brushed in soft strokes and allowed to blend into softer edges on the back.

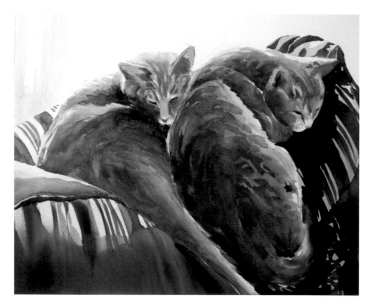

▲ ► 5 At this point, the cats and pillows are nearly finished, although the full painting isn't complete. The area behind the cats is still weak. As the detail shows, the side curtains, dark against the light, are painted wet-into-wet and lightly spritzed with water for texture. Next the painting is turned upside down, and the central light area between the curtains is spritzed. A medium yellow mixture is painted in and spritzed again, and excess paint is allowed to run off at the top of the painting. The area is dabbed with a tissue to make a centre of light that is white.

▶ **6** Before the painting is finished, one more pass around the composition is necessary to strengthen the darks and pop the lights. To do this, a bit of Neutral Tint is added to each of the colours used. More important, this strengthens the inside shade and contributes to the atmosphere of warmth and comfort. A few quick scratches with the knife to make the whiskers completes the painting.

Cat Nap
28 x 38 cm (11 x 15 in.), on Arches cold-pressed 300 gsm (140 lb.) paper stretched onto Gatorboard.

Robin Berry

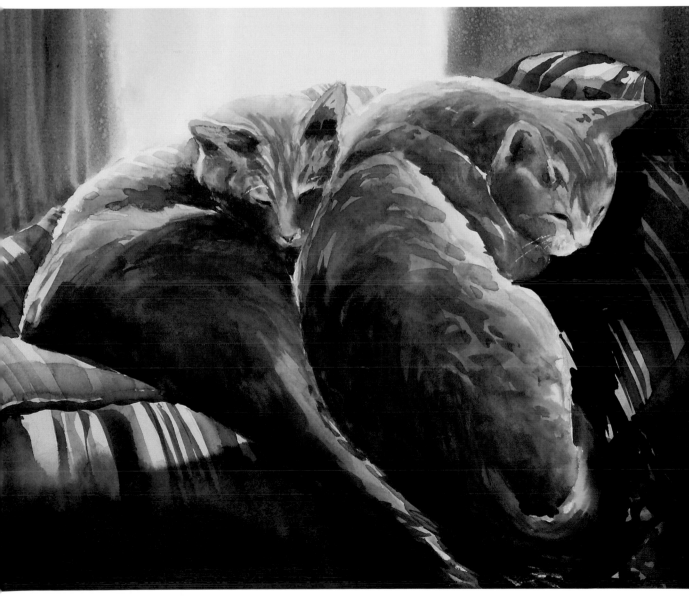

Capturing motion

Learning a few simple techniques will help you add motion to the subjects in your paintings, adding liveliness and interest to your painting as a whole.

204

Make your lines dynamic

Static lines stop motion. The use of diagonal and curved lines brings more life to your subject than a horizontal or vertical line would. In the sketchbook samples left and above, notice the dominance of diagonals and curves in the eagle sketches. These were part of the process of working out a larger painting.

Developing a sketchbook
The next steps in visualising motion for the eagles was a series of sketchbook ideas, which took the idea from one eagle to two and explored the motion of the second bird.

205

Use the motion tools

- Make your sketches loose and lively, whether with a pencil or a brush.
- Make the strokes of your brush or pencil mimic the motion you are depicting.
- Hard edges tend to look static, but soft and lost edges indicate motion.
- Value and colour appear to go to extremes in proportion to the speed of the subject.
- In addition to the strong diagonals and curves mentioned above, subjects should appear off balance, at least a little. The more off balance a subject is, the greater the motion indicated: one or more feet will be off the ground.

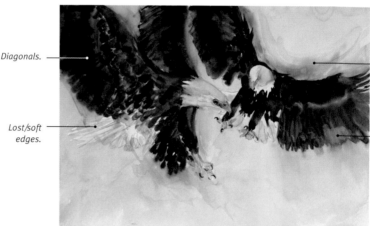

Diagonals.

Strokes in the direction of the movement

Lost/soft edges.

Paint loosely.

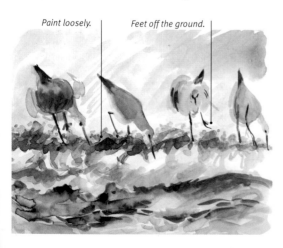

Paint loosely. Feet off the ground.

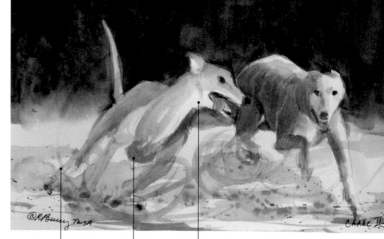

Lost edges. Extreme value/colour. Both dogs off balance.

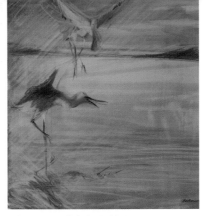

Afternoon Delight by Robin Berry.

206

Making bird flight real

The more distant the bird from the viewer, the less likely the feet will show. For example, in Robin Berry's *Afternoon Delight* (right), the spoonbills almost appear to float.

Simply having a bird's wings spread isn't enough. In *Pigeons,* by Doug Lew (below right), master motion painter, the faster the bird is moving, the more likely that the wings will be only a blur. Eventually they blend. Both speed and distance erase detail such as face and feathers and even borders.

FIX IT
Breathing life into a static sketch

Using a finished sketch that appears static, add motion to the sketch by softening edges in the moving parts, leaving only the focal point hard-edged. Eliminate some edges completely.

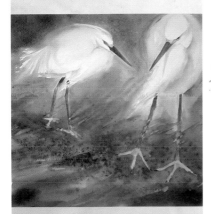

In this painting, *Lily and Friend*, when it appeared too stilted, the edges were softened with a scrubber brush, giving the feathers a more natural quality. Diagonal strokes were added in the grassy area, partially obscuring the legs. The features of the faces were left hard-edged.

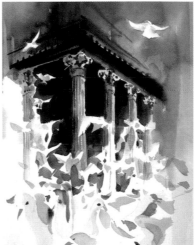

Pigeons by Doug Lew.

▲ **Extreme movement**
In *Cyclists,* Doug Lew shows the speed of the bikers by thrusting their bodies forward at a diagonal, pushing both colour and value to the extreme, and completely losing many edges.

207

Moving people

Although people usually move much more slowly than birds and animals, the rules are the same. An individual walking will have at least one foot off the ground; when running, he will be pitched at an angle; and when jumping, both feet will be off the ground. In *Runners* by Gerard Hendriks (see right), the edges of the figures are softened or lost.

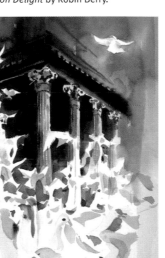

— Diagonal thrust.

— Lost edges.

— Extreme value.
— Extreme value.
— Extreme colour.

— Feet off the ground.

Feet off the ground. Invisible parts.

Palette

Cobalt Blue

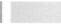
Cadmium Yellow

Yellow Ochre

Alizarin Crimson

Opera Rose

Prussian Blue

Cadmium Red Deep

Chinese White

Cerulean Blue

Materials

Moldmade watercolour board 600 gsm (240 lb.), rough

4B pencil

Liquid masking (grey)

Old pencil to apply masking

Wide varnish brush, approx. 3 x 5 cm (1 x 2 in.)

Spray bottle

Japanese mop brushes: no. 6, no. 8

Sea salt

Hair dryer

Chinese goathair brush

Toothbrush

Pipette

Tissue

ARTIST AT WORK

Applying paint to show movement

For Gerard Hendriks, painting birds in motion from reference photos often requires creative rearrangements of the birds to give the scene both excitement and cohesiveness. It is important to consider what it is you want to convey, or what story you want to tell. Once you know, the design should become apparent. Make many small sketches before you draw on the watercolour paper.

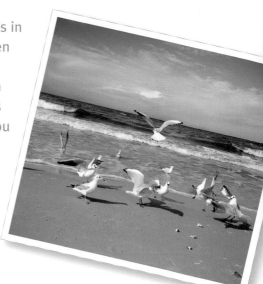

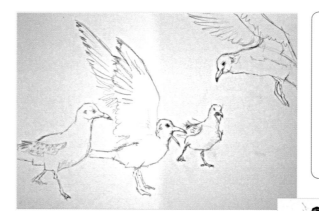

Techniques used

Masking (see pages 96–99)

Spattering (see page 150)

Wiping away (see page 170)

Dropping and spattering paint (see pages 150–151)

Salt (see page 148)

▲ **1** The composition of the reference photo is adapted to add more excitement and movement to the design of the painting – the birds are worried about something. To create this feeling, some gulls are removed and others are moved closer to each other. By placing the gull in flight off to the right, the viewer is drawn into the painting. Notice that where the light shines on the gulls, a thin line of liquid masking is applied in a few spots.

Try using an old pencil or pen lid to apply liquid masking fluid and also to drop splashes of masking into the background.

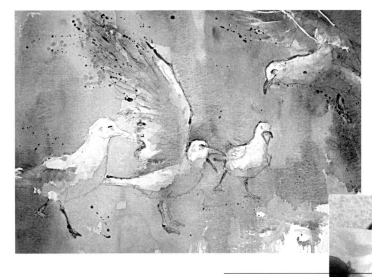

◀ **2** With the watercolour board tilted at a diagonal, and using a wide varnish brush loaded with water and pigment, stroke colour onto the paper using Cobalt Blue, Cadmium Yellow, Yellow Ochre, Alizarin Crimson and a small amount of Opera Rose. Allow the colours to mingle by tilting the paper in various directions. Spritz the paper with water to encourage the movement of paint.

Areas of the gulls intended to be white are dabbed with tissue if paint runs into them.

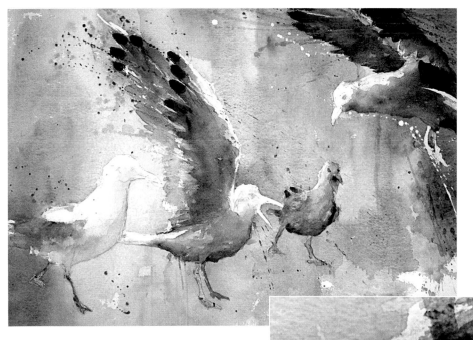

Use a large mop brush to put colour into the gulls – the size of the brush keeps the painting loose.

▲ **3** When the painting is thoroughly dry, the masking is removed from the birds and more colour and shadow are painted into their wings. More splashes of paint are added to the background and the area between the gulls.

The handle end of a brush is used to draw with the wet paint, much as a pen would be.

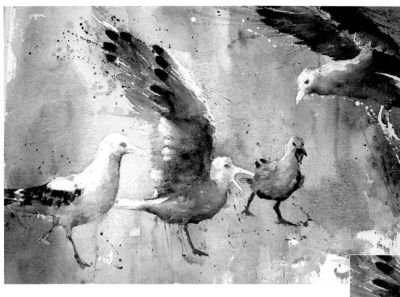

Sea salt is added to areas of wet paint on the undersides of the wings.

A hair dryer is used to dry the entire painting; it also makes the salt dry faster.

▲ **4** Dry the painting thoroughly. Add structure and colour to the birds by dropping and spattering various pigments in your palette. Use the handle end of the brush to draw with the small puddles of paint created by spattering.

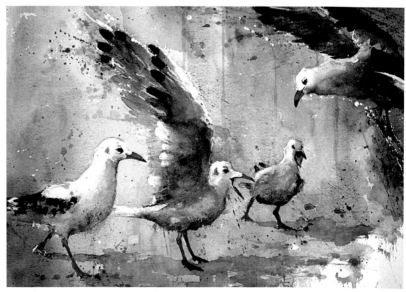

▶ **5** All remaining liquid masking is removed. The wings are finished by the addition of more colour – Prussian Blue and Opera Rose. The beaks and legs are painted with a smaller brush to give them harder lines so they command more focus. Shade is put into the sand to get more depth in the painting.

A toothbrush is used to spatter paint for added texture.

208

Study the artists you admire

Studying the work of other artists often provides information as well as inspiration. Journal it into your sketchbook as a reminder and think about how you can incorporate a particular skill or effect into your own work. The author has learned a great deal from Gerard Hendriks's bold use of splattered colour to enhance the excitement of a painting.

209

Be creative with backgrounds

Practise thinking about the feeling or sensation you'd like to create around your subject. In this step-by-step demonstration, rather than placing the ocean waves behind the gulls, which would be beautiful but predictable, Hendriks has, instead, created a colourful sun shower in colours that complement the blues and greys of the gulls.

▶ **6** Finally the painting is laid flat. Pipettes are filled with Cadmium Red Deep, Cerulean Blue and Cobalt Blue and used to add irregular details to the painting. Chinese White is used for unanticipated highlights on the wings of several birds.

Close-up of the pipettes being used.

Gulls
56 x 76 cm (22 x 30 in.), on mould-made 600 gsm (240 lb.) watercolour board.

Gerard Hendriks

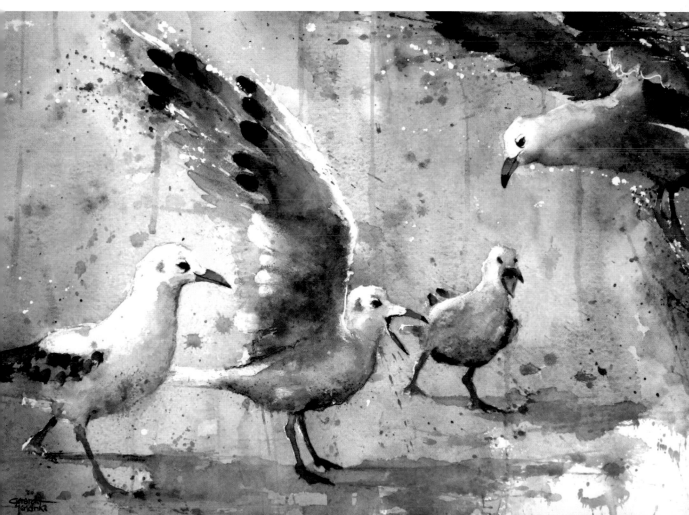

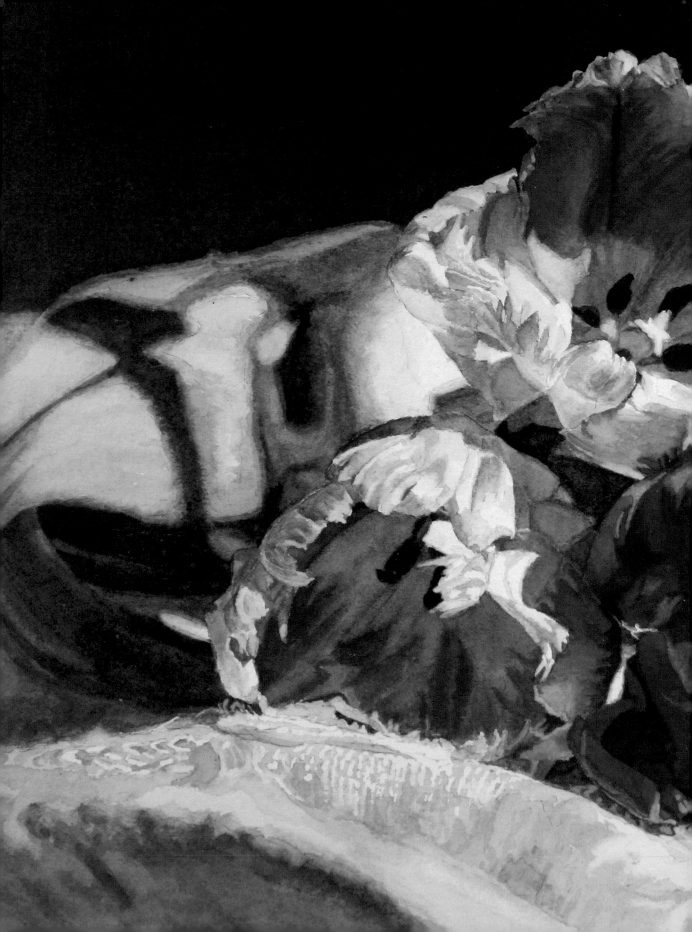

Techniques

Techniques are the tools you use to achieve particular effects. The better you learn to use them, the more depth and interest you can add to your work. Techniques can be thought of as the accumulation of knowledge of illusions and shortcuts gathered from artists across the centuries.

Practice makes perfect
Mastery of technique combined with good composition and careful colour choices will help you create wonderful paintings as fine as Keiko Yasuoka's *Tulips*, shown here.

Enlivening the paper surface

Watercolour artists paint on a two-dimensional paper surface yet have the challenge of producing lively, colourful and expressive images of three-dimensional objects. There are times when simple washes are enough. But often, the artist wants to increase the excitement and bring more life to the painting. Creating texture is one way of making this happen.

210

Using salt for depth and sparkle

The use of salt on a damp wash produces a snowflake effect. Both table salt and kosher salt can be used in this way. Table salt produces a smaller flake. This is one of the most common techniques in use today; use it judiciously to avoid a clichéd look. Once an area has salt in it, it will take longer to dry. Let it dry completely so crystals will form. Once dry, brush off any salt that remains.

Kosher salt wet

Kosher salt dry

Table salt wet

Table salt dry

211

Spraying effects

Spraying is a technique that, if used well, will produce results such as sun rays and silver streaks on a body of water. It is differentiated from spritzing (see below right) only in the strength of application. By trigger-spraying a stream of water onto a lake, for example, you can make a highlight trailing a bird or a boat. If a thin line has been masked first, then the lake wash applied, using this technique will produce a beautiful streak, light at the centre and fading outwards. When spraying into a wet wash, you risk creating a bloom (see page 171). This can be avoided by holding your board at a steep angle, almost vertical, and letting the water run and dry without spreading. Practise this before you try it on a painting.

212

Salt vs. spray

Before you spray water or paint, or apply salt, think first about the effect you want. Salt gives a harder, darker edge to the texture and light centre. Spraying water alone gives many soft, tiny blooms. If you want depth in the area, try spraying a light colour, getting it nearly dry before spraying a darker colour. Get that second layer nearly dry and spray a dark (shadow) colour last. As in *Line Dancing*, (opposite), the result will be rich foliage.

TRY IT
Experiment with effects

On a scrap of paper, paint a wash several inches wide. Do this with three primary colours. Let the sheen begin to disappear. Now try your spray bottles and see what effects you get: a stream, a spray and a spritz from various distances.

213

Spritzing for subtlety

Spritzing uses the same bottles as spraying, but with a gentler touch. It is a light mist of water from a pump or trigger-spray bottle. The distance from which you spray will determine how the end result looks on your paper. The greater the distance, the finer the resulting dots. With both spraying and spritzing, less is more. Overdoing will either oversaturate your paper or produce blooms (see page 171).

Types of spray bottles

There are several different types of spray bottles, and each has their particular characteristics and uses.

◀ Small plastic atomisers are available from art stores and are very inexpensive. They produce a fine mist. Atomisers can be used to spray both water and paint, although they produce an awkward blob and plug easily if masking fluid is used. Remember that some paint colours are toxic when sprayed.

◀ Pump sprays, available empty in art supply stores, are also found containing cleaning and beauty products. The nice thing about these is that they produce drops of water (spritzing) as well as a mist (spraying), depending on how hard the pump is pressed. They also produce the most varied spray and are the easiest to control.

◀ Trigger spray bottles, also available empty, are commonly used for many household products and can be reused. Clean them well first. The trigger spray is adjustable at the nozzle end, and you can achieve a fairly fine spray or a stream. The main problem with trigger spray bottles is that if the nozzle is set on stream and squeezed too hard, you can mar the surface of the paper, and this mark will show in subsequent washes.

Spray

Stream

◀ **Refined texture**
Of the three choices in spray bottles shown above, the most interesting effects are possible with a pump spray because it gives you the most control as well as a varied texture; you are less likely to get blobs of water. Here a close-up of the spray effect is shown; it is similar to salting, but softer.

Effects for natural-looking foliage

Using simple techniques makes painting natural-looking foliage easy. Below are two examples.

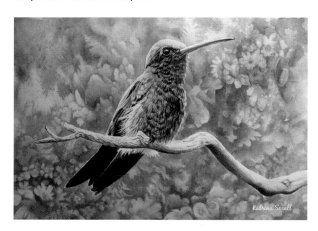

▲ **Negative painting**
In *Little Hummer* by Katrina Small, salt was used on the foliage. When the salted area was dry, she painted around the resulting interesting shapes to form the flowers. This is known as negative painting.

▼ **Combined techniques**
In *Line Dancing*, artist Suzanne Hetzel used the techniques of spritzing, spraying and dropping in colour to enliven the surface of the paper and make the tree foliage appear natural.

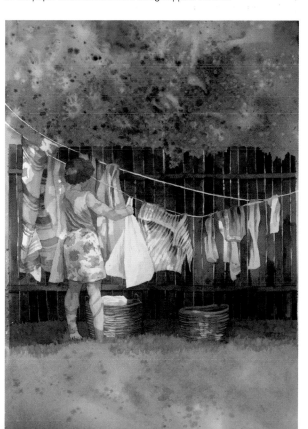

Spattering and throwing paint

Spattering or throwing paint onto the paper in a controlled way provides more ways to enliven the surface of your paper and add colour and texture at the same time. These two techniques put paint on the paper in somewhat random patterns and look quite natural.

Spattering basics

Spattering works most effectively over other washes, on beach sand, brickwork or grasses for example. Try dipping an old toothbrush into a saturated mixture of paint and, having covered all the areas that need protecting, pull your thumb or the end of a brush over the bristles, aiming the spatter at the desired area. This can be repeated with another colour. It can also be used to give depth to foliage in a tree or even to add interest to a plain area of the painting.

▲ Bold spatters of colour
Gerard Hendriks' beautiful painting of poppies, *Klaprosen*, is filled with energy and excitement created by the thrown and spattered reds and blues. Although this technique may seem risky, the result can be an explosion of colour.

◄ Obscure effect
Effects such as spattering or throwing paint are a part of the painting and are not an end in themselves. In Catherine Brennand's painting, *Hawes & Curtis, 23 Jermyn Street, London*, spattered and thrown paint blend into the shadowy façade of the building. A mysterious quality is given to the painting; a sense that not all is seen.

◄ An old toothbrush makes an ideal spattering tool. Wearing a latex glove, pull your thumb across the bristles.

Basic spattering technique: worn brickwork

1 Wet your paper and lay on a variegated wash of the colours for the wall. Then, using a stronger mixture of the paint – here, Burnt Sienna – spatter the painted area with a toothbrush.

2 Rinse the toothbrush and dip it in a complementary colour – in this case, French Ultramarine Blue – and spatter again.

3 Before the spattering dries, using a 2.5-cm (1-in.) flat brush or a sponge, dip into white gouache, and brush randomly over the still-wet spatters.

4 Using reference material or your imagination, complete the wall with painted cracks and peeling areas.

How to throw paint

There are times when a controlled throwing of paint is the only way to accomplish a realistic look. Nature isn't always orderly. Tree branches hanging into the foreground have a draped and uneven look to them. Other uses for thrown paint might include depicting disturbed water, showing textural effects in sand or grass, or adding spots of colour to a garden scene. It is best accomplished on paper that has been spritzed with water, using a full brush filled with strong paint and painting from light to dark. Practise on scrap paper, and protect nearby walls and other areas to be kept clean.

TRY IT
Field of flowers

Visualise a scene in which the foreground is a field of wildflowers in many different colours. Cover the top third of your paper, and spritz the lower third (see page 148). Drop in spots of bright colours and, with short flicks of a brush loaded with grass colours, add the grass and foliage. If it starts looking out of control, let it dry and complete it later. You might want to try dropping some salt into the area as well.

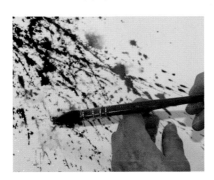

1 With a brush loaded with strong colour and all non-throwing areas covered, use a strong wrist flick and tap the brush against your free hand, directing the spray of the paint. Give it a quick spritz with a pump bottle.

2 Continue until the branch is as full as desired. After each throwing, spritz with water and watch the drops of paint spread and become leaves.

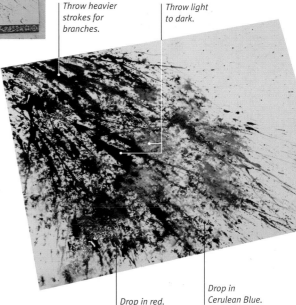

Throw heavier strokes for branches.

Throw light to dark.

Drop in red.

Drop in Cerulean Blue.

3 Before you're done, fill the brush with creamy Cerulean Blue and drop it in. Finally, using red, repeat this action.

FIX IT
▶ Too-smooth walls

Maybe you've painted a building but the walls look dull and too smooth. In Robin Berry's painting *Green Door*, the following process was used. First the wall area was wet just enough to make it damp. A medium mixture was spattered onto the area. Next a stronger mixture was spattered onto the wall. Finally the painting was spritzed from 30–38 cm (12–15 in.) away to add even more texture and left to dry flat. Effects should not be visible in the final painting; they should blend into the other elements.

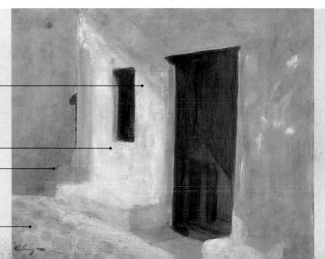

Brush warmer, darker colours into the sunlit areas.

Over the Naples Yellow, unevenly brush an opaque white.

Brush cooler, darker colours into the shade areas.

Use Naples Yellow as the base colour.

Other special effects

Special effects are those techniques used in a painting to add excitement to the subject or to the surface of the paper itself. Experiment with the ideas shown here and incorporate them in such a way that they blend into your painting, rather than stand out and become the focus of it.

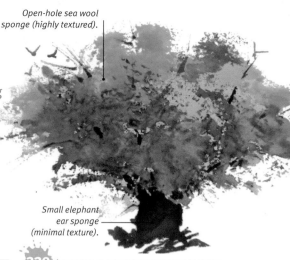

Open-hole sea wool sponge (highly textured).

Small elephant ear sponge (minimal texture).

218

Stippling

Stippling is any method of making an area of fine dots without having to paint each one individually (which would be pointillism). There are several kinds of tools you can use. Any stiff, flat brush of the type used in oil painting works if the top of the bristles are pushed into the paper. A glue brush with cut-off bristles also works, as does an old toothbrush. You can also buy special stippling tools. Simply dip the tool into a medium to dark pool of paint and touch it to the paper. Consider using stippling for bushes, trees, fabrics, beards or fuzzy flower parts.

1 Stippling with a toothbrush on dry paper.

2 Stippling with the same toothbrush on too-wet paper.

3 Stippling with the toothbrush after the paper has dried a little.

219

Using sandpaper

Many painters do not want to use sandpaper on their beautiful, often handmade, watercolour paper. Once you have used sandpaper, you can't apply paint over it without getting a sgraffito effect. That said, a fine grade of sandpaper can be used to gently lift highlights into a lake surface, a waterfall or an article of clothing. Depending on how it is moved across the paper, it can make a smooth transition or create a roughened area.

220

Sponging

The most popular sponges for achieving effects in painting are natural sea sponges. Sea wool and sea silk sponges are full and textured; elephant ear sponges are flatter. All clean easily and last for many years. Art and ceramic supply stores carry a selection, and they are best picked out individually, since every one is different. Wet and wring out the sponge, and dip it into a paint mixture. Shaping it with your fingers, apply it to the paper to form treetops, bushes, wave shadows and clouds.

221

Scumbling

Scumbling is a practice that goes back a few centuries. It involves mussing up the surface of paint by applying a darker or more opaque colour on top and moving it unevenly around. As a method of applying texture, it's great for walls, fields, treetops, fur or any area where a smooth coat of paint would not produce the right effect. In *Still Life with Awl* (detail), Janis Zroback uses cheesecloth to apply paint coarsely, which enlivens the surface and gives it sparkle.

Stamping

Don't let anyone tell you that stamping into your painting is cheating. Whether you use commercial or homemade stamps, you can achieve some very interesting effects using this technique. For example, using the side of a piece of mat board dipped in paint and stamped and dragged a short way can make a tree trunk. Doing this many times makes a forest. A square of mat board with triangular grooves cut into it and dipped in paint can make the treetops of conifers above the forest, or a whole hillside of them.

A line of stamped conifers.

1 Make a stamp out of a scrap of mat board by cutting into it with a knife. Make whatever pattern you like.

2 Cover your carved texture with paint.

3 Stamp a pattern into your painting. Add a darker colour to the stamp, then add to the painting.

TRY IT
Make your own tools

The ways of creating texture are as varied as your imagination allows. Various materials such as bubble wrap, wax paper, plastic wrap, corrugated cardboard, construction paper and stencils have been used to make contemporary masterpieces. See what you can do with what you find around your home or studio. Make tools for applying texture out of things you have around the studio, such as rubber bands glued into the end of an old brush or pen, or simply bound together and then cut short. Or how about a loofah? Let your imagination run wild and see what effects you can create.

Sgraffito

Sgraffito as a decorative technique has been used for centuries, all over the world. The word means 'scratching into', and from it we get the word 'graffiti'. Sgraffito is used in ceramics and in all painting mediums. In watercolour, while a wash is still wet, use a knife or stylus to impress a design into the paper. You press a groove into the paper, softened by the paint, into which the paint pools. The colour will appear darker where the paper has been scratched.

Scrape with a pocket knife (top) or a craft knife (bottom).

Any sharp point will scrape (top). A stylus is useful for added control (bottom).

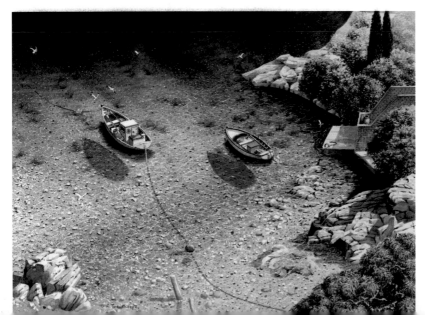

◀ In *Ionian Paradise,* D. R. Gawthorpe has used almost every watercolour technique, including spattering, drybrush and various masking methods. The water was built up in layers, and for the final overpainting, white acrylic was mixed with watercolour.

Palette

Winsor Blue

Venetian Red

Sap Green

Raw Sienna

Materials

*Cold-pressed watercolour paper,
640 gsm (300 lb.)*

2B pencil

Masking fluid

Dip pen

*Round brushes: no. 0 sable, no. 8
sable, no. 14 sable*

5 cm (2 in.) flat wash brush

Tissues

Techniques used

Masking (see pages 96–99)

Wiping away (see page 170)

Dropping in colour (see page 49)

Scumbling (see page 152)

Dabbing (see page 115)

Drybrush (see page 109)

Scraping away (see page 153)

ARTIST AT WORK

Techniques for distressed effects

Several techniques in this chapter can be
used to create the effect of ageing wood.
In this step-by-step demonstration, Naomi
Tydeman uses scumbling, along with dabbing,
scraping and drybrush into both wet and
dry paint.

*The reference photo presents
an interesting, elongated
composition with the added
challenge of representing the
aged wood of the boat hulls.*

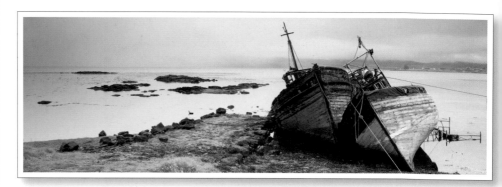

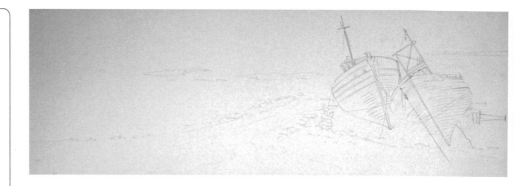

▲ ◀ **1** The long format of this image enhances
the contrast between the soft emptiness of the
background and the intensity of the detail in the
boats. A careful sketch is made, paying particular
attention to the shape of the boats, but keeping
background lines soft. The ropes are masked
using a dip pen in the masking fluid. These carry
across the dark areas of the boats, breaking up the
larger shapes.

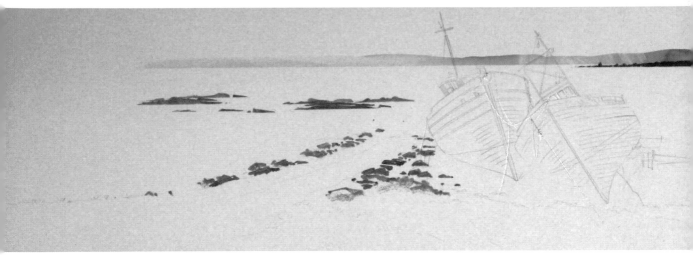

▲ **2** Using a mix of Winsor Blue and Venetian Red, the artist paints the distant coastline with the no. 8 brush, diluting parts with water to vary the tone and suggest soft clouds and rain, fading to the left. Next, the rocks in the middle ground are painted and softened in subsequent washes.

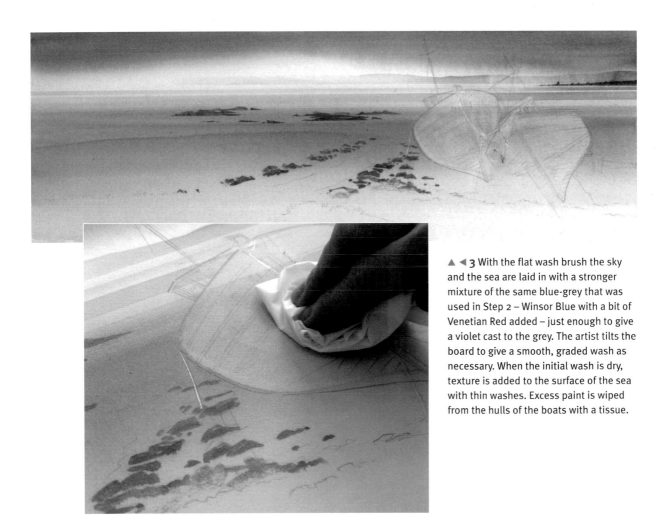

▲ ◀ **3** With the flat wash brush the sky and the sea are laid in with a stronger mixture of the same blue-grey that was used in Step 2 – Winsor Blue with a bit of Venetian Red added – just enough to give a violet cast to the grey. The artist tilts the board to give a smooth, graded wash as necessary. When the initial wash is dry, texture is added to the surface of the sea with thin washes. Excess paint is wiped from the hulls of the boats with a tissue.

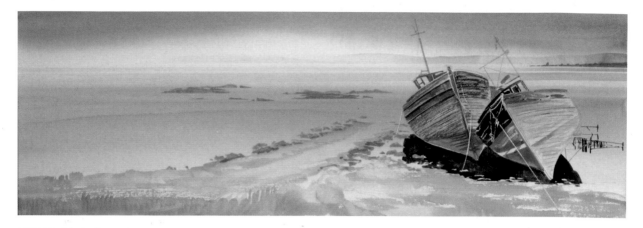

224

Creating a base for rich textures

To create rich textures on old wood and metal, mask all whites and highlights, then give the area a rich wet-into-wet underpainting of pure colours, dropping one into the other, then letting them dry. This will form a base onto which various textures can be applied.

▲ **4** The base layers and undercolours of the boats and foreground are painted with the no. 14 and no. 8 round sable brushes using various mixes of Winsor Blue and Venetian Red as for the boats and rocks, and Sap Green and Raw Sienna for the foreground and slipway.

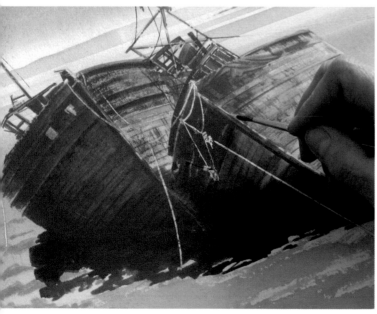

◀ ▲ **5** Texture is worked into the surface of the boats to suggest peeling paint and rotting wood using scumbling, dabbing and drybrush with a no. 8 brush and scraping with a sharp edge. The shadows are blended into the dark reflections of the water until there is no separation between the two. Rust trails are painted in Raw Sienna with a dry brush, and details are added.

Plan masked areas

Vary the colour and value of the lines and rigging of a boat. Some will be in light and should be masked. Others will be in shadow and are darker than their background. Those with colour should be in a contrasting or complementary hue to what is behind them. Because lines such as these play an important role in the overall design of the painting, careful thought and planning are necessary. Remember: light on dark is masked; dark on light doesn't need to be. Colour should contrast.

▲ **6** Sap Green and Raw Sienna are worked into the grassy areas, while washes of grey are flooded over the stones and shingle. Thicker paint is scumbled into the drying washes to create texture in the little beach. When the paint is dry, the masking is removed and the ropes painted in with the no. o brush dipped in pure Winsor Blue or Venetian Red.

Boats
260 x 735 cm (102 x 289 in.), on cold-pressed
640 gsm (300 lb.) watercolour paper.

Naomi Tydeman

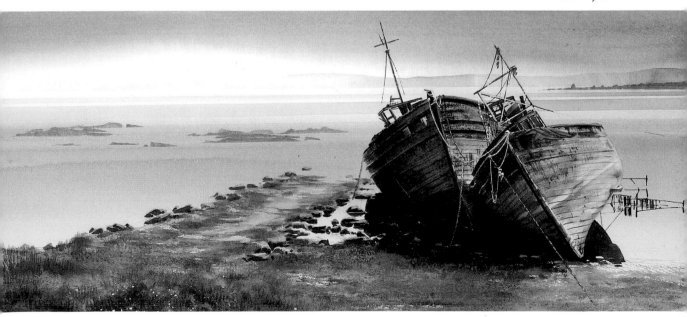

Glazing

Glazing is the layering of repeated, thin applications of transparent colour. There are many reasons to use this technique. These include altering the saturation of colour in an area and altering the colour itself – warming it up, cooling it down or greying it. Glazing is a great way to fix weak areas of a painting. By gradually changing a colour or value in the painting or in an object, you can maintain complete control, layer by layer.

▲ Glazing for intensity
Lisa Hill, in *Standing Out in a Crowd*, uses glazing to create exceptional shadows and reflected colour, as well as intense, saturated hues, in the sculpting of these bell peppers.

226

Use transparent pigments

Nothing will kill a glaze faster than using a colour with too much opacity. Good glazing colours are very transparent and non-granular. This is something you can experiment with using the paints in your palette, but here are a few to try: Aureolin, Quinacridone Gold, Hansa Yellow, Raw Sienna, Burnt Sienna, Quinacridone Burnt Orange, Permanent Orange, Quinacridone Red, Brown Madder, Quinacridone Rose, Quinacridone Magenta, Quinacridone Violet, Phthalo Blue, Cobalt Blue, Phthalo Turquoise, Phthalo Green and Viridian. There are many others, and the brand matters, too. Commonly used brands include Winsor and Newton, Daniel Smith, Holbein, DaVinci, MaimeriBlu, Daler Rowney, Grumbacher, Grahm and Schmincke. There are many more; some artists have created their own brands as well.

◀ Glazing with primaries
First a fairly strong wash of yellow was laid down and dried. Next, a relatively weak wash of red. The result was orange. A glaze of a medium mixture of blue, the complement of orange, was laid on top for grey-violet. Yellow was glazed on top of that to make dark olive.

227

1	Base colour under whole area
+2	
+3	
+4	
+5	
+6	
+7	
+8	
+9	
+10	
+11	
+12	

How many layers?

It is possible to glaze many layers, as many as 50 or more, to a very dark dark. All that matters is that the paint is transparent, applied in a diluted wash, and dried thoroughly in between. If there is an area that needs to stay white, mask it first so you can paint your washes without hindrance.

▶ Creating black
Following the rule of drying thoroughly between glazes, you can see that in 12 glazes, black was achieved. At no point do the colours get muddy, only richer and more complex. This is due to transparency.

TRY IT Foolproof glazing

For best results apply a thin (diluted), wet, flat wash over the dry area to be glazed. If you pre-wet the area, there is a greater chance of lifting the colour already on the paper. Do not go over what you've just done. Apply the paint and let it dry. Remember that subsequent glazes can correct anything you don't like. Be sure to let the paint dry thoroughly between applications.

1 Goal: extend the shadow on the edge of the petal to show its curve.

2 Paint a shadow colour along the edge in a single pass.

3 Immediately brush back and forth along the hard edge with a thirsty brush to blend.

4 Dry. Note the soft shadow formed by the curve of the petal.

Layer 1 Layer 2 Layer 3 Layer 4

228

Increasing saturation

You can glaze again and again with the same colour, but each time, the mixture should be stronger – otherwise the colour will not change or darken. For maximum saturation, apply many layers of a colour. Note that many thin layers will remain more transparent than a single application of a mixture dark enough to match.

FIX IT
Adding warmth

Take a painting you consider a 'failure', and look at it with fresh eyes. Would it benefit from warmth? Does it lack a clear value plan? To fix it, make a mixture of a colour that would warm up the area in question. Glaze, dry, reapply and dry, until it looks better to you. Perhaps this has also changed the values. If not, try glazing with a thin red, then a Phthalo Blue, then a Phthalo Green. If it looks too green (Phthalo Green is a strong colour), do a last glaze of red, the complement of green.

229

Greying or muting colours

Glaze with the complement of a colour, or an analogous colour to the complement, if you want to grey or mute an area. If you are glazing over several colours, try to find the colour that links them. For example, yellow links blue and green, so glaze with the complement of that colour (violet) to mute them.

▶ Achieving neutral and greyed colours

To make a painting with soft, subtle and natural neutral colours, one can take two approaches: using the exact colours from a tube or glazing with several colours to achieve the same. Usually, the latter is more transparent. *To the right,* Paul Dmoch uses velvety greys and sepia tones to set off the intense spots of red. *Below,* James Boisett achieves a soft, rolling look to his landscape with glazed greys and olives, using a greyed violet shadow in the middle ground to set off the golden bluffs.

▲ Pigment glazing

A medium mixture of Quinacridone Coral was applied to dry paper and dried (Layer 1). Layer 2 was another wash of the same pigment mixed slightly stronger. Layer 3 was yet another slightly darker layer, and finally, achieving full, yet still transparent saturation, a fourth layer was applied. Had Quinacridone Coral been applied at full strength the first time, it would have had a chalky look rather than the luminous look that results from glazing.

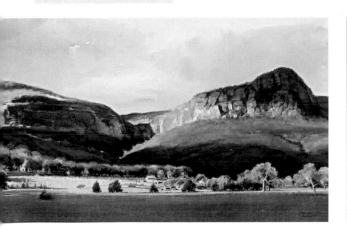

TRY IT
Testing glazes

On scrap paper, practise glazing over sections to see exactly what your chosen pigments can accomplish in one, two, or three passages. Remember to dry thoroughly between layers.

Violet was applied over its complement, Permanent Yellow.

Cobalt Blue was applied over its complement, Permanent Orange.

Permanent Green Light was applied over its complement, Permanent Red Light.

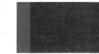

Note: All pigments used here were MaimeriBlu.

Palette

Raw Umber

Ultramarine Blue

Quinacridone Gold

Rich Green Gold

Winsor Red

Orange Lake

Materials

Arches 300 gsm (140 lb.) cold-pressed watercolour paper

HB pencil

Masking fluid

Clay shaper

Round brushes: no. 4, no. 6, no. 8 and no. 40

Paper towel

Rubber cement eraser

Toothbrush

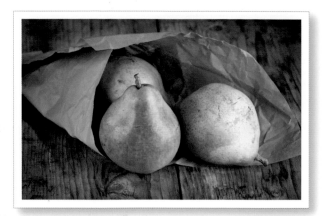

Techniques used

Masking (see pages 96–99)

Wet-into-wet (see page 59)

Glazing (see pages 158–159)

Wiping away (see page 120)

Spattering (see page 150)

Ripe, glowing pears are a perfect subject to demonstrate rich, complex glazes.

ARTIST AT WORK

Exaggerate the light to bring out the glow

This is a successful painting not only because it is technically adept and colour-correct but also because it takes on a state of presence, a life, that the photograph does not communicate as successfully. Katrina Small spent so much time painting the subject, at one with the process, that a special state-of-being was transferred, imbuing the painting with life.

230

Multi-functional tools

Many tools cross the borders from one medium to another. The clay shaper, used by potters and sculptors to move clay around, is also called a colour shaper and used for masking as well as sculpting a puddle of paint into desired channels. Picks used in sculpting make excellent sgraffito tools. Artists are very inventive when it comes to usurping the tools of one trade for their own. Dental picks, medical syringes and scalpel blades have all been put to use by artists everywhere. Walk around your home and see what you can put to use in your own paintings.

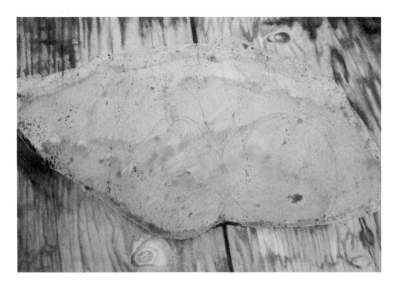

◄ **1** After the image is drawn, the pears and paper bag are masked with liquid masking, using the clay shaper. The paper is lightly moistened with clear water using the no. 40 round brush, and the artist begins painting the background, applying a wet-into-wet wash combination of Raw Umber and Ultramarine Blue. Once dry, the details of the wood-grain are worked using wet-into-dry with the same colours plus Quinacridone Gold. The pigmented edges are pulled out with a no. 6 round brush with fresh water to achieve a seamless transition from high to low saturation.

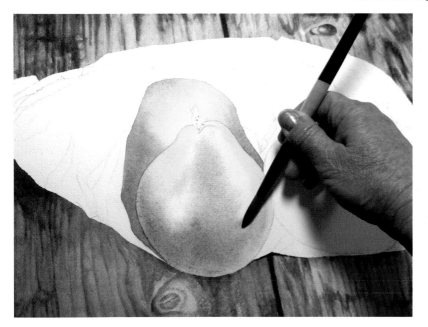

◄ **2** After the masking from the pears and paper bag is removed, the pears are glazed using the wet-into-wet technique and a no. 8 brush to apply Rich Green Gold, Quinacridone Gold, Winsor Red, Orange Lake and Ultramarine Blue. A clean, slightly moist brush is laid on top of the wet paint to soak up the colour in the targeted areas. Once dry, the pears are further glazed with the same colours, using the wet-into-dry technique.

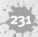

Thirsty brush

A 'thirsty brush' is one that has been moistened and then squeezed to remove excess moisture. It is always good for removing spots of colour while the paint is still wet or damp. The thirsty brush acts as a sponge, but it is better able to deal with specific, shaped areas and small spots. Gently lay the brush into the area to be removed or softened.

► **3** Once the initial colours of the pears are painted in and fully dry, liquid masking is applied with the clay shaper to make little speckles on the pears. This is done at this stage so that when the masking comes off, the colour underneath will be slightly saturated, rather than just the white paper. Further saturation is glazed into the pears. The edge of a paper towel is used to soak up the wet pigment so that the highlighted areas stay desaturated.

▶ **4** For the paper bag the artist uses an initial wash of Raw Umber and Rich Green Gold, making sure to preserve lighter areas as highlights. The paper bag structure is built up using the same colours plus Ultramarine Blue in a glazing technique, wet-on-dry.

232

Working with two brushes

Keeping two brushes in your hand, one charged with paint and one damp with clean water, allows you to immediately feather the edges of a stroke of colour just laid down.

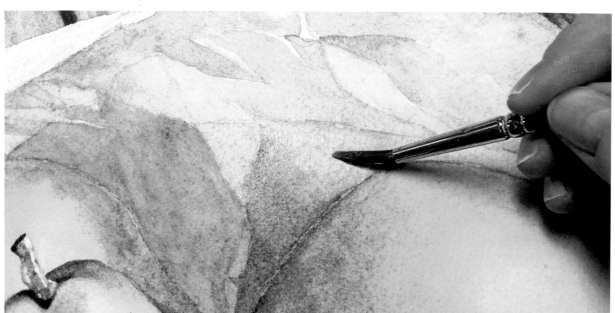

▲ **5** Once the paper bag structure is in place, it is glazed in Winsor Red and Quinacridone Gold, using the wet-on-dry technique. The colour is pulled out while still wet with clean water to soften the edges.

▶ **6** Once the painting is close to completion and dry, the masking on the pears is removed with a rubber cement eraser. With a thirsty brush, the artist lightly pulls some of the colour away from the area just painted to give a curved, light and shadow appearance.

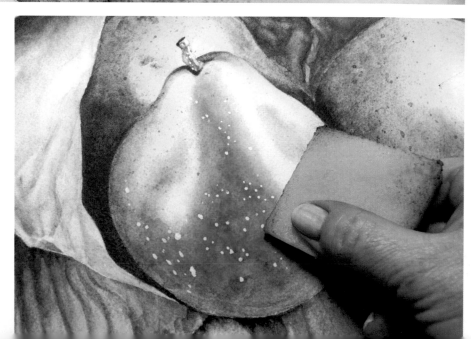

▶ **7** The final step in the painting is to add darker speckles to the pears. First the surrounding areas that shouldn't be speckled are masked off. A puddle of Ultramarine Blue and Raw Umber is prepared. A small toothbrush is dipped into it and the bristles are flicked over the pears. This creates a spray of small, dark speckles that add a deeper dimension to the pears.

Pears
37 x 25 cm (14 x 10 in.), Arches cold-pressed 300 gsm (140 lb.) watercolour paper.

Katrina Small

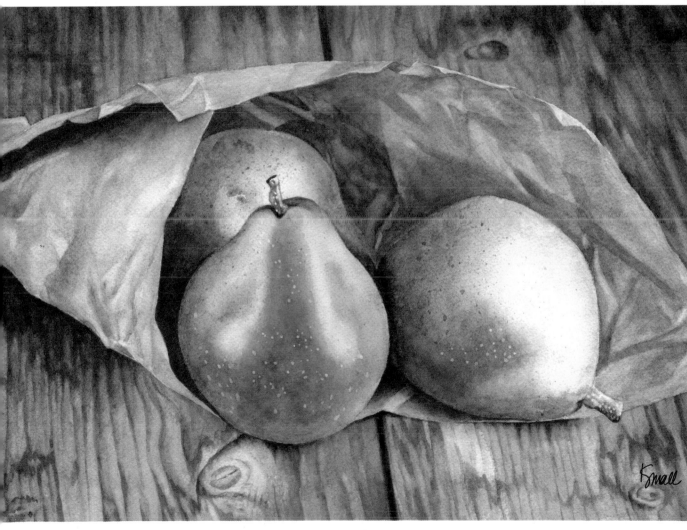

Edges

Handling edges skilfully can dramatically raise the overall quality of a painting. We do not see everything with perfect clarity. Things that are next to each other and very bright, for example, may appear to merge. The same is true of dark objects, objects with shadows or objects of similar colours. Only the centre of focus is clear. By learning how to control your edges, you will have better control over the illusion of reality in your painting.

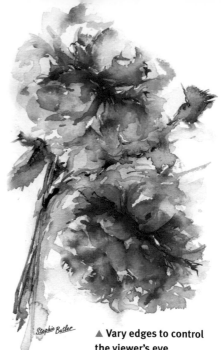

▲ Vary edges to control the viewer's eye

In *Flower of my Dreams*, Stephanie Butler uses the harder edges to draw the eye into the centre of the flower and frames it with softer edges fading to white, creating a dreamy state.

Varying edges

When we take in a scene, our eyes do not see everything clearly – only what we're focusing on. The best way to show this in a painting is to vary the edges. In Robin Berry's painting, *A Pair of Pears* (below), all three types of edges have been used in the creation of the dramatic moment of the sun striking the pears. Lost edges add mystery, hard edges define shape and soft edges show volume.

Hard edges

Hard edges, also called found edges, are those that have a hard line and are easily seen. These would be at your centre of interest and occasionally elsewhere in the painting. They are most often painted wet-into-dry.

Lost edges

Lost edges are those that disappear or that blend with another. Wet-into-wet painting is one way to achieve this. Another way is to let the white of the light source blend with the highlight on the edge of an object. Painting outside the lines is yet another way, blurring one colour into another. Lost edges are an excellent way of showing motion.

Soft edges

Soft edges appear in areas where a discrete division can be seen but from a distance are not sharp. Most paintings make use of all three types of edges.

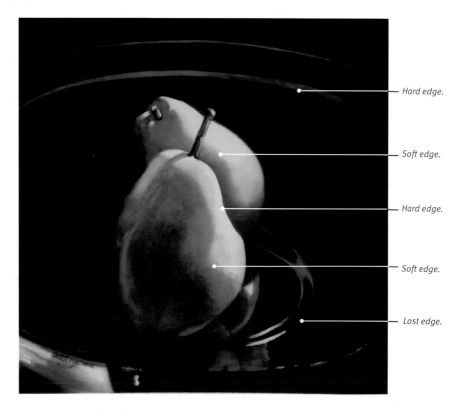

Hard edge.

Soft edge.

Hard edge.

Soft edge.

Lost edge.

▲ Hard edges

Hard edges are the primary definers of the fruit and leaves in Lisa Hill's painting *Apples,* although there are plenty of soft edges found inside the foliage in highlights and shadows. The skill of observation results in paintings of exceptional detail.

TRY IT
Varied edges are natural

Try a still life using a single simple form, such as the cherries at right. After designing your arrangement, choose a light source. If you can't imagine it, light it in sunlight or with an electric bulb. Choose the side or an upper corner. After drawing, find the highlights and shadows (lightest and darkest values) on your subject. Where the light spots meet other light spots, you will find lost edges. Where you want the viewer to look, choose hard edges, as well as your brightest colour, lightest lights and darkest darks. In showing the curve of the fruit, you will find many opportunities to create soft edges, especially when painting wet-into-wet.

Photos vs. paintings

Notice that photographs see most edges as hard. You do not need to paint exactly what you see in a photo though. Keep your centre of interest hard and soften out from there.

▼ Soft edges

The hard or soft edges of a painting can give the viewer a sense of how the artist feels about a scene. In Doug Lew's painting, *Arno in Daylight,* there are predominantly soft edges, giving a sense of relaxed otherworldliness.

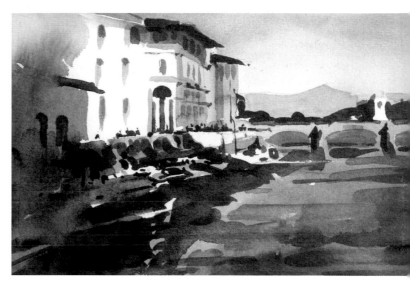

▼ The round form

In her painting, *Cherries Ripe,* Janis Zroback shows how choosing the appropriate edges, highlights and shadows can fill out the volume of a round form. You can see here the principle that cast shadows have hard edges and shadows formed by the curve of a surface away from the light have soft edges. Where like value meets like value, you will find the opportunity for lost edges.

Soft edges.

Hard edge.

Lost edges.

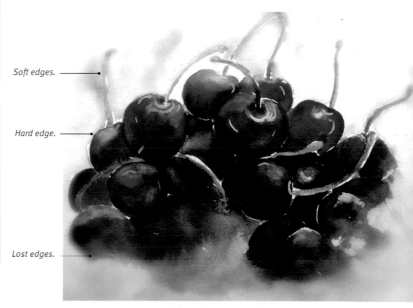

Adding drama

Using strong light and shadow can inject drama into a scene and engage the viewer. By linking darks or lights together, a stronger pattern of light and shadow emerges. Layering values is one way to do this. The pattern you design can evoke a sunny day or a mysterious atmosphere.

Using shadows

Shadows touch the object that casts them if that object is on the ground. If the casting object is in the air, the shadow is a distance away from the object. Shadows can bring life to a scene that would otherwise be static. Think about adding them in, even if you don't see them in your subject.

▲ **Completing the painting**

In *Santorini* by Robin Berry, despite the motion and the colour of the flags, the finished painting looked dull and static until the quickly painted, random shadows were painted on the wall. Though they were not actually in the photo, they made sense and also completed the painting.

▼ **The edges of shadows**

Shadows not only add depth to *Sleepers*, by David Poxon, but also make the painting very mysterious. Also visible here is important information about shadows. Cast shadows, such as the shadow cast in the centre of the painting by the bolt, have hard edges. Shadows made by the curvature of the form of an object have soft edges, as seen in the centre form of the painting.

▶ **Added shadows**

In *Paris Opera Light* by Robin Berry there were no shadows on either the flat area below the statue or on the sidewalk. However, until they were quickly and randomly applied with a big mop brush, the painting was dull.

236

A lighting primer

The photos at right show the various effects of light on an object. These basic examples will become more complex as your subject does, so hone your observation skills as you study the light on your subject.

Direct, face-on light gives very little shadow.

Light from the left creates a strong shadow on the right.

A spotlight from above adds drama.

Here, light from the left is reflected onto a white wall on the right.

Light from the left, with weaker light on the right, gives soft shadows.

Backlit objects create strong foreground shadows.

TRY IT
Playing with lighting

- Place a strong light on a still life you have assembled. In your sketchbook, using various value studies, draw the light pattern. Then move the light and repeat. Do this three or four times. Look for the most effective lighting, bearing in mind that the most dramatic is not always the most effective.
- On a white surface, place a clear glass and a couple of coloured objects. Shine a light down from various angles above and from the side and observe what happens to the shadows. Do two or three watercolour sketches of the results in your sketchbook.
- Draw a simple scene with strong lighting. In painting the scene, make sure the shadows are filled with colour and are connected to the object that casts them, unless that object is in the air.
- While you are doing these light and shadow exercises, take photos. You never know when you might hit on a spectacular view.

237

Exploit lighting

To increase the drama in a painting, push the values to their extremes and leave part of the story untold. Stage lighting is strongly spotlit with the background floating in darkness or mysterious and abstract images. By exploring your lighting from different angles, you will find the right feeling and atmosphere for your particular painting. Paul Dmoch's painting *La beauté du detail à l' intérieur de Gesuiti, Venise, Italie,* exploits the already dramatic lighting of the church by placing the viewer in the dark looking at the expanding light. Perfectly symbolic for the setting, the viewer is enlightened.

◀ **Small spotlight**
In Robin Berry's painting, *No Regrets,* the spotlight fades on the scene. Drama is increased in this story by light and shadow alone.

Removing colour

Many people think you can't make corrections to watercolour, but there are actually many ways a painting can be corrected if it has gone wrong. Some of these have already been touched upon; others are discussed here. You should know you never have to waste a sheet of paper. If you don't like something and don't see how to correct it, put it away in a drawer. Someday you might see it differently and be able to fix it. Otherwise it can be coated with gesso (an opaque acrylic white primer), returned to white and used for acrylic.

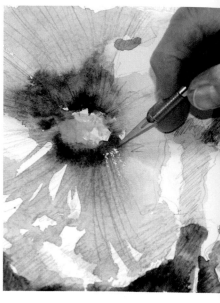

Removing colour – small area

If you've lost a few highlights, try one of the following techniques.

Sponge when dry
The corner of a damp sponge can be used to retrieve small highlights – as in Robin Berry's *Surfscape* (below). Even a beam of light across a face can be retrieved in this manner. The area must be dry and the sponge (elephant ear is best) wrung out and just damp. A gentle dabbing, first with the sponge and then with a tissue, should do it.

Opaque paint
Many watercolourists use opaque white paint, such as Chinese White or a white gouache, to dab on highlights when the painting is done. This way they don't have to think about them until the end when the whole of the picture is seen. Purists will not use this method. Be warned that there are watercolour societies that will not allow a painting into a show if it includes any opaque paint. Do not use this method if you plan to enter such a show.

▲ **Scratch tiny areas**
If you have lost small areas of highlights – light on the tops of the heads in a crowd, perhaps, or the light in an animal's eye (shown above) – you can use the point of a blade to gently scratch them back in. Highlights such as these are important to a finished look.

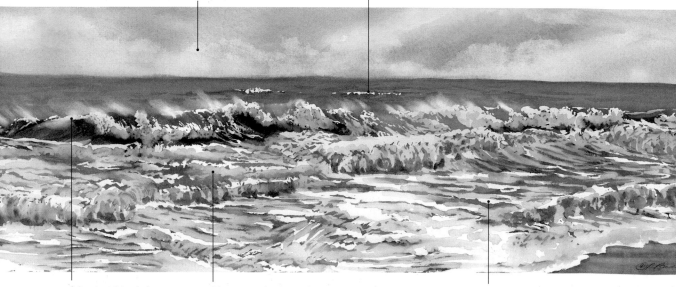

Dab wet sky with tissue to form clouds. When dry, a scrubber or damp sponge can be used to remove more paint.

White sparkles can be picked away with a sharp point, such as a craft knife.

Colour in unintended areas can be removed with a sponge or scrubber.

Wipe away colour in gentle strokes with the corner of a wet natural sponge.

Masked whites can be softened with a scrubber later.

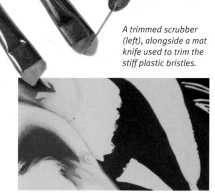

A trimmed scrubber (left), alongside a mat knife used to trim the stiff plastic bristles.

▼ Electric eraser and Dremel tool

It takes a lot of practice to use these power tools on watercolour paper, but it's worthwhile. Perhaps you've painted a crowded park scene and the sunlight is shining down on dozens of heads, and hitting the tops of fences. A quick touch of the Dremel tool with a cone-shaped sanding bit will recover these white highlights. The electric eraser will accomplish the same task, but it's slower. Don't let either tool rest on the paper or press too hard on it as they may go through the paper. Here, in the centre of a flower, highlights were recovered. Use both hands to control the Dremel tool and touch the paper lightly and briefly.

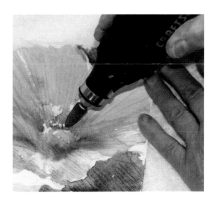

Using a scrubber

A scrubber is a specialised brush, or a brush with a specialised use. Although some use natural bristle brushes, most artists find the nylon bristle brush made for this purpose easier on the paper. The bristles are cut shorter to give them strength and stiffness. Re-wetting the paper and using a gentle circular or backwards and forwards movement of the scrubber, followed by a dab with a tissue, will remove paint from the paper.

Hard edges are left by masking when it is removed.

TIP
Scrubbing to make wave foam

The plastic-bristled scrubber brush has tremendous versatility as a painting tool, but it is also ideal for removing colour. If for example, you've masked the foam pushed up onto the beach by a wave and then painted the scene, removing the masking may be startling at first. It will look like a woodcut – all hard edges – especially if you've laid in intense colours. This is where the fun starts. Dip the scrubber in water and begin to soften the hard edges of the surf shadows, letting the wet move into the white area in places. You will be creating middle values between your darker shadows and the white paper.

Wet the edge of the hard line with clean water. Wet the scrubber and gently remove the hard line. Dab with tissue. Dry. Repeat if necessary.

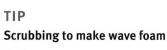

The softened line looks more natural and gradually blends into the white.

TIP
Multiple techniques

If you've been painting away and suddenly realise you've missed the light on the lawn, across a shirt, or in the sky, quickly grab a tissue and dab the area. Gently! If you push too hard, you'll push colour into the paper rather than absorb it from the paper. (If you've used a staining colour, such as Alizarin Crimson, you may not lift all the colour this way.) Let it dry thoroughly and try a sponge. Dry it thoroughly again. If there is still colour to remove, use a scrubber brush, gently. Dry it, then burnish it with the back of your fingernail. Don't try to paint over this.

▶ Last-minute highlights

Just before *Waiting*, by Robin Berry, was finished, a Dremel tool was used to touch light to selected heads in the crowd and the sculpture on the fountain.

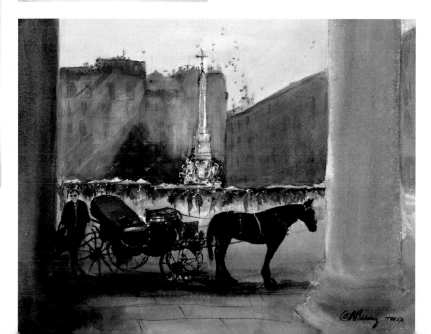

240

Removing colour – large area

It is occasionally necessary to remove larger areas of colour from a painting that may have become out of control. Try the following techniques on scrap paper, using the same pigments, before you try them on your painting. Some may work better than others, depending on the colours you've chosen.

Washed off paint.

Scrubbed paint.

Paint removed using toothbrush.

Toothbrush. Scrubber.

Masking.

◄ Using scrubber brushes

Scrubbers can be ideal for removing larger, soft-edged shapes. For example, if you've painted a flower close-up, once you've removed the masking, there will be a hard edge. Be sure that the painting is very dry before you begin to soften these edges. Wet the edge with clean water and wet the scrubber, then gently stroke the hard line. Dab frequently with tissue. Dry between attempts. Taper the colour into the white, leaving a soft edge. There may be areas of a painting in which you only want to soften it a little. Simply pull the wet scrubber along the hard line and dab as you go.

◄ Removing a specific shape

If you have a line or a series of lines that have become too dark and a scrubber or sponge will not give a sharp enough edge to remove a narrow or specific shape, try this. On a dry painting, using white artists' tape, surround the area to be removed. Be sure that the paper is completely dry first. Using a damp sponge or a scrubber, begin to work on the enclosed area. Dab with tissue regularly so water doesn't seep under the tape. Dry well and then remove the paint.

◄ Giving the painting a bath

If you feel you've gone way overboard with colour and the paint has become much too dense or muddy, fill a bathtub with clean water and float the painting in it. After a few minutes, you can gently begin to wipe away colour with a soft,

natural sponge. It will leave a ghost of the painting you were doing on the paper. At this point you can choose to remove more colour or repaint over the first image.

Using an old toothbrush

If the area to be lightened is a more soft-edged, organic shape and masking wouldn't work well (see left), try using an old toothbrush, dipped in water and applied in a light, circular motion. Dab regularly with tissue. After a couple of passes, dry the paper. If it's not light enough, repeat. Drying the paper between attempts will help keep it stronger. Too much rubbing will go through the paper, so use a light touch.

241

When all seems lost

- Put the painting up in a place where you will see it casually from time to time over a couple of weeks or months. Sometimes it just takes distance in space and time to spot the weakness.
- Put the painting completely away for a while.
- Re-evaluate your value plan.
- Remove paint in the various ways described.
- Crop the painting. Save the cutaway scraps to test techniques on the back.
- Last resort – apply acrylic gel and paint over with acrylic.
- Last, last resort – cover with gesso and do a new painting in gouache or acrylic.

Blooms

Blooms can be your friend or your enemy. They occur when a weaker mixture of paint (more water) is applied on top of still-wet or damp paint that is a stronger mixture of paint (less water.)

FIX IT
Fixing blooms

1 Blooms that are accidental and threaten to mar your painting can often be fixed.
2 If you catch the paint right away while it is very wet and before you can see it, try dropping a heavier paint mixture into what you've just applied and gently mixing it around and tilting your paper. If you see that a bloom has already started to form, dry it.
3 Next, using a stiff brush or a damp sponge, gently dab away the dark paint ridge to match the paint around it. If you can take the whole area all the way back to white, do so. It will then be easier to just dry the paper and reapply the paint. If not, remove what you can, dry it and carefully apply new paint of the desired intensity.

Bloom characteristics

When a bloom occurs, the water pushes outwards and piles up excess pigment at the edges. The spots you get in a wash when you spritz the paper (see page 148) are miniblooms. Intentional blooms can be very useful in some situations. They are somewhat organic in appearance and can be useful in painting gardens or trees. However, be careful not to overuse them.

▶ **Intentional bloom**
In *Hardy Wessex Tales 2*, Janis Zroback allows intentional blooms to virtually explode in the fiery sky around the background trees. This is a carefully planned effect that requires much practice working with adding water and or weaker paint into a freshly wet area.

FIX IT Turn your blooms into a garden

1 Into an area spritzed with clear water, drop and spatter several strong colours, adding drops of water to create intentional blooms as the paint dries.

2 Throwing green paint, (protect some of the sky with tissue), create some foreground grasses and leaves. Continue to spritz and drop colour in. Dry.

3 With a rigger brush, turn any unwanted spatters into birds and make a few sharp, in-focus grasses, leaves and flowers.

Glossary

ACRYLIC PAINT A water-soluble paint in which the pigment is suspended in a synthetic polymer resin. Acrylic paint dries hard and is waterproof.

ATOMIZER Consists of two hollow hinged tubes that form an L-shape. One end is placed in liquid, the other is blown through to create a fine mist of liquid onto your paper.

BODY COLOUR An opacifier, usually Chinese White, added to a pigment to make it more opaque.

BUTCHER'S TRAY A metal tray used in the meat industry that makes an excellent, well-less open palette.

COLD-PRESSED PAPER Medium-surface texture paper, achieved by running the paper through cold rollers in the drying process.

COLOUR WHEEL The arrangement of the 12 main colours into sections of a circle showing the relationships between primary and secondary colours. For instance, orange is naturally placed between red and yellow, being made up of these two colours.

COMPLEMENTARY COLOURS These are colours that sit opposite each other on the colour wheel. Complementary colours are red and green, blue and orange, yellow and violet. Note that each primary colour is complemented by a secondary colour.

COMPOSITION/DESIGN The arrangement of the elements of design in a composition so as to achieve the principles of design.

DRYBRUSH A technique of brushing fairly dry paint onto dry paper in order to achieve abrupt and broken lines. Works well with grass and heavily textured subjects.

DRY-INTO-WET The use of thick paint on the wet surface of the paper. It produces a strong mark with colour that bleeds out from it.

EARTH COLOURS Pigments made from minerals mined from the earth and ground to a fine grade. These are then mixed with the appropriate medium to turn them into paint.

ELEMENTS OF DESIGN Line, shape, size, texture, direction, value and colour.

FLAT BRUSH A wide, square-cut brush with a thin profile. The larger square brushes (over 2.5 cm /1 in.) make good wash brushes.

FRENCH CURVE A template used for drawing curved lines of all kinds.

FRISKET/MASKING A removable, waterproof substance painted into areas of a painting to be temporarily protected from paint.

GESSO A mixture of acrylic polymer, white pigment and glue used to prime a surface to make it waterproof.

GLAZE A thin coat of colour applied over another dry colour to either change its hue or intensify its value.

GLYCERINE A multi-purpose substance used as a medium to suspend watercolour pigment.

GOUACHE Opaque watercolour.

GRID SYSTEM The system of dividing a reference photo and the paper onto which you will paint into an equal number of squares, regardless of their size, to assist in enlarging a small picture into a large drawing.

HOT-PRESSED PAPER Paper with a smooth texture achieved by running it through hot rollers during the drying process.

LIGHTFAST A term used to refer to paint that will not lose colour in the sunlight. There are degrees of lightfastness and these are determined for each pigment.

LIGHT TO DARK The traditional approach to the laying on of colour in watercolour, beginning with the lightest values and saving the darkest until the end.

LOCAL COLOUR Refers to the actual colour that something is. For example, the local colour of an aubergine is purple.

MEDIUM A liquid in which pigment is suspended. Which liquid that is depends on how the pigment will be used. The type of material one works with, such as watercolour, oil, acrylic, etc.

NEGATIVE SPACE The space formed around the drawing or painting of an object or objects that becomes a part of the whole composition.

OPAQUE Not transparent. Opaque paint, no matter how light in hue, will cover what is underneath it.

PALETTE (HUES) The selections of colours used by an artist.

PALETTE (PAINT HOLDER) A tray with wells around the edges to hold and mix paint.

PALETTE KNIFE A tool with a thin blade (various shapes and flexibilities are available) and handle used for applying or mixing paint.

PASTEL A chalk-like stick of pure, compressed pigment. Also a painting medium.

PERSPECTIVE The process by which the illusion of three dimensions is created on a two-dimensional surface.

PICTURE PLANE The two-dimensional surface of a painting regardless of pictorial illusions.

PIGMENT The raw substance of colour. Each pigment has its own origin, be it an earth mineral or organic substance. Paint is made from pigment mixed with a medium.

PIGMENT STICK A water-soluble stick of compressed pigment that can be used to draw.

PLEIN AIR Painting outside.

PORTRAIT An up-close study of a person, animal or flower. Implies a degree of accuracy and formality.

PRIMARY COLOUR A colour that cannot be mixed from any other. There are three: red, yellow and blue.

PRINCIPLES OF DESIGN Balance, repetition, variation, contrast, harmony, dominance and unity.

RIGGER A fine, round brush with long, pointed hair best for making long, continuous strokes. Named for painting the rigging of ships in marine art.

ROUGH PAPER Paper with a pebble-like texture formed by letting it dry naturally.

ROUND BRUSH The most common watercolour brush with a full body tapering to a fine point. Made in sizes from 0000, with just a few hairs, to very large, mop-like sizes.

SALT Used to add texture in watercolour by pushing pigment away from itself.

SATURATION The intensity of a colour in relation to white. The more saturated it is, the closer the colour comes to its strongest potential, which would be 100 per cent.

SECONDARY COLOUR Colours, such as orange, green and violet, mixed from primary colours.

SCUMBLE The technique of dragging or messing up semi-dry paint that is on top of a dry layer to create texture.

SGRAFFITO Comes from the Italian word to scratch. It involves scratching through a layer of paint to expose what is underneath. Creates texture and graphic lines.

STAINING/NON-STAINING PIGMENTS Pigments referred to as staining sink into the surface of the paper and cannot be completely removed. Not all pigments stain. Some, such as Cobalt Blue, sit more on the surface and can be almost completely removed.

STRETCHING PAPER The process of anchoring soaked paper to a stiff board, usually with staples, and letting it dry, thereby creating a surface to paint on that will not buckle.

SPATTER Forcing small droplets of paint onto the surface of the paper. Usually done by dipping an old toothbrush in paint and dragging a finger across the bristles.

SPRAY Use of one of several types of plastic bottles designed to direct a stream or droplets of water or paint from the bottle. Commonly used to create texture and effects in water media.

SPONGE Aside from obvious uses, a natural sponge can be dipped in paint and applied to the paper to achieve textural effects, such as tree foliage.

SPRITZ A weak spray.

STAMP Use of a carved object dipped in paint to apply a repetitive design to paper.

STIPPLE Bristles dipped into paint and applied in an up-and-down motion to create a dot pattern on paper.

TERTIARY COLOUR Colour made from mixing a primary and secondary colour. These colours have descriptive names such as red-orange or yellow-green.

THROW PAINT Propelling paint from a brush across the surface of the paper. Can produce both natural objects, such as branches and foliage, or simply texture, such as falling leaves.

THUMBNAIL A small sketch of what might become a larger painting.

TRANSFER PAPER Paper that has a coloured or graphite side. When slipped face-down between a drawing and a sheet of paper and traced over, an identical line will be reproduced on the paper.

TRANSPARENT WATERCOLOUR Not opaque. Transparent watercolour allows the white of the paper to illuminate from beneath. As a medium, no white paint is used but only makes use of the actual white of the paper.

TRIAD Any combination of three paints that, when used together, form a complete palette for a painting.

VALUE In painting, refers to the scale of greys from white to black. Colours have value when translated to grey.

WARM AND COOL COLOURS Warm colours lean towards the yellow and red side of the colour wheel; cool colours to the blue and green. Within each hue, a colour can be made to lean in either direction by the addition of a warm or cool colour.

WASH A light and even coat of paint across an area of paper.

WATERCOLOUR BLOCK Watercolour paper glued on all four sides with a small area left open so a knife can be inserted when it is time to remove the top sheet. The advantage over a tablet is that the paper won't buckle.

WATERCOLOUR CRAYON Pigment suspended in a water-soluble, waxy substance. Can be used dry and later painted with water and turned into paint.

WATERCOLOUR PENCIL Compressed watercolour pigment inserted into a pencil body and used as a regular pencil. It can also be brushed with water and will dissolve into paint.

WET-INTO-DRY Wet paint applied to dry paper, resulting in hard lines.

WET-INTO-WET Wet paint applied onto wet paper, resulting in soft lines and shapes.

Useful resources

WEBSITES
www.artistsmaterialsonline.co.uk
www.artmaterials.com.au
www.artsupplies.co.uk
www.cheapjoes.com
www.danielsmith.com
www.dickblick.com
www.discountart.com.au
www.handprint.com/HP/WCL/water.html
www.gordonharris.co.nz
www.greatart.co.uk
www.jerrysartarama.com
www.londongraphics.co.uk
www.michaels.com
www.richesonart.com

BOOKS
Capturing Motion in Watercolour, Douglas Lew
Everything You Ever Wanted to Know About Art Materials, Ian Sidaway
How to Make a Watercolour Paint Itself, Nita Engle
How to Paint Watercolour Flowers, Robin Berry
How to Paint Watercolour Landscapes, Hazel Harrison
Learn Watercolour the Edgar Whitney Way, Ron Ranson
Painting from Life, Douglas Lew
Painting Spectacular Light Effects in Watercolour, Paul Jackson
Pouring Light, Jean Grasdorf
The Wilcox Guide to the Best Watercolour Paints, Michael Wilcox
The New Drawing on the Right Side of the Brain, Betty Edwards
The Natural Way to Draw, Kimon Nicolaides
Watercolour Painting with Passion, Alvaro Castagnet

WATERCOLOUR SOCIETIES
The Royal Watercolour Society
www.royalwatercoloursociety.co.uk

American Watercolour Society
www.americanwatercoloursociety.com

National Watercolour Society
www.nationalwatercoloursociety.org

The Australian Watercolour Institute
www.awi.com.au

The Canadian Society of Painters in Water Colour
www.ospwc.com

Transparent Watercolour Society of America
www.watercolours.org

Watercolour New Zealand
www.watercolournewzealand.co.nz

Watercolour West
www.watercolourwest.org

Index

Credits

Publisher credits

Quarto would like to thank the following for supplying images for inclusion in this book:

James Boisett p.115t, p.159b
Denny Bond p.54–55, p.112b, p.126b, p.128–131, p.124t
Francis Bowyer p.25br
Catherine Brennand p.66bl, p.67t, p.150c
Paul Dmoch p.45tr, p.67b, p.83br, p.112t, p.113tl, p.124t, p.125cl, p.159cr, p.167
D. R. Gawthorpe p.153
Tracy Hall p.135t
Ruth S. Harris p.122bl
Gerard Hendriks p.141br, p.142–145, p.150t
Suzanne Hetzel p.62br, p.64t, p.149br
Lisa Hill p.50–53, p.66t, p.158t, p.165tl
Shari Hills p.17bl
Brian Innes p.18bl, p.113b
Paul Jackson p.63b, p.83bl, p.125br
Terry Jarvis p.121
Keith M. Kennedy p.78
William Lawrence p.11br
Doug Lew p.141c/tr
Adrienne Pavelka p.19bl, p.114t, p.116br
David Poxon p.127br, p.166bl
Sarah Rogers p.44br
Yuriy Shevchuk p.10bl, p.64bl, p.69, p.126t
Katrina Small p.116tr, p.149t, p.160–163
Ann Smith p.132bl
Nancy Smith Emmons p.66br, p.117t
Naomi Tydeman p.110–111, p.119b, p.154–157
Lennox Wallace p.16bl, p.57t, p.58t, p.74b, p.81b, p.123b
Bridget Wood p.114, p.115b, p.119tl/tr
Keiko Yasuoka p.146–147
Janis Zroback p.63cr, p.113tr, p.152, p.165cr, p.165bl, p.171

All step-by-step and other images are the copyright of Quarto Publishing plc. While every effort has been made to credit contributors, Quarto would like to apologize should there have been any omissions or errors – and would be pleased to make the appropriate correction for future editions of the book.

Author credits

With deepest gratitude to four people without whom this book, and indeed my career as an artist, would not have happened: Norman and Doris York, Denise Tabet and Barbara Callender Olson.